CAPITAL
BEER

CAPITAL BEER

A HEADY HISTORY OF
BREWING IN WASHINGTON, D.C.

GARRETT PECK

AMERICAN PALATE

Published by American Palate

A Division of The History Press

Charleston, SC 29403

www.historypress.net

Copyright © 2014 by Garrett Peck

All rights reserved

First published 2014

Manufactured in the United States

ISBN 978.1.62619.441.0

Library of Congress CIP data applied for.

Dedicated to Jan Evans—Christian Heurich's granddaughter and a guiding force in creating the Heurich House Museum.

Jan Evans. *Photo by Garrett Peck.*

CONTENTS

FOREWORD

W hat cities come to mind when you hear the word "beer"? A generation ago, St. Louis and Milwaukee would have been the obvious answers. Today's craft beer enthusiasts, more mindful of quality than quantity, might cite San Diego or Seattle or Portland, Oregon. Few would place Washington, D.C., on their short lists. The District of Columbia, to many, is a symbol of bureaucratic inertia. They find it hard to believe that anybody has actually made anything here. And yet before it had a White House or Smithsonian, before it had a mile of paved road or a population equal to modern-day Podunk or Peoria, our nation's capital had a brewery.

In 1796, Cornelius Coningham unpacked his brewer's tools in a modest stone building a short distance from the Potomac, near where modern-day tourists toss dimes and quarters into the Reflecting Pool on the Mall. He made table beer, ale and porter for his customers in the Federal District until…

Well, keep reading Garrett Peck's *Capital Beer* to find out the fate of the city's first brewery, as well as the source of Washington's first lager beer. I always thought George Juenemann brewed the first German-style, bottom-fermented brew in 1856. But Peck's detective work provides compelling evidence that Washingtonians were quaffing lager a year earlier. In 1856, a Captain Bell was murdered at Beckert's Park on Capitol Hill, a beer garden and microbrewery. At the trial, one witness testified that a suspect flung a glass of lager at owner George Beckert. Because lager requires prolonged aging, Beckert must have brewed it the previous year.

Peck traces the history of brewing in D.C. from a cottage industry to a big business dominated by local beer barons. You'll meet Robert Portner of Alexandria, who helped revolutionize brewing with his advances in artificial refrigeration. His Manassas, Virginia mansion was the first home in the country to have air conditioning. You'll get to know the remarkable Christian Heurich, who, fortified by his Senate Beer and Ale, lived long enough to marry his first wife's niece and celebrate his own personal centennial in 1942.

Peck knows where the bodies are buried—literally, he does. He lists the cemeteries where the city's brewing luminaries lie in repose, just in case you Washington beer buffs want to honor your homies by pouring a nice pilsner or pale ale on their final resting places.

But D.C.'s best days as a brewing center are ahead of it, not behind it. Peck carries the story into the twenty-first century as a cadre of microbrewers return brewing to its artisanal roots. As of this writing, there are nine breweries in the city proper, and many more in the Maryland and Virginia suburbs. Still more are on the way.

Settle back with a local brew—a piquant double IPA from DC Brau maybe, a chewy porter from Port City Brewing in Alexandria or Chocolate City Beer's tribute to former mayor Marion Barry: an imperial stout brewed with marionberries (a type of blackberry). You've got a good read ahead of you.

GREG KITSOCK
Beer columnist for the *Washington Post*
Editor of *Mid-Atlantic Brewing News*

ACKNOWLEDGEMENTS

The brewing community in Washington, D.C., is burgeoning, and I am grateful to the many people who contributed their stories and helped further my research. *Capital Beer* covers more than 240 years of brewing history, predating the founding of the nation's capital. Much of the information you'll find in this book comes from archival materials, interviews and personal collections.

Few people ever realize the near-super powers that archivists, curators and librarians have. They walk among us, and yet you would never guess how valuable a resource they are (they really ought to be issued capes). As with *Prohibition in Washington, D.C.*, I am deep in gratitude for the work of Cindy Janke, an archivist at the Historical Society of Washington, D.C., whose work helped identify the early breweries and who is an encyclopedia of Capitol Hill's brewing history.

The Heurich House Museum has become the go-to resource for Washington's brewing legacy. Executive director Kimberly Bender and her amazing staff—including curator Yana Myaskovskaya, archivist Erika Goergen and assistant director Rachel Jerome—opened the museum's doors and archives to me. Christian Heurich's granddaughter Jan Evans provided a wealth of family history and personal perspective to this narrative. She has well earned this book's dedication for her decades of local history support.

The staff of the Historical Society of Washington, D.C., was incredibly helpful, but I have to single out Laura Barry for scanning a treasure-trove of brewing-related images. The other major archival center for Washington

history is the Washingtoniana room at the D.C. Public Library. Special collections librarian Jerry McCoy helped me find historic brewery locations and proudly displayed his vintage Alhambra beer stein (you'll see it in the color insert), while Derek Gray and Mark Greek found historic images of the Heurich brewery's demolition.

Leave no stone unturned when doing research, I like to say. Sylvia Augusteijn and Jennifer King of the Special Collections Research Center at the George Washington University's Gelman Library opened their extensive collection of historic maps and helped me find maps of historic brewing locations and pinpoint the site of the Washington Brewery near the Navy Yard.

George Combs of the Alexandria Library helped identify historic brewery locations and was a wonderful sounding board for Alexandria's brewing history. Don Dahmann of the Old Presbyterian Meeting House identified the burial location of Alexandria's first brewer, Andrew Wales. Mary Helen Dellinger of the Manassas Museum opened her archives of Robert Portner and his family.

Not all historic materials are in archives and libraries; many people have family histories and brewing artifact collections, known as Breweriana. The Breweriana images you find in this book are all because of the gracious support of Mike "Chosi" Cianciosi of the Potomac Bottle Collectors and the many enthusiastic members of the DC Collectors, including Jack Blush, Rayner Johnson, Chuck Triplett, David Hagberg and Wes Ponder.

Ceci Didden Weiland, a great-granddaughter of brewer Albert Carry, shared her family's history and historic images. Chris Kozel, a great-grandson of brewer John Kozel, provided fantastic images of the family beer garden on Fourteenth Street. My friend and fellow author John DeFerrari of the Streets of Washington blog has a neat collection of antique postcards; among them he found one for the Alhambra Summer Garden, which he graciously provided.

A number of friends gave generously of their time to edit and review the manuscript. I've been especially blessed to have Knight Kiplinger serve as a volunteer editor for the second time. He is an encyclopedia of Washington history and a wonderful thinker and preservationist. Mike Stein, a homebrewer, DC Beer blog contributor and a folk hero among the craft beer scene for his re-creation of Heurich's Lager, reviewed an early draft of this book and provided much background about how brewing actually works. Dr. Mark Benbow, the foremost scholar of brewer Christian Heurich, provided a much-needed sounding board for all things Heurich. Greg Kitsock, beer

columnist for the *Washington Post* and editor of the *Mid-Atlantic Brewing News*, wrote the foreword and always reminds me that writing should be not only informative but also full of grace, humor and wit.

We should all raise our glasses to the men and women who brew beer around the nation's capital. They have revived a proud tradition and important part of our local culture. This book is really their story, as they carry the tradition forward. The long list of dedicated souls begins with the three Bills: Bill Stewart of Bardo, whose brewpub was my first introduction to Washington beer; Bill Butcher of Port City; and Bill Madden of Mad Fox. Brandon Skall and Jeff Hancock of DC Brau, Jason Irizarry of Chocolate City Beer and Dave Coleman and Mike McGarvey of 3 Stars Brewing were the pioneers of production brewing in Washington in 2011. Justin Cox and Will Durgin of Atlas Brew Works, Megan Parisi and Greg Engert of Bluejacket and Ben Evans and Patrick Mullane of Hellbender round out the list of brewers, all of whom were extremely generous in their time for this project.

Let's not forget the important role that the brewpubs serve in bringing craft beer to the public. David von Storch of Capitol City was the first brewpub operator in Washington, and today Kristi Griner keeps the taps full. Barrett Lauer of the District ChopHouse & Brewery and Thor Cheston and Nathan Zeender of Right Proper Brewing have brought beer back to neighborhoods. Catherine and Margaret Portner of Portner Brewhouse continue their great-grandfather's tradition of brewing in Alexandria.

And lastly—and most of all—sincere thanks go to my editor, Hannah Cassilly at The History Press. We've worked together on four books. She planted the seed for this book, which is her very last book for the Washington, D.C. area. I raise my glass to you!

Prosit!

INTRODUCTION

Is there anything as pleasant in this world as sitting in an outdoor beer garden and sipping suds with friends over a long, languid conversation? It is one of life's simplest and most enduring pleasures. You're sharing an experience that people enjoyed in prehistoric Mesopotamia, where beer was invented; that medieval monks perfected; and that generations of Americans have enjoyed since the wave of Germans appeared on our shores in the 1850s. Germans call it *Gemütlichkeit*: the golden glow of conviviality.

No country in the world is more associated with beer than Germany. I lived in Germany for five years, including in high school and college, and was stationed there with the U.S. Army after the Cold War ended. I was always impressed with how many breweries there were—every village seemed to have one and an accompanying beer garden. I also remember Germans dismissing fizzy American beer of that era with a condescending joke about having sex in a canoe (I can't repeat it here, as there may be children within earshot; it has a crass punch line. Ask me if you see me in person). I daresay Americans have made jaw-dropping improvements in our beer since the craft brewing revolution got underway in the 1980s.

Beer is one of the foundations of German culture. It was so important, in fact, that Duke Wilhelm IV of Bavaria mandated that just three ingredients—barley, hops and water—could go into beer in what is known as the *Reinheitsgebot* (Purity Law) of 1516. Yeast wasn't mentioned, as fermentation was done in the open, where wild yeasts would simply float into the tank (the Germans later amended the law to allow wheat and yeast).

Alex Luther enjoys a Bavarian breakfast of sausage, pretzels and Hefeweizen at the Weihenstephan Brewery in Freising, Germany – the oldest continuously operating brewery in the world. *Garrett Peck.*

Today, brewers use specialized yeasts and enclosed tanks to better control the fermentation process. But five centuries of pure ingredients and process have also proved a modern problem for German brewing, where tradition has supplanted innovation. You want experimentation in beer? Come to the United States, where craft brewers stretch the imagination with hoppy, malty brews or yeast-driven beers. There has never been as good a time to be a beer drinker as right now.

American culture is a giant sponge. We readily adopt traditions that immigrants bring to our shores, including drinking holidays such as Cinco

de Mayo, Oktoberfest and St. Patrick's Day. We use any excuse to put on a funny hat and gather at bars to drink. The same thing applies for contemporary American brewing, which borrows liberally from Belgian, Czech, English and German traditions to form our eclectic American style, one that is boldly innovative.

German immigrants of the 1850s put a permanent stamp on the culture of Washington, D.C. They opened dozens of breweries, large and small. Our most famous bar, Shoomaker's, was founded by two German immigrants who served the Union during the Civil War. Beer gardens dotted the urban landscape and provided a major outlet for the city's locally brewed beer. Washington was awash in suds, thanks to the soaring popularity of a German invention: lager. Before the invention of air conditioning, people dealt with muggy summers by drinking lager. Water wasn't always potable and was rarely trusted. Brewing produced a beverage that was safe to drink, as fermentation kills bacteria.

Washington had been a wet city since its founding, but the temperance movement had other ideas. It intended to turn Washington into the model dry city for the country. Organizations such as the Anti-Saloon League (ASL) and the Women's Christian Temperance Union (WCTU) attacked the beer gardens' licenses and eventually shut down the burgeoning saloon culture in the city. The ASL even provoked a change to the U.S. Constitution to ban the manufacture, sale and transportation of intoxicating liquors. That included beer. Prohibition closed the breweries in the Washington area and nearly silenced an industry that was the city's second-largest employer after the federal government.

It was notoriously easy to purchase alcohol in Washington during Prohibition—but, sadly, not beer. Bootleggers preferred distilled spirits, which were vastly more profitable. Washingtonians changed their drinking habits toward cocktails. Beer seemed forgotten from the city's drinking culture for decades. Today, half of the alcohol consumed by Americans is beer. So why did Washington seem so late to the craft beer game that began in the 1980s in the rest of the country?

This is my third book dealing with the question of alcohol and Prohibition. My first book, *The Prohibition Hangover* (2009), examined how Americans became a nation of drinkers again after Prohibition failed. In my second book, *Prohibition in Washington, D.C.: How Dry We Weren't* (2011), I included one chapter on the loss of Washington's brewing scene. It was called "The Bottom of the Barrel." This book is much more than a simple rehash. It includes a huge swath of new research and tells the history of more than two

centuries of brewing in the district—not just in the immediate years before and after Prohibition.

Production brewing in Washington was reborn in 2011 with the opening of Port City Brewing in Alexandria and DC Brau in the district, followed by a slew of craft breweries. These brewers are making history. Journalism is the first draft of history, and thus the final chapter deals with the modern breweries and leans heavily on interviews with the key players.

The greatest difficulty in researching this book was deciding where to draw the line about what to cover. The craft brewing movement is exploding around the Washington metropolitan region, and that includes some dynamite breweries in the suburbs. I used the historic boundaries of the District of Columbia—the original one hundred square miles—and that includes Alexandria and Arlington County, Virginia. This book focuses on the history and current state of brewing within these boundaries.

BEER BEGINNINGS

The United States may have won its war of independence from Great Britain, but it was still dependent on foreign imports for even the most basic staples. The young American republic needed to harness the bounty of its vast lands to replace foreign-made goods that sapped the wealth of the nation. It replaced foreign-imported molasses and rum with domestically produced whiskey. After his presidency, George Washington briefly became the country's leading whiskey producer through his Mount Vernon distillery. The country tried (but mostly failed) to produce wines to replace French imports and Madeira. And it encouraged local producers to brew beer rather than rely on English imports. Beer was easy to make and the ingredients readily available.

In 1810, an anonymous writer known as Juriscola penned an open letter in the *National Intelligencer* titled "To the Cultivators, the Capitalists and the Manufacturers of the United States." He noted how well domestically produced beer had done: "Our malt liquors are nearly equal to our consumption, for we import only 185,000 gallons, and the cider and beer, exported under the proper names, are 187,000 besides sea stores." Juriscola believed that locally produced beer was healthier than that shipped from far away: "The medicated porter of G. Britain, as our physicians can demonstrate, is far less wholesome than the pure extracts of hops and grain which compose our whole tribe of beers. Foreign liquors are often adulterated." People were already complaining about adjuncts in beer.

Americans may have sought independence from all things British, but there was no escaping the absolute Englishness of that quenchable staple:

ale. The problem was that ales are heavy and not particularly conducive to Washington's hot and humid summers. Many of the first brewers were English or of English descent, and they produced beer that may not have been the most appropriate for the climate of the New World. And yet English-style ales are where we begin our history.

THE WALES BREWERY

The District of Columbia was established as the national capital in 1791, and within it a new city was created: the city of Washington. There were only a handful of existing settlements within the district boundaries: the port city of Alexandria, Virginia, founded in 1749, and Georgetown, founded two years later. As you may know, the Virginia side of the district was retroceded to the Old Dominion in 1847.

This may come as a surprise and a disappointment to proud Washingtonians, but the first brewery in the district was not in the city of Washington but rather across the river in Alexandria. In fact, it opened even before the American Revolution. The first brewer was Andrew Wales, who opened the Wales Brewery around 1770. (This would not be the last time that Alexandria opened a brewery before Washington—history repeated itself in 2011.)

Wales brewed for decades, operating a complex that included his brewery, home and store along Wales Alley between Fairfax and Lee Streets. The complex burned down in 1786, but Wales rebuilt. With his health declining, he turned over the keys in 1798. He died a year later. Cornelius Coningham, the first brewer in the city of Washington, briefly ran the Wales Brewery (which he renamed the Alexandria Brewery, in counterpoint to the Washington Brewery that he owned) until a new proprietor could be found.

John Fitzgerald, an aide-de-camp to George Washington, Irish immigrant and local businessman, purchased Wales's property. The brewery operated only four more years before it closed for good. The facilities were put up for sale in November 1802 after the death of Fitzgerald, who owned considerable property in the city but also considerable debts. Fitzgerald's estate was liquidated to pay off his creditors. The brewery, "commonly called Wales' Brewery," was one of many properties listed for sale in the *National Intelligencer*. It had rented for $600 per year and fronted forty feet on Water Street (now Lee Street). Nothing is left of the brewery, but if you

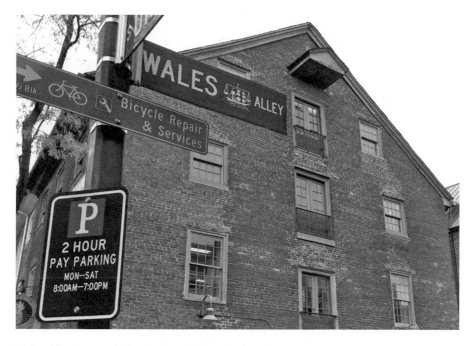

Wales Alley is named after Andrew Wales, the first brewer in Alexandria and the District of Columbia. In the photo is the 1789 Fitzgerald Warehouse, built by John Fitzgerald, an aide-de-camp to George Washington. *Garrett Peck.*

visit Old Town Alexandria, you can still see Wales Alley, along with the historic Fitzgerald Warehouse (built around 1789) that stood right across the street. The brewery was near the waterfront docks, where it hailed the longshoremen and sailors for their daily sustenance.

Fitzgerald's ownership of the property echoes down to our own time. He placed an easement on a section of Wales Alley in 1789, an easement that the Virginia Supreme Court ruled in 2013 was still in effect even though Alexandria owns the alley. The Old Dominion Boat Club fought for and retained the right to use the alley.

THE WASHINGTON BREWERY

Dr. Cornelius Coningham (1746–1820) opened the Washington Brewery in 1796, establishing the first brewery in the city of Washington. He was an English businessman, civic activist, physician and slaveholder. He brewed

English-style ales, including strong beer and table beer. The brewery stood near the village of Funkstown along the Potomac River shoreline near what is now the Reflecting Pool at Constitution Avenue and Twentieth Street NW.

Coningham had gone into business with James Greenleaf, an early land speculator in the district. Greenleaf sold his shares to John Appleton in 1797, but the brewery remained on his property. When Greenleaf landed in debtor's prison, Coningham decided to move. He found a more provident location where a steady stream of workers might sip his ale: the Navy Yard. Coningham reestablished the Washington Brewery in 1805 along the Anacostia River and operated it for the next decade in a former sugar refinery that he leased from Thomas Law, a wealthy Washington investor. The *National Intelligencer* described its location as "at the old Sugar House, foot of New Jersey avenue." The site is now adjacent to a DC Water building, a couple blocks west of the Navy Yard.

John Collet assumed the lease in 1811 and began operating the Washington Brewery. An advertisement in the *National Intelligencer* from January 1812 mentioned that Capitol Hill bookstore owner Daniel Rapine was taking orders for beer. It was the first mention in print of a Washington retail outlet for beer. The brewery made porter, table ale, strong ale and extra strong ale. Collet purchased the adjacent land along the Washington Canal with the intention of building a new brewery. Sadly, however, the beer market was declining as American men instead took to drinking whiskey, which was cheaper. Collet listed the brewery for sale or five-year lease in July 1813. He died fourteen months later, six weeks after the British raid on Washington during the War of 1812.

At the time of the British raid in August 1814, there were three breweries in the city of Washington: Daniel Bussard's Georgetown Brewery, Henry Herford's on Pennsylvania Avenue and John Collet's Washington Brewery near the Navy Yard. Across the river in Alexandria stood the Entwisle Brewery. One might think that a conquering army would seize barrels of beer as a prize of war, but the British weren't looters and were remarkably disciplined. After defeating the American militia at Bladensburg, the British occupied the city and torched only the public buildings. The American commander of the Navy Yard, Commodore Thomas Tingey, ordered his ships burned rather than see the British capture them. A British contingent searched the nearby Arsenal at Greenleaf Point. They discovered 150 barrels of gunpowder, which they threw down a well to destroy, but somehow the gunpowder ignited. A tremendous explosion shook the city, killing more than three dozen soldiers and injuring many more.

A Heady History of Brewing in Washington, D.C.

The Washington Brewery sat just west of the Navy Yard, and British soldiers would have passed by on their way to the Arsenal. Looters (Washingtonians, not the British, it should be noted) made quick work of the Navy Yard, and chaos reigned at the Arsenal after the explosion. But what was the fate of the Washington Brewery? The British respected private property, but did looters sack the brewery and steal the beer? The record doesn't say. We know that Herford's Brewery survived unscathed and that the British didn't go as far as Georgetown. It may well be that the breweries escaped damage or looting during the burning of Washington.

Henry Herford's small brewery would be distinguished (and extinguished) as the first recorded brewery fire in Washington history—the first of many. Starting around 1805, Herford opened a brewery and grocery store on the south side of Pennsylvania Avenue between Ninth and Tenth Streets in what is now the Federal Triangle. He sold not only strong and table beer but also grain and yeast for home brewers. Herford's brewery survived the British raid on Washington but caught fire five months later on January 23, 1815. Citizens raced to rescue the building, and fortunately prevailing winds prevented the blaze from spreading to other buildings. "The loss is probably more than one and less than two thousand dollars," the *Daily National Intelligencer* reported.

After John Collet's death in September 1814, the Washington Brewery sat idle for the next three years until two brothers—Clement and Thomas Coote—immigrated to the United States from England in 1817. Clement opened a dry goods store, while Thomas and a business partner, David Ott, bought the Washington Brewery and began producing ale and porter. Their partnership fell apart within two years, however, as Thomas took out identical ads in the *Daily National Intelligencer* and the *Washington Gazette* in August 1819 mentioning that he was now the sole proprietor and beseeching customers to return to buy beer, adding that "all orders from punctual customers will meet the most prompt attention."

In 1822, Thomas brought in his brother Clement, and the two now owned the Washington Brewery together. Debts constantly pursued Thomas, and in January 1825, Clement took over ownership of the brewery—including his brother's debts related to the business. Thomas was not satisfied, and the case was referred to arbitration. Their dispute broke out in the press when Thomas placed a notice against his brother in the *Daily National Intelligencer* in February 1826:

> *The public are cautioned against receiving security on the real or personal property belonging to the "Washington Brewery," as I hold drafts drawn by*

> *the present occupant, Clement T. Coote, on the Rev. Luther Rice, unpaid, and an agreement in writing by them to give me a mortgage if required, which they have subsequently refused to do. The unpaid acceptances and agreements are in the hands of Wm. Redin, Esq., Attorney, Georgetown.*

Clement countered the next day with his own notice in the newspaper, essentially calling out Thomas for making their dispute public and pointedly noting that Thomas had left the brewery in bad financial condition:

> *The caution and information, contained in an advertisement in the Intelligencer of yesterday, by Thomas Coote, relative to the Washington Brewery, was not called for; as he left the estate and personal property too much encumbered to apprehend much danger from an addition of that kind; and, as it regards the drafts in question, neither Thomas Coote or myself are of sufficient importance for our private disputes to be interesting to the public; and our private friends are aware that they are now before a friendly committee of investigation.*

The Thomas brothers' ads ran next to each other for several days. Thomas was in dire financial shape; he was imprisoned for debt later that year. His brother, meanwhile, had become one of Washington's leading citizens. Although not well remembered today, Clement T. Coote was, at various times, an attorney, a dry-goods store owner, grand master of his Masonic lodge, justice of the peace and a city alderman. Given his civic responsibilities, it's understandable why Coote leased the brewery to William and Thomas Gunton in October 1826. But things didn't work out with the Guntons, so Coote resumed brewing in 1832.

The earliest known image of a Washington brewery wasn't a photograph but rather an idyllic painting. George Cooke painted his *City of Washington from Beyond the Navy Yard* around 1833, portraying the tiny national capital in pastoral terms. The Navy Yard gleams white with its buildings and dry dock right along the Eastern Branch (now the Anacostia River)—and just to the left and almost dead center of the image (and directly below the greatly enlarged White House) is the brick building that housed the Washington Brewery. You can see the painting in this book's color insert.

Breweries were often built as multi-story facilities. Boiling the wort on the top floor allowed the heat to escape the building, and gravity could then move the heavy liquid downward through the various stages of the brewing process. A brewhouse was often a vertically stacked operation.

Washington Brewery owner Clement T. Coote's signature on the July 14, 1836 deed of transfer that sold his brewing equipment to William Hayman. *Historical Society of Washington, D.C.*

Despite Clement's respectable reputation, the Washington Brewery was frequently in debt. We find repeated mention of Coote transferring large quantities of beer to his debtors. In an era when whiskey was the preferred beverage, Coote may have had difficulty selling heavy English ales in the steamy Washington market. Four years after resuming active ownership, he put the Washington Brewery up for sale in 1836. The buyer? William Hayman, who hauled off the equipment to his brewery near Georgetown. A brewery would not operate near the Navy Yard again until 2013.

THE GEORGETOWN BREWERY

Georgetown was the last point on the Potomac River that ships could navigate upriver, and thus it became a harbor town, in particular for Maryland tobacco farmers. Before industry sprang up along the C&O Canal in the 1830s, Georgetown was a tobacco-shipping town.

Georgetown proper got its first brewery in 1809. Little is known about the brewery other than the fact that owners Daniel Bussard and a Mr. Renner

named it the Georgetown Brewery. Bussard was a leading businessman and merchant who served on Georgetown's board of alderman. We can't be certain of the brewery's location, as the many print references fail to define where it stood. (Historians have likewise long wondered about the location of Suter's Tavern, the best known of Georgetown's taverns.) Bussard brought in a new business partner, William Hayman, around 1813. A severe thunderstorm in August 1820 damaged the brewery, but it was soon back in action. Just two weeks later, Bussard advertised in the *Metropolitan* for "12,000 bushels of good Barley."

Bussard died in 1830, and Hayman built a new brick brewery that same year. Could this have been on the same site as the Georgetown Brewery? We don't know. In any case, the location for Hayman's Brewery was clear—in fact, it became a storied site for brewing and bottling. It stood on the northeast corner of K Street at Twenty-seventh Street NW on the east side of Rock Creek, which provided a steady supply of water. The site was technically not in Georgetown but in the city of Washington. It was near the terminus of the C&O Canal, which had recently commenced operating. After witnessing the three-storied brewery's opening in 1830, the *Daily National Intelligencer* wrote, "This establishment is said by competent judges to be the most complete, although not the largest, in the U. States." Hayman's Brewery had capacity for up to six thousand barrels per year. (It was Hayman who purchased the Washington Brewery equipment from Clement T. Coote in 1836 when that brewery shut down.) Hayman died in 1842. The following year, the Orphan's Court ordered the brewery's equipment, fixtures and barrels auctioned to pay Hayman's debts, including 140 barrels of ale.

Hayman's next became Jacob Harman and N.P. Gordon's for four years, then the property was auctioned off again in August 1847. Joseph Davison acquired the brewery in 1850, and he renamed it the Washington Brewery, as the former brewery by the same name at the Navy Yard had been closed for fourteen years. Many people, however, simply called it Davison's Brewery. An 1857 article in the *Evening Star* claimed that it was the largest brewery in the city at that time, with its three stories, vast underground storage space ("an exploration forcibly reminds one of the fabled stories of the dreary prisons of the Old World in ancient times," the *Star* wrote enticingly) and thoroughly modern brewing equipment for the day. Davison's produced ale, brown stout and porter.

The Washington Brewery changed hands again in early 1860 after Davison was sued for failing to complete payments to the family trust that owned the land. Clement Colineau was listed as the proprietor. The brewery

was now making ale, porter and brown stout. Colineau's ad in the *Daily National Intelligencer* explained that the brewery was also making table beer, a lower alcohol beer that was considered family friendly and safe for children to drink: "The Family or Table Beer (a new article in Washington) is made of the same materials as ale, and alike in appearance; but it is fermented more on the principle of wine, forming an excellent substitute for it," the brewery's ad in the *Daily National Intelligencer* read. "Ladies and children especially will find it a most agreeable and wholesome drink during the summer months." At one dollar for an eight-gallon keg, it cost half the price of the brewery's stout.

In 1865, the Washington Brewery changed hands to Harvey North but remained at K and Twenty-seventh Streets. John North ran it starting in 1867, followed by the North brothers, George and William, in 1871.

In the years after the Civil War, the Washington Brewery declined and even briefly went idle. A new owner attempted to revive the business in 1872. George Wilson changed the name to the Arlington Brewery, which focused on producing ale rather than the more popular (but time consuming) lager. It went through a number of owners over the next several years as the business failed to revive. Francis Denmead, the Baltimore maltster who had an eye for distressed properties, purchased the brewery in 1877. He would do this many times in the Washington market, purchasing the plant cheaply, repackaging it as a speculative real estate venture and then reselling it. The last recorded owner of the Arlington Brewery was Thomas Trafford, who purchased the plant in 1879 from Denmead. The record then falls silent for six years, and sometime in that period, the Arlington Brewery went out of business.

To further confuse the reader, there was another and completely separate Arlington Brewing Company located in Rosslyn, Virginia. Consumers' Brewing adopted the Arlington name in 1902, two decades after the earlier namesake near Georgetown had folded.

The Washington Brewery/Arlington Brewery site, however, was a location with much potential, given its proximity to the city's largest brewery, that of Christian Heurich. Heurich's nephew, Charles Jacobsen, opened the Arlington Bottling Company in 1885 in the former brewery. He immediately acquired a contract to bottle Heurich's Lager and Maerzen beers. It may well be that Heurich purchased the site or at least provided financing for his nephew, who was only twenty-five years old at the time. Jacobsen ran the Arlington Bottling Company for decades. As Prohibition set in, he shifted from beer to ginger ale, sarsaparilla and near beer, but the public wasn't much interested in no-alcohol brands like Blatz's Barma, Noalco, Nulo or

Progressive Brew. The historic bottling and brewing building was torn down to make room for the Whitehurst Freeway after World War II.

ONE NAME, SEVEN BREWERIES

In the annals of Washington brewing, one name rings out more than any other: the Washington Brewery. It existed at seven different locations—enough to confuse the reader as much as the writer. Cornelius Coningham began the brewery in Foggy Bottom in 1796 but in 1805 moved it to the Navy Yard, where it operated until 1836. Joseph Davison renamed the old Hayman's Brewery near Georgetown in 1850 as the Washington Brewery. It continued operating there until the 1870s. Brewer Henry Rabe briefly picked up the name in 1886 and then sold his Capitol Hill brewery to Albert Carry several years later. A British syndicate allegedly purchased the Mount Vernon Brewery on Capitol Hill in 1889 and renamed it the Washington Brewery. The brewery closed in 1917 when the district went dry. The sixth and last brewery to carry the moniker was Abner-Drury in Foggy Bottom, which picked up the name in 1935 but closed its doors just two years later. It seems appropriate that the Washington Brewery ended in Foggy Bottom, near where it began.

There was a seventh company to use the Washington Brewing Company name, a short-lived contract brewer that made Monument Ale in the 1990s (contract brewing means that the beer is produced by someone else—in this case, a company in Norfolk, Virginia). Washington still awaits the resurrection of its namesake brewery.

THE GERMANS ARE COMING!
THE GERMANS ARE COMING!

Political revolutions convulsed Germany and much of Europe in 1848 as populations revolted against monarchies and demanded greater civic and democratic rights. Most of the uprisings were put down. The result in Germany in particular was a major exodus of Germans to the United States. Some of these were intellectuals, known as the "Forty-Eighters," but most were farmers and merchants, many of them skilled in a particular trade. The Germans were highly organized and known for their work ethic.

Between 1819 and 1871, 2.5 million Germans came to the United States. Washington, D.C., went from having no German-born residents in the 1850 U.S. Census to having 3,254 Germans in 1860 and 4,159 in 1870 (the city's population was 109,199 in 1870, so the German-born population was 3.8 percent. This didn't account for their native-born children, who magnified the size of the local German American community).

The Germans also put their architectural stamp on Washington. The notable Gothic and Romanesque Revival styles of Adolf Cluss, Clement Didden and Thomas Franklin Schneider defined Victorian-era buildings in the city. They built public schools and churches like Concordia German Evangelical Church in Foggy Bottom and St. John's Lutheran Church in Southwest (since torn down).

They were strongly involved in the German American community and in the broader Washington society. They formed the bedrock for a number of charities in the city. A number of them became wealthy—there was great

money in brewing, as beer was not just a staple but also the center of social life in beer gardens and halls.

The Germans brought their daily beer-drinking habits with them, along with their love of Sunday beer gardens. This put them at odds with the evangelicals of the temperance movement, who sought to stamp out drinking, and Sabbatarians, who believed that Sunday drinking was sacrilegious. And the Germans brought a most welcome gift, one that beer-drinking Americans should be eternally grateful for: lager beer.

ACH, DU LIEBES LAGER

Americans had been drinking English-style ales and porters since the Pilgrims arrived, but these were never hugely popular given the hot, humid summers in North America. It was a German invention—lager—that met the public's appetite for quenchable, refreshing beer.

Lager, which means "to store" in German, is a beer fermented by yeast that sinks to the bottom of the fermentation tank and requires a much colder temperature than does top-feeding ale. Because of the need for a cool environment, fermenting lager takes much longer. The beer then needs to be stored and aged, which many breweries did in cool underground storage spaces or even in caves in Germany. It often took six months to produce a batch, so brewing was confined to the cooler months of the year. As chilling plants and ice-making machinery were invented in the 1870s, breweries upgraded their equipment so they could brew lager year round.

There are different kinds of lager. The main kinds are:

Bock. Bock was brewed in late fall and released for Lent or in early spring, often by monks to assuage hunger while fasting. It is more malty and higher in alcohol. A bock is a billy goat in German, which is why the goat is the symbol for this beer. You may sometimes find *Doppelbock*, or Double Bock, which is even maltier and stronger.

Lager. Lager is light in color, lightly hopped, mild but crisp in flavor and fairly low in alcohol. There are numerous regional styles of lagers: Dortmund, which is pale; *Dunkles* (dark-colored); *Helles* (light-colored and brewed in Bavaria); and Vienna style, which is an amber lager.

Märzen. This amber lager was begun in March (*März* in German) before the spring warm-up made brewing impossible in the years before refrigeration. It is the beer of Oktoberfest, which actually begins in September.

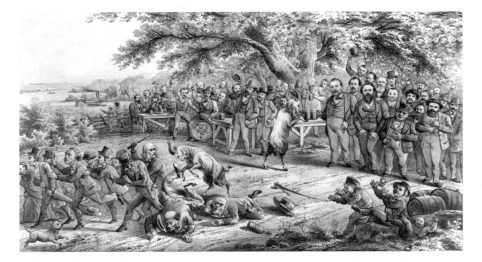

A humorous image showing the Bock (billy goats) routing the feeble cold-water temperance men while upstanding beer-drinking men cheer the goats on. The date (March 21, 1873) refers to the day when the brewers coordinated the release of Bock beer in spring. *Library of Congress.*

Pilsner. A pale lager, pilsner was invented in 1842 in the city of Pilsen (now Plzeň in the Czech Republic). The definitive version is the original brand, Pilsner Urquell. This style uses Saaz hops, which gives pilsner a distinct aroma. In 1876, St. Louis brewer Adolphus Busch introduced a new pilsner that he named after the Czech city of Budweis (now České Budějovice). It was a huge hit in the American market, as it was lighter than more traditional Bavarian lagers. The beer, Budweiser, is still America's best-known brew.

There are other less common kinds of lager, such as *Rauchbier* (smoked beer) and *Schwarzbier* (black beer). Baltic Porter is brewed as a lager as well.

Not all German beers are lagers. *Altbier, Berliner Weisse, Kölsch* and *Weizen* (also known as *Hefeweizen* and *Weissbier*) are ales. *Weizen* is largely produced in Bavaria.

Who First Brewed Lager in Washington?

The first person to brew lager in the United States was John Wagner, a small production brewer in Philadelphia in 1840. Lager exploded in popularity, and Philadelphia became its leading producer. Over the next decade,

Washingtonians sipped Philadelphia lager—until brewers caught on that they, too, could produce lager locally. But who was the first Washington brewer to produce lager? We can narrow down the candidates to the German immigrants who began brewing in that decade—George Beckert, Charles Gerecke, George Juenemann (and his business partner Owen Humphreys) and John Kozel—as well as established local brewer Joseph Davison.

George and Teresa Beckert opened Beckert's Park, a pleasure garden and restaurant with a small brewery, on Capitol Hill in the 1850s. After a Captain C.W. Bell was murdered at the garden in July 1856, George was summoned to testify at the trial. A witness mentioned that one of the suspects had been drinking lager and threw his glass at Beckert. Thus, Beckert was brewing lager by 1855 at the latest, as the beer takes some time to produce.

John Kozel began brewing in Washington around 1854 but possibly as late as 1858. His 1881 obituary in the *Washington Post* claimed that "he established the first beer brewery in this city." Certainly he wasn't the first brewer, but could this mean that he was the first lager brewer? It's an open question. Kozel was best known for his Weiss beer, the wheat-based ale that originated in southern Germany.

A June 1856 article in the *Evening Star* noted that Joseph Davison, owner of the Washington Brewery, had brewed twenty thousand gallons of lager the previous winter, meaning that he probably started in late 1855. Davison also advertised in the 1858 *Boyd's Directory* that he was brewing lager in addition to his English-style ales.

Charles Gerecke advertised in the *Evening Star* in November and December 1856 that he was brewing lager at his brewery at Pennsylvania Avenue and Nineteenth Street. Gerecke then disappears from Washington's historical brewing record. He was probably related to the Gerecke family that was importing lager from Philadelphia in the years prior, whose advertisements pop up frequently in that same newspaper.

Our fifth (and least likely) candidates are George Juenemann and his business partner Owen Humphreys. Juenemann's obituary in the *Washington Post* in 1884 mentioned that he "built the first brewery ever erected in Washington." (Notice the similar claim about John Kozel above? Neither man was, in fact, Washington's first brewer). Juenemann began brewing with Humphreys in 1857, later than the other candidates. A poorly written advertisement for "Humphries and Junniman" appearing in the *Evening Star* from June through August 1857 stated, "They have on hand and constantly make the purest Larger to be obtained in the city." Juenemann renamed the business the Mount Vernon Lager Beer Brewery in 1863.

In Alexandria, there is no contest as to who first brewed lager. That title goes to German immigrants John Klein and Alexander Strausz, who opened the Shuter's Hill Brewery in December 1858.

We may never know definitively which Washington brewer first produced lager, though the evidence points to George Beckert, as he opened his establishment before the others. If you visit Beckert's grave in Congressional Cemetery, George Juenemann's in Mount Olivet Cemetery or John Kozel's in Prospect Hill Cemetery (or the graves of Joseph Davison and Charles Gerecke, wherever they may be), raise a glass to them for the gift of lager.

CIVIL WAR–ERA BREWING

Alcohol historian William Rorabaugh pointed out in *The Alcoholic Republic* that American men primarily drank cider and rum around the time of the American Revolution before shifting to whiskey in the early 1800s. The whiskey binge of the 1820s directly led to the birth of the temperance movement, and after that, American men gradually reduced their drinking. But it took the wave of German immigrants to permanently alter American drinking habits with the introduction of lager. The Germans made brewing ubiquitous. By the end of the Civil War, beer had replaced whiskey as the national beverage. Its demand skyrocketed, peaking in 1915 shortly before Prohibition began.

Armed with democratic ideals, German immigrants settled in the Northern states and overwhelmingly supported the Union during the Civil War. For example, the slave state of Missouri remained in the Union because of the strong presence of Germans in St. Louis. Tens of thousands of German soldiers fought for the Union and took their thirst for lager with them to the army camps. It was their demand for beer that helped transform the nation's drinking habits.

The Civil War marked a turning point in Washington brewing. With the passing of the armies through the city, demand greatly increased. Many breweries opened during the war. And with the advent of railroad transportation, beer kegs could be hauled long distances to other markets and even travel with the armies. Beer was such a crucial staple that Congress levied an excise tax on beer of one dollar per barrel to help finance the war. In direct response to the tax hike, the United States Brewers' Association was formed in 1862 to lobby for their interests.

In 1860, on the eve of the Civil War, seven breweries operated in Washington and two in Alexandria, Virginia. The number doubled to thirteen by 1870, as the throngs of Union soldiers had a great thirst. But with the war's end, the soldiers went home, and many breweries closed or changed hands. A shakeout took place in the postwar years as the small operators closed shop, gradually replaced by larger breweries that were well capitalized and had adopted the latest mechanical inventions, including refrigeration. By 1880, fourteen breweries churned out beer in the city, their capacity ever increasing. Brewing was being transformed from a family business into a corporate model that had much greater scale—often capacity for 100,000 barrels a year or more. These were typically owned by a handful of investors (or a single brewer, such as Christian Heurich) who owned a controlling stake in the business. By 1900, there were just six breweries in the Washington metropolitan area, all of them large-scale operations.

Given that Civil War–era brewing was largely a family business, the death of the brewer often led to the auctioning of the business to pay off debts. In the January 6, 1868 edition of the *Evening Star*, for example, two breweries were listed for sale. Francis Frommell had purchased Paul Baumann's brewery on Capitol Hill in 1864 and then died just two years later. The empty site was looking for a buyer. That same day in 1868, the auction notice was posted for Baumann's new brewery on Pennsylvania Avenue and Ninth Street SE after Baumann died (he had sold his earlier brewery to Francis Frommell in order to buy a larger facility). In the 1866 *Boyd's Directory*, Baumann's wife, Catherine, was listed as the first female brewer in Washington. (Whether she actually brewed is questionable, given that she soon put the brewery up for auction.) She was the executor for her husband's will.

Washington's population continued to grow after the Civil War—and with it the demand for beer. The 1903 publication *One Hundred Years of Brewing* noted the rise of brewing in the city. It stated that, based on federal excise tax records, the city produced 3,580 barrels of beer in 1863, which grew sixfold to 21,573 barrels in 1875 after a postwar slump and then more than tenfold to 228,647 barrels in 1902. Brewing became a major industry in Washington in a relatively short period, and it was a major employer for the city's workers.

In the 1880s, the major national breweries like Anheuser-Busch and Schlitz established a presence in Washington, providing further competition and pressuring small family producers to exit the market. National breweries shipped beer in refrigerated railcars, bottled it in the destination city and then distributed it.

German immigrants often built clusters of breweries around Washington. The Waterfront was a significant hub for nineteenth-century breweries, both for its proximity to the Navy Yard and the Washington Arsenal and for the many workers and ships that docked there. The Washington Brewery—the first brewery in the city—had its second location near the Navy Yard. The neighborhood was known as the "Island," as the Washington Canal separated Southwest from the rest of the city. It was a working-class neighborhood with ramshackle wooden houses and alley dwellings, populated by African Americans and immigrants. Among the cluster of breweries that served the sailors and workers was the Island Brewery, which offered beer from its Maine Avenue location from the 1840s until it closed in 1858. A number of German-owned breweries then began operating near the Waterfront along 4 ½ Street (a street that no longer exists) from the 1860s until the 1880s. Southwest was largely bulldozed and redeveloped in the 1950s as part of urban renewal.

Another cluster of German-owned breweries stood near New York Avenue NW and North Capitol Street. These included the Metropolitan Brewery, Kernwein and Kozel's breweries and Widmann's brewery.

THE METROPOLITAN BREWERY

In 1860, Ernst Loeffler opened the Metropolitan Lager Bier Brewery and Washington City Garden at 115 New York Avenue NW. His timing was impeccable: the Civil War was beginning, and thousands of thirsty Union soldiers would soon arrive in the city and drink from Loeffler's taps. In fact, Loeffler briefly became a soldier himself as the captain of Loeffler's Company, a local volunteer militia unit that protected Lincoln's inauguration and was mustered out in July 1861. Loeffler returned to his brewery and beer garden. With his health suffering from so much wartime work—or perhaps realizing that the value of his brewery had peaked—Loeffler sold the Metropolitan Brewery in 1864 but continued operating the neighboring beer garden, which was informally known as Loeffler's Garden until his death in 1885. The beer garden was located where the New York Avenue Playground now stands.

Edward Abner, Louis Beyer and Frederick Hugle purchased the Metropolitan Brewery in 1864. (This was the same Edward Abner who had partnered with Robert Portner and then sold his share after the Civil

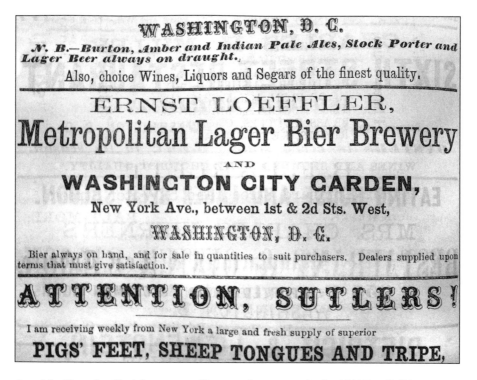

An ad for Ernst Loeffler's brewery and beer garden appears in the 1864 Boyd's Directory. *Historical Society of Washington, D.C.*

War ended.) Their timing couldn't have been worse, as the post–Civil War brewing slump hit when the soldiers went home. Louis Beyer bought out the partners in late 1866, though he must have sublet the operation to Edward Abner and Charles Mueden, as they advertised the business as the Abner & Mueden Brewery. Within two years, the brewery was bankrupt, and the remaining 890 barrels of lager were auctioned off in 1869. The brewery closed for good.

In 1878, the city school board, facing an urgent shortage of classroom space, leased the dilapidated Metropolitan Brewery. This briefly placed a school next to Kernwein's Brewery and Loeffler's Garden. In 1885, the old Metropolitan brewery gave way to the National Homeopathic Hospital, which operated until 1939.

KERNWEIN'S BREWERY

In 1874, George Kernwein opened his brewery at 124 N Street NW, directly adjacent to Loeffler's Garden and in the shadow of the shuttered Metropolitan Brewery buildings. Kernwein's plot of land was narrow and cut through from N Street to New York Avenue, and he built several brewing buildings or possibly leased them from the former Metropolitan. After Kernwein died in 1888, his son Maurice assumed ownership until 1900. The last records show that Anton Danhakl brewed there from 1904 to 1910, making him one of the last pre-Prohibition small brewers in the city. Brewing in this corner of town was all but forgotten by the time Dunbar High School opened nearby in 1917.

KOZEL'S BREWERY

John Kozel, a German immigrant from Württemberg, arrived in Washington in 1854. Kozel's first brewery was at Ninth and M Streets NW. He moved to a larger facility near North Capitol Street (43 N Street NW) in 1861, just a year after Ernst Loeffler started operating nearby. Kozel brewed ale and lager but was best known for his Weiss beer.

When John Kozel died in 1881, his son George took over the brewery for a year and then sold it to Leo Ewald in 1882, who in turn sold it the following year to John Eller. The brewery is believed to have closed around 1890. The buildings were torn down, replaced by a charming 1912 brick garage and warehouse that still stands. The Kozel name continued in Washington in a storied beer garden on Fourteenth Street, which you can read about in chapter six.

WIDMANN'S BREWERY

Next to Kozel's was Joseph Widmann's brewery (45 N Street NW), which moved into the location soon after the Civil War. Times were tough for brewers—not only did they see a reduction in demand, but the federal government also retained the higher excise tax rate (one dollar per barrel) that had helped finance the war. In July 1867, Widmann and his wife were

caught attempting to evade paying federal excise taxes. Revenue agents heard rumor of the shenanigans and paid the Widmanns a visit one evening. A woman met the agents at the back entrance, saying that the lager vaults were locked and that they'd need to get the key. She then anxiously passed over the vaults, crying out, "Cuckoo! Cuckoo!" as if calling for her chickens (but really warning whomever was inside). When she and the agents reached the trapdoor, she anxiously called out someone's name—Charles—to draw his attention and then announced that she'd go to the house to get the key.

Meanwhile, the revenue agents discovered that the trapdoor wasn't locked but rather bolted from the inside. This, coupled with the woman's fowlish behavior, raised their suspicions, and they pried open the door. There they found two men drawing off beer into unstamped kegs. The fact that they were unstamped meant that they were evading paying the excise tax, saving them considerable money. The penalties for such fraud were heavy: a fine of at least $500, imprisonment for up to a year and forfeiture of all the equipment used in the fraud. The authorities immediately arrested the two men, shut down the Widmann Brewery and confiscated the equipment, which the *Evening Star* estimated cost the couple $10,000. "Repeated warnings have been given by the revenue authorities by the manufacturers concerning the stringent provisions of the law, but the temptation to evade it seems to be too strong to be resisted in many cases," the newspaper observed.

Widmann managed to reopen, but a major fire in April 1869 heavily damaged the wooden-framed brewery. The fire spread to Kozel's next door, damaging Kozel's pavilion before the blaze was extinguished. Widmann moved his brewery to several other locations. John G. Cook took over the N Street brewery in 1874 and continued brewing there until 1880.

BREWING ON CAPITOL HILL

Capitol Hill was once fairly crowded with breweries, but as the market consolidated, only two survived into the 1890s. Their names and owners changed many times over the years, but the locations didn't. These were the National Capital Brewing Company (Fourteenth Street between D and E Streets SE) and the Washington Brewery (the entire city block bound by Fourth and Fifth Streets NE and E and F Streets NE). Both were closed when Washington went dry in 1917, and their historic properties were eventually redeveloped.

THE JUENEMANN/MOUNT VERNON/ WASHINGTON BREWERY

George Juenemann (1823–1884) was a German immigrant who came to the United States with his wife, Barbara, in 1851. After settling in Washington and working as a tailor, he teamed with Owen Humphreys in 1857 to found the Humphrey and Juenemann's Pleasure Garden, better known as the Juenemann Brewery. Five years later, Juenemann bought out Humphreys and renamed it the Mount Vernon Lager Beer Brewery and Pleasure Garden, smartly tying the name to George Washington. It was the largest brewery in Civil War Washington, surpassed only by Christian Heurich in the 1870s. Juenemann ran the brewery until his death in 1884.

The Juenemanns' son, George Jr., continued working at the brewery. He was badly injured in an assault a block from his home at 908 Fourth Street NE in April 1889 and died two days later from a fractured skull. The police closed the case, deciding that he had been hit by a B&O Railroad train, even though the inquest determined Juenemann had indeed been murdered.

Barbara Juenemann sold the Mount Vernon Brewery to Albert Carry in 1886. She continued living at the family residence at 510 C Street NE on Stanton Square—a home that still exists. Her husband had died in the home, and the inquest for her son's murder was held there as well.

Albert Carry (1852–1925) transformed small breweries into marvels of the mechanical age, becoming one of Washington's leading brewers and businessmen. (Carry doesn't sound like a German name, and it isn't—it was originally Carri. His ancestors had moved from Lake Cuomo, Italy, to Germany several generations before.) Born in Baden-Württemberg, he left Germany in 1872 at age twenty. Carry worked his way up as a brewery manager in Cincinnati before moving

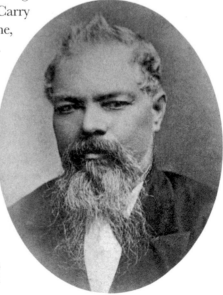

A portrait of spikey-haired George Juenemann, one of the first in Washington to brew lager. *Historical Society of Washington, D.C.*

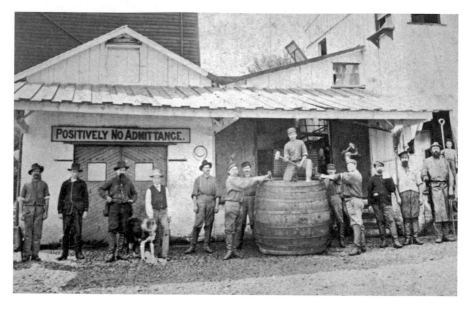

Workers pose at George Juenemann's Mount Vernon Lager Beer Brewery, ca. 1865–1870. *Historical Society of Washington, D.C.*

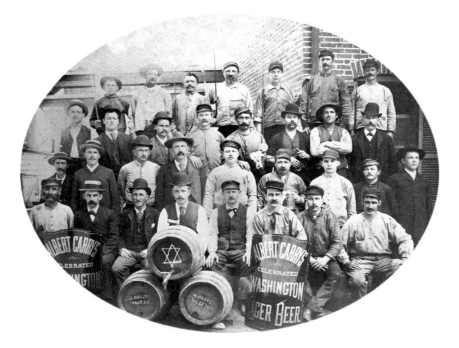

Workers from Albert Carry's brewery pose for the camera. Albert Carry sits directly behind the cask with the six-point Brewers' Star, identical to the Star of David. Brewers had used the symbol since the Middle Ages. *Historical Society of Washington, D.C.*

to Washington in 1886 to purchase the Mount Vernon Lager Beer Brewery. He would own that brewery for only three years, but in this short period, he modernized the facilities, tearing down the obsolete Civil War–era brewhouse and raising new buildings. He doubled production to 100,000 barrels, and it was his high energy and vision that attracted Gilded Age investors.

British syndicates (early hedge funds) aimed to buy up many American breweries in the 1880s, figuring them to be profitable investments while also steering around American import tariffs. One of them attempted to buy the Washington Brewery. This created a public relations sensation, and Albert Carry told the *Washington Post* that he was not selling the brewery to the British. When the allegations of the brewery sale appeared in the *Economist*, the board of directors denounced the story. Yes, the syndicate had approached them, but they had rejected the offer. "There is some scoundrel at the bottom of it," Carry told a *Post* reporter, "and he wanted to enrich himself at the expense of others."

A group of New York investors stepped in to purchase the brewery, which may have been a front for the British syndicate. Albert Carry begged to differ and, upon the brewery's sale, told the *Post*, "The men named in the deed are all American. Congress would not allow me to sell the square to Englishmen." (It would be decades before the brewery admitted that it was, in fact, British-owned). In any case, Carry sold the brewery for $400,000, a princely sum. The terms of the sale required him to stay on for one year to run the business during its transition and to help complete the plant upgrade. The new owners renamed it the Washington Brewery. It was best known for two beer brands: Culmbacher dark lager and Imperial Export light lager.

Like Christian Heurich and Robert Portner, the other Gilded Age brewers in the Washington area, Albert Carry was involved in far more than just brewing. He sat on the boards of several banks and invested in real estate. Carry married Wilhelmina Bock in Cincinnati in 1875. The couple had seven children (five daughters and two sons). After he sold the Mount Vernon Brewery, he built a Capitol Hill mansion at 145 Twelfth Street SE in 1892. The architect was Clement Didden, the man who Carry frequently employed on his real estate ventures. Carry also owned a 135-acre dairy farm called Red Gables in Suitland, Maryland. Both the Carry mansion and farmhouse were demolished for redevelopment.

THE NATIONAL CAPITAL BREWING COMPANY

George and Theresa Beckert emigrated from Germany in 1844. They settled in Washington and in 1850 purchased a half-block of land on Capitol Hill that became known as Beckert's Park (later Beckert's Garden). It was a pleasure garden and amusement park offering picnic grounds, a restaurant and a saloon that was a family-friendly destination for Navy Yard workers, a major employer on Capitol Hill. It also had a small brewery whose production was sold in the beer garden, making this an early brewpub. Beckert's Park was located on Fourteenth Street between D and E Streets SE.

Interestingly, George Beckert was always listed in the city directories as a plasterer, his main trade, rather than brewer and restaurateur, which was what he became. Beckert died in 1859 at age forty-nine, leaving behind his wife, Theresa, and their five children. The following year, Theresa sold the brewery to two of her sons-in-law, Herman Richter and Henry Schoenborn, but continued running the beer garden and restaurant. Three years later, Richter bought out Schoenborn, who returned to his architectural practice. The brewery became known as Richter's Brewery.

Richter died in 1874, and the brewery passed first to Alexander Adt and then to Francis Adt. In 1882, it was acquired by John Guethler, who renamed the brewery the Navy Yard Brewery and the gardens Guethler's Park. The beer garden had room for one thousand people. Four years later, new owner Henry Rabe renamed the facility the Washington Brewery (the brewery of the same name near Georgetown had closed in the early 1880s and become home to the Arlington Bottling Company). Rabe modernized the brewery and expanded capacity to thirty thousand barrels per year. He then sold it to Albert Carry and Robert Portner in 1890. The brewery yet again underwent a name change to the National Capital Brewing Company.

Confused? Let's recap: Beckert's Park begat Richter's Brewery, which begat the Navy Yard Brewery, which briefly begat the Washington Brewery (not to be confused with the Washington Brewery in Northeast), which begat the National Capital Brewing Company, which begat Carry's Ice Cream, which then begat the Meadowgold Dairy, which in turn begat the Safeway that now stands there. All existed on the same site in a little more than a century.

Albert Carry had transformed the Washington Brewery into a modern marvel, and he would do it again. But before he established a new brewery, he realized that Capitol Hill lacked a bank. In 1889, the same year that he sold the Washington Brewery, he founded the National Capital Bank (316 Pennsylvania Avenue SE), and this bank is still run by his descendants, the

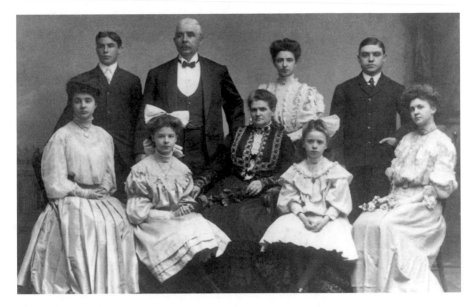

A portrait of the Carry family taken around 1905. *In clockwise order from upper left*: Joseph, Albert, Marie, Charles, Anna, Louise, Wilhelmina (Albert's wife), Antoinette and Minna. *Ceci Didden Weiland.*

Didden family. Carry employed a German-born architect, Clement August Didden, on many of his projects. Didden's son George married Carry's daughter Marie in 1905, joining the two families. Carry was foremost a businessman and sat on the boards of numerous local banks.

In 1890, Carry teamed with Robert Portner to form a new business, the National Capital Brewing Company. They purchased the Navy Yard Brewery and upgraded the plant, with Carry investing $140,000 and Portner $110,000 (as a result, Carry was president and Portner vice-president). It was a state-of-the-art brewery in its day, capitalized at $500,000 and able to brew 100,000 barrels each year in its five-story brewhouse. It was built of brick, iron and stone so as to be fireproof. The new brewery drew its water on site with a four-hundred-foot artesian well. The *Washington Post* covered the brewery's opening reception in 1891, describing it as follows: "Of necessity the location is remote, for so large an establishment must seek a section of the city where there is plenty of room, but the journey was well worth taking." This is now in the heart of the Hill East neighborhood.

National Capital's brands included Diamond (light lager), Golden Eagle (lager) and Munich (dark lager) labels. Its beer was intended entirely for

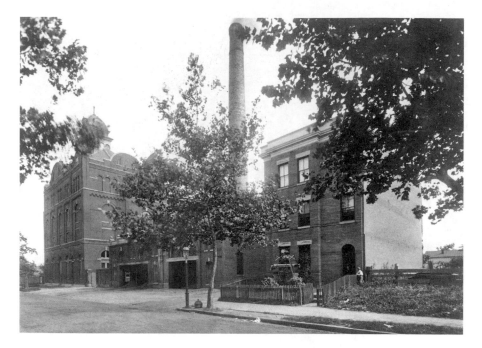

The National Capital Brewing Company on Capitol Hill. *Library of Congress.*

location consumption, and the brewery boasted of using no preservatives. The *Evening Star* reported that Albert Carry boasted of his beer's fine ingredients and integrity in the brewing process, noting that anyone could "take the keys of the entire establishment at any time, go through it thoroughly, and if he found anything at all used in the making of their beer that was not pure and wholesome the company would give him $1,000."

Congress amended the law in 1890 to allow brewers to bottle their own beer, but National Capital apparently never installed a bottling line, choosing instead to outsource bottling. When the brewery opened, it put 80 percent of production into wooden barrels, which showed that most of its beer was consumed at saloons. The company shipped twenty thousand barrels (or 20 percent of its production) to F.H. Finley & Son for bottling.

National Capital employed nine wagons and thirty horses to deliver beer to customers. In 1903, it became the first Washington brewery to buy an electric truck, a five-ton vehicle that could haul thirty barrels of beer. One truck could do the work of six horses. Albert Carry was a leader in innovation.

Brewing in Foggy Bottom and Georgetown

Looking at Foggy Bottom and Georgetown today, it's hard to tell that these were once working-class neighborhoods, but that's what they were. Along with the Navy Yard, these were the industrial districts of the city, located right along the Potomac and Anacostia Rivers. Georgetown was crowded with factories along the C&O Canal, and Foggy Bottom became a major gas storage area. It's no surprise, then, that breweries sprang up to support the significant workforce—along with bottling plants.

A young immigrant from Bavaria, John Albert opened a brewery in Foggy Bottom in 1870. It was located at 2445 F Street NW (now the approaches to the Watergate complex). It was a small brewing affair, Albert & Company, but it brewed beer for a quarter century. His son Charles ran the business for just two years after 1895 and then sold it to Edward F. Abner.

Abner was born in Cologne, Germany, in 1864 and came to the United States in 1885. His uncle was Edward Abner, the man who went into business with Robert Portner during the Civil War and who ran several successful beer gardens (you'll read more about that in the next chapter). The younger Abner became secretary-treasurer of National Capital Brewing in 1890, a

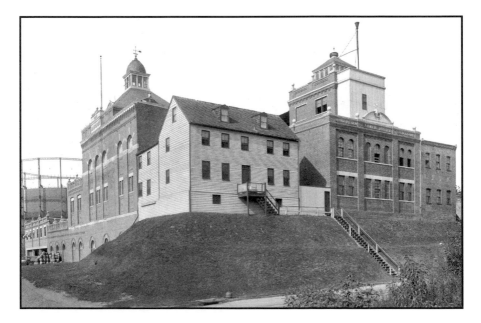

The Abner-Drury Brewing Company in Foggy Bottom. *Library of Congress.*

position he held for five years before deciding to light out on his own when the Albert Brewery came on the market.

After purchasing the Albert Brewery, Abner brought in attorney and Irish immigrant Peter Drury (1864–1942) as his business partner. The two men were young (each thirty-three) and ambitious. The rechristened Abner-Drury Brewing Company went from being a small, father-and-son business to being a major operation capitalized at $300,000 in 1901. It expanded from one building to nine in its large complex, just up the street from the Christian Heurich Brewing Company, the city's largest. Abner-Drury was known for its Old Glory and Royal Pilsen beer brands and proudly stated that it did not use adjuncts (then called "substitutes") like corn grits and rice but only barley malt and hops.

Most of the breweries in Washington were run by German immigrants, but Abner-Drury was the only one partly owned by an Irish immigrant. When Abner died in 1910, Drury kept his partner's name on the business. In 1904, he even named his second son after his business partner (thus Abner Drury). Like other major brewers at the time, Drury invested in local banks and real estate. As we'll see, he attempted to resurrect the brewery after Prohibition, but the business failed. He died in 1942.

THE FANTASTIC MRS. DENTZ

Henry Kaiser was a big name in Georgetown, a businessman who ran many ventures. When the Civil War started, he noted the high demand for beer from the soldiers and opened a brewery in 1862. Kaiser's stood at 42 Greene Street (now Twenty-ninth Street NW between M Street and the C&O Canal—where the Four Seasons Hotel now stands). In 1870, Kaiser and his business partner, Herman Richter, owner of a Capitol Hill brewery, advertised picnics and pleasure grounds on Analostan Island (now Theodore Roosevelt Island) in the *Evening Star*.

With the postwar brewery shakeout, Kaiser decided to leave the brewing business. In 1874, Simon Dentz opened a brewery at 40 Greene Street, right next door. Kaiser may well have sold the brewery to Dentz. The Dentz brewery made lager, offering beer in both bottles and kegs. Simon was assisted by his young wife, Catherine, born Catherine Winkler in 1851.

Just two years into running his Georgetown brewery, Simon died of a heart attack in July 1876, leaving Catherine a twenty-five-year-old widow with three young children to support and no safety net. Catherine did what

she had to do to provide for her family, which was to continue brewing. Many women got into the saloon business this way. Catherine Dentz was unusual in the history of brewing in Washington, as she was either the first or second woman to own and operate a brewery. (Ten years earlier, Catherine Baumann was listed in *Boyd's Directory* as owning a brewery after her husband Paul's death that year, but she soon put the business up for sale.)

Catherine Dentz established herself as an independent person who not only operated a brewery but was also a licensed liquor retailer. Her business brought constant legal problems. In January 1881, she was brought to criminal court for operating an unlicensed bar. She was found not guilty. In August of that same year, she was fined $105 for selling liquor on Sunday. A week later, she found herself in court again, accused by Henry Rabe, the foreman at George Juenemann's brewery, of stealing five beer kegs. The judge ordered the kegs returned and dismissed the case.

That wasn't the end of her legal troubles. In April 1882, Dentz was brought before the criminal court again for operating an unlicensed bar, known as a "stove-pipe house" (she had a wholesale or retail license to sell packaged goods, but she was caught selling liquor by the glass). The judge fined her $105. She was caught selling liquor on Sunday in November, and the following February was caught operating a stove-pipe house once again. It was a sting: African American men were sent in to buy a pint of beer, and once they were served, special license agent Henry Raff and his officers entered the bar to deliver the bad news. "When the woman [Dentz] saw them, she attempted to snatch the glasses of beer, and succeeded in getting one of them, the contents of which she showered on her guests," the *Critic-Record* wrote. "The scene that followed was an animated one, beer glasses, etc., flying about, but singularly enough no one was injured." In March 1883, she was fined $5 for selling cigars on Sunday.

William Cahill served as Dentz's attorney, and he was frequently called to court on her account. A marriage license was issued for Cahill and Dentz in 1878; however, Cahill's wife, Harriet, immediately came forward and filed for divorce, accusing Cahill of abuse and attempted bigamy. Cahill and Dentz never married but remained friends—very close friends, one suspects: Catherine's fourth child, Simon, was born in 1879. Cahill died in 1885 and left his property to her in his will and then to her (and most likely his) son Simon.

It's not known exactly when Dentz decided to stop brewing. By the 1880s, small family operators simply couldn't compete against the scaled-up breweries that now commanded the city's beer business. But she continued

running a grocery and liquor store in Georgetown and built a home for her family at 2700 O Street NW.

Most of the brewing in the Washington, D.C. area occurred in the city of Washington—most, but not all. Suds were bubbling up across the Potomac River in Alexandria, Virginia, as we'll see in the next chapter.

PORT CITY SUDS

B rewing in the Washington area began in Alexandria, or Port City, as some call it. The early Alexandria brewers were near the waterfront, close to the dockworkers, sailors and shipyards. As we learned, Andrew Wales was the first brewer, but other nineteenth-century breweries popped up to quench the thirst of dockworkers and sailors. Entwisle's Brewery stood just behind the waterfront on Union Street between Wolfe and Wilkes Streets. It witnessed the British occupation of Alexandria in August 1814 during the War of 1812.

Entwisle's later became Irwin's Brewery when James Irwin and, later, William Irwin ran it. Irwin's was the only brewery operating in the District of Columbia after Hayman's Brewery near Georgetown closed in 1842. William Irwin attempted to sell the brewery in 1843, placing ads in the *Alexandria Gazette* and *Daily National Intelligencer* that tell us about the beer market at the time: "There is no brewery south of this in the United States; and as it is the only one now in operation in the District of Columbia, it possesses great advantages, which will be increased with the completion of the Chesapeake and Ohio and Alexandria canals."

Irwin didn't have the local beer market to himself for long. When Joseph Davison opened the Washington Brewery on the Hayman's site in 1850, Alexandria beer drinkers finally had some real choices. Davison began selling his beer in Alexandria's Theatre Building (89 and 91 Cameron Street).

Despite the advertisements, William Irwin apparently didn't sell the brewery, as he still owned it when a fire consumed the plant in November

1854, destroying the brewing equipment and much of the ale in storage. The *Daily National Intelligencer* estimated the losses at a staggering $20,000 to $25,000, though the owner was partly insured. Irwin decided not to rebuild. For two years after Irwin's fire, there was no brewery at all in Alexandria until Martin's Ale Brewery opened in 1856. Two years after that, the Shuter's Hill Brewery opened.

You may not recognize the name Shuter's Hill, but you've no doubt seen it: it's the hill crowned by the George Washington Masonic National Memorial, the obelisk monument that towers over Old Town Alexandria. The brewery stood in the West End south of the hill, near the intersection of Duke Street and Diagonal Road (it was excavated in 1997 before the Carlyle Center was built atop it).

Shuter's Hill opened in December 1858 as Alexandria's first lager brewery, built by German immigrants John Klein and Alexander Strausz. Their partnership dissolved seventeen months later when Klein bought out Strausz. It thus became Klein's Brewery, and Klein ran it for five years until his death in 1865. Baltimore brewer Francis Denmead then purchased the buildings. He leased it out for one winter (1865–66) to Robert Portner. Denmead hired Henry Englehardt as brewmaster, and the brewery became known as Englehardt's. Englehardt bought the brewery from Denmead in 1872 and operated it until it burned down on August 18, 1893.

The brewery near Shuter's Hill didn't adapt to the changing beer market after the Civil War. It never scaled up, remaining a small production, local brewery that muddled along for decades. Few small breweries survived the 1890s.

On the eve of the Civil War, there were two breweries in Alexandria: Martin's Ale Brewery and Klein's Brewery (also known as Shuter's Hill). A savvy young businessman, Robert Portner, would open a third brewery during the war. He would soon eclipse the others and become a regional brewing powerhouse.

ROBERT PORTNER COMES TO TOWN

The Civil War was an opportunity to many businessmen. The federal government spent enormous sums to field its armies to defeat the Confederacy and brought tens of thousands of soldiers to defend the nation's capital, which bordered Virginia, a state that had seceded. Many brewers realized that these thirsty soldiers would want to drink beer and set up shop to

accommodate them; however, few succeeded on the scale of Robert Portner. In the decades after the war, Portner would become the largest brewer in the South. Like Albert Carry and Christian Heurich, he was a German immigrant who achieved remarkable success as a Gilded Age brewer.

Robert Portner was born in Westphalia in 1837 and attended a Prussian military academy as a teenager, graduating in 1852. He then immigrated to the United States the following year to join two of his brothers. He was only sixteen years old, but he quickly learned English and tried his hand at a number of trades, including baking, bookkeeping, being a grocer and owning a liquor store in New York City. Portner became an American citizen six years later—just in time to vote for Abraham Lincoln in the 1860 election.

Portner's liquor store in New York didn't do so well, but when the Civil War began, he sensed an opportunity and ventured to the nation's capital. It is interesting to note that despite his military schooling, young Portner didn't enlist. In April 1861, the Union army occupied Alexandria, Virginia, directly opposite the nation's capital, and began building a ring of forts to protect the city.

Portner and his friend Frederick Recker journeyed to Washington from New York in September 1861. The city was crowded with soldiers. A chance visit to a cousin stationed with the army in Alexandria showed Portner a business opportunity. Although much of the city was abandoned, Alexandria was crowded with Union soldiers on garrison duty. The two friends decided to buy a grocery store at King and St. Asaph Streets, a store they named Portner and Recker. It opened on September 2, 1861. (The store is now the site of Columbia Firehouse, 109 S. St. Asaph Street.)

The grocery store soon made a brisk trade, and so high was the demand from the soldiers that the two business partners had trouble keeping goods in stock. They even sold beer when they could get it from New York.

Portner's career as a brewer began when one of his customers, Edward Abner, approached him in 1862 with an idea. Abner was born in Wiesbaden in 1834 and immigrated to the United States in 1855. When the Civil War broke out, he became a caterer for the Union army, preparing meals for generals and politicians who visited the front. Knowing the high demand for beer among the soldiers, Abner suggested that Portner and Recker brew beer themselves. They invited Abner and a brewer named Kaercher to join them as partners. The Portner and Company Brewery opened on the northeast corner of King and Fayette Streets and brewed almost two thousand barrels of beer during the war. It stood directly across the street from Martin's Ale Brewery.

Because of the great number of intoxicated soldiers, the Union army banned liquor in Alexandria in 1862; however, beer was still allowed, as it was low in alcohol and considered harmless. Regulations were enforced unevenly. When a new provost marshal discovered that Portner had sold beer to an innkeeper who in turn sold the beer to soldiers, he threatened to shut down Portner's brewery unless Portner paid a bribe. Portner refused to pay and spent nine days in jail. He was politically savvy enough to then be appointed to the city council, which in turn helped negate such dire actions from happening again.

The Portner brewery rented a schooner and shipped beer down the Potomac to Union lines at Fredericksburg, Virginia, all the while expanding capacity because of high demand. This was one of the closest breweries to the Union army, and it was a major business opportunity to supply the troops with fresh suds. Portner halted beer shipments, however, when Confederates confiscated his beer and took his men as prisoners. During the war, Portner was accidentally shot in the arm by a gunsmith examining a pistol.

After the Civil War ended in 1865, the Portner and Company brewing partnership dissolved. Portner bought out the other partners and owned the brewery outright, while Recker took over the grocery store. In 1909, on the occasion of his seventy-fifth birthday, Edward Abner looked back wistfully at having sold his stake in the brewery. "This is where I made a mistake," he remarked. "Had I remained with Mr. Portner, I would today be a millionaire." Abner went on to run several beer gardens, but his own foray into brewing in the district ended in bankruptcy in 1868.

In 1865, Portner expanded his brewing operations by acquiring a one-year lease for the Shuter's Hill Brewery in Alexandria from Baltimore maltster Francis Denmead. At this point, Portner still knew little about brewing and was in for a shock. The local beer market contracted with the end of the Civil War and the disbandment of the army. Portner was deep in debt as business dried up. While many brewers failed during this period, he still sensed the high growth opportunity for beer. Portner doubled down, later writing, "After thinking over carefully whether I should give up the business and start something else, I decided to stay in the business where I had lost my money." It was a bold risk. After refinancing with his creditors (predominantly Denmead), he steadily improved his business and returned to solvency. Portner also learned how to brew.

In Alexandria, Portner had rented cellars on Washington Street between Pendleton and Wythe Streets in which to age his lager, but that required him to transport the beer from the brewery to the cellars. He wanted a single

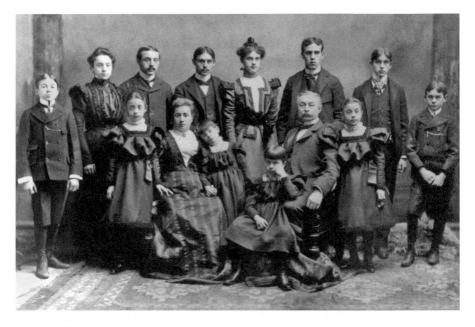

A circa 1897 photograph of Robert and Anna Portner and their large family. *Courtesy of the Manassas Museum System, Manassas, Virginia.*

locale at which he could do both. In 1869, he opened a brewery over the cellars—again with credit from Francis Denmead. He added an icehouse in 1870 to chill lager while it aged, producing a better tasting product. This proved a key to his success, as the market wanted good lager. The energetic businessman soon had more business than he could handle. By the end of 1872, he was debt free and thinking of expanding into new markets. Alexandria was too small for his ambitions.

Portner went into business with Peter von Valaer, a Swiss immigrant and Philadelphia brewer, and began regularly traveling to Philadelphia to meet with Peter—and to court Peter's sister Anna (1848–1912). Robert and Anna would marry in 1872. Their first son, Edwin, was born the following year, though he died at just five months. The couple had thirteen children, of whom eleven survived to adulthood. The boys were particularly known for being rowdy, as the Portners decided not to raise their children with the stern discipline common among German families. Though Portner spoke English in all of his business dealings, he insisted on German at home, as he wanted his children to know his mother country's tongue.

Whereas Washington had blue laws since 1857, Virginia wasn't dry on Sundays yet, so Portner opened a beer garden in Alexandria. This attracted

much business and brought him new customers. Deciding that it was a headache to run, he closed the operation after the 1876 season. However, he did invest in a number of tied-house saloons in Alexandria, giving him direct retail outlets to consumers.

Another German immigrant, Adolphus Busch of St. Louis, began pasteurizing beer in 1874, extending its shelf life. The national beer market was born, especially as beer could be shipped great distances by rail, even without refrigeration. In the 1870s, the Hutchinson stopper and the lightning bottler stopper were invented. Brewers no longer had to use corks to seal their beer. The new enclosures were a vast improvement as they kept the beer under an airtight seal. Plus, they were attached to the bottles so that they could be reused again and again.

Portner was in an excellent position to expand into the regional brewing market. His Alexandria brewery stood right along a railroad spur line, and Portner would eventually own fifty refrigerated rail cars to distribute beer around the South. In Washington, he opened his first depot in 1875 along the rail lines at 626 Virginia Avenue SW (near L'Enfant Plaza) so that he could compete in the regional brewing market. Portner would eventually operate nearly twenty depots throughout Virginia, the Carolinas and Georgia by 1890—and his beer was shipped as far as Cuba.

Images for Robert Portner's Tivoli Brewery in Alexandria are most often found on account statements and letterhead. *Rayner Johnson.*

In the increasingly competitive market, Portner understood the need for an effective brand. Brands convey an image and a lifestyle. In 1877, he introduced the Tivoli ("I love it" spelled backward) brand, and that became the name of his brewery. He began advertising and distributing glassware and trays with the Tivoli brand on it, using the signature diamond in the name. Portner's brands included Bock, Cream Ale, Virginia Extra Pale, Lager, Select, Tivoli-Hofbrau and Vienna Cabinet. In the early 1900s, he began producing a near-beer called Small Brew in response to the temperance movement.

Robert Portner was the most innovative of the Washington-area brewers, adapting his business to new conditions, adopting branding, expanding into new markets and inventing technologies that would forever change brewing. He continually made improvements to the Tivoli Brewery over the years. Its capacity was twenty-five thousand barrels per year in 1883. Seven years later, it had reached sixty thousand barrels.

Ice and Refrigeration

Lager requires cool conditions to ferment and age, which made it nearly impossible to brew in the summer. In fact, some parts of Germany had banned summer brewing for fear of the threat to public health. Many brewers, including Portner, built icehouses to chill their lager. The building of these structures required a large number of men to cut ice from a frozen river, such as the Potomac, and pack it underground. The alternative was to order expensive ice from Boston and have it shipped down. Working with ice was inefficient, labor intensive and unhealthy, as the ice cellars were wet and mildewy.

Portner permanently changed the brewing industry in 1878 by inventing a mechanical chilling system that he patented. Lager could now be produced year round. That same year, he added a machine that could manufacture ice. In 1880, he earned a patent for an ammonia-fed air-conditioning system. Many breweries now bought cooling and ice-making machinery based on Portner's patents, earning him yet more money through his Brewers' Refrigerating Machine Company (but also earning him a number of lawsuits, as the machines performed erratically). These innovations drew the attention of his fellow brewers, who elected him president of the U.S. Brewers' Association in June 1880.

In 1903, the *Western Brewer* trade magazine published its seminal review of brewing in the United States, *One Hundred Years of Brewing*. It noted the enormous impact that refrigeration had had on the industry: "Indeed it may be said that the wonderful progress made in the art of brewing during the last twenty-five years is mainly attributable to the introduction of artificial refrigeration in the brewery."

Ice was an important component to brewing (Christian Heurich would maintain an ice plant until 1940), but now it was used differently. It was placed on the top floor of the fermentation building, where the cold air would then sink to keep the fermenting lager at a cool temperature. The cellars, once dripping wet with melting ice, were now used for storing and aging lager and could remain dry. Ice was also used in refrigerated rail cars. Breweries adopted ice-making machinery in the 1870s as a substitute for natural ice. From this point on, brewing became far more mechanical. Lager could now be produced year round on a much greater scale than ever before. The brewers who succeeded were those who had the capital to invest in machinery; those who didn't were left behind.

Portner was such a highly regarded citizen that his comings and goings were regularly reported in the newspapers. When he returned from the 1880 Brewers' Association election in Buffalo, New York, the *Washington Post* reported that he was "met with quite a reception at his residence. Music, refreshments and fire-works were liberally supplied, and Mr. Portner received the congratulations of many friends. The large brewery was decorated with flags and evergreens and presented a pretty site."

Portner resigned from his Brewers' Association presidency in March 1881 because of ill health—he was simply overworked and needed a break. He then journeyed with his entire family to Europe, visiting relatives in Germany and Switzerland. The return voyage on the steamer *Necker* was horrendous, as the ship was storm-tossed most of the way across the ocean. Fellow passengers included former Confederate president Jefferson Davis and his wife and daughter.

The growing Portner family moved from Alexandria to Washington in 1882. They briefly inhabited 724 Twelfth Street NW while building a new home at 1104 Vermont Avenue NW. Robert and his wife, Anna, would ultimately have thirteen children. Both houses were later torn down for office buildings.

The Robert Portner Brewing Company was incorporated in 1883. Like many of the brewers, Portner worked too much, and his health suffered accordingly. Having a corporate structure meant that he could take a step back from managing the details of the business, as a board of officers was now in place. Incorporation also helped shield an owner like Portner from financial liability while still retaining control and ownership of the company.

In 1883, at the urging of his wife, Anna, Portner purchased a farm in the small town of Manassas near the location where two major Civil War battles had been fought two decades before. It had a lovely view of the Blue Ridge Mountains that reminded Anna of Switzerland, where she was born. The family began spending more time in the country, and Portner acquired additional land, eventually owning two thousand acres. He named the estate Annaburg after his wife (though some argue that he named it after the military school he attended as a youth).

In 1888, Portner took a major break, moving most of his family to Germany for two years. He could afford it, now being a millionaire. He returned to Washington much rested. Upon returning from Europe in 1890, Portner made a strategic shift in his business. He began a new venture, distributing the Hygeia brand of mineral water across the South. He already had the distribution network and production scale; in addition, brewing had become fiercely competitive, and profit margins had shrunk. He also toyed with the idea of building a new brewery in Washington near his Southwest depot to keep up with the growing demand for his beer. This would double his capacity.

Portner decided on another direction. After Albert Carry sold his Mount Vernon Brewery in 1889, Carry sought a new opportunity in which to invest. He teamed up with Portner to build a brand-new brewery on the site of the Navy Yard Brewery on Capitol Hill. Portner sold his Washington depot to Schlitz in 1890 and reinvested the proceeds ($110,000) in the new brewing venture. The National Capital Brewing Company opened the following year with Carry as president and Portner as vice-president.

Carry and Portner reached a commercial agreement to split their business along the line of the Potomac River so that their breweries wouldn't compete. National Capital would sell north of the river, while Robert Portner would sell south of it. The Tivoli brands of beer thus disappeared from the Washington market, though it could still be found in Alexandria and points south.

WORK AT THE TIVOLI BREWERY

Portner expanded the Tivoli Brewery in 1894, adding a five-story brewhouse that modernized the facility and increased capacity to 100,000 barrels per year, though the brewery never produced quite that much. He now owned the largest brewery in the South, one that employed 110 people and whose annual payroll approached $69,000. Including all of his ancillary branches and depots, the Robert Portner Brewing Company employed 278 people and had an annual payroll of more than $140,000. The Tivoli Brewery had grown to cover four blocks. It was now the largest employer in Alexandria, employing a broad swath of working-class men that included not only German immigrants but also African Americans. Alexandria remained unabashedly wet in a state that was increasingly dry.

Accidents and injuries at breweries were not uncommon. This was an industrial operation in an era before the heavy focus on worker safety. In January 1881, the third floor of the Tivoli Brewery, which held four hundred tons of ice, suddenly collapsed. It fell onto the second floor, which was then fermenting about five hundred barrels of beer. Part of the second floor in turn collapsed under the weight, wrecking numerous large casks of beer stored on the ground floor. Fourteen men were working on the ground floor at the time, but miraculously none were injured. One African American worker was trapped by the ice but was quickly dug out. Much beer was lost in the building's partial collapse.

In September 1891, a fire struck the Tivoli Brewery. A hot resin kettle overturned, igniting a wooden shed. Despite the efforts of the brewery's own fire engine and hydrant, the blaze spread to the bottling plant and to surrounding wooden buildings. Fortunately, the main building was built of brick and had an iron roof. As crowds gathered in the streets to watch the fire, two Alexandria fire engines arrived. The firemen battled to save a one-hundred-foot-long wooden storage shed that housed hundreds of thousands of empty Portner bottles. "Nearly all of the immense mass of bottles and the fire was prevented from invading a hollow built up with light cabins inhabited by colored people," the *Evening Star* reported. The fire destroyed an estimated $8,000 to $10,000 in property, but Portner had insurance. He built a new bottling plant on the site of the fire and sourced the bottles from the Virginia Glass Company in Alexandria.

Brewery worker George Lamb shot and killed his brother Sam on June 11, 1896. The *Washington Post* quickly took sides, calling it a "midnight tragedy" rather than a murder. It reported that George "is a sober, industrious man,"

while his brother Sam "is a dissolute character who seldom does any work." Sam had been drinking and came to the Tivoli Brewery at midnight, where he threatened his brother with a knife. George took the night watchman's pistol and fired three bullets into his brother.

In 1901, an explosion wrecked one of the five boilers at the brewery, causing about $5,000 in damage and severely burning the night engineer, Lewis Hart.

In July 1902, a Portner brewery cooper named Henry Kloppmeier awoke to a banging on his door. He opened the door and was confronted by six men, who bound him and then beat him up. Instead of reporting to work the next day, he made his way to the police station, where he told a vague story about the strangers (he couldn't or wouldn't identify any of them) and explained how brave he had been when they tied a noose around his neck. When the police investigated, they discovered that Kloppmeier had been abusing his housekeeper. The six men who appeared on his doorstep were most likely coworkers who wanted to teach him a lesson about domestic violence. In cases like this, the police often stepped aside, knowing that justice had been served.

Portner wasn't without labor difficulties. He went through a number of head brewers over the years and was threatened by a bottlers' strike in 1902 and another general strike over shortening the working day in 1906, shortly before his death.

Robert Portner finished writing his autobiography in 1890. He prefaced it with a letter to his children, written in German while in the German city of Hanover on June 3, 1890. It indicated his plans for the Annaburg estate in Manassas as a family retreat:

> *This home I wish to reserve for you all. Those of you who feel tired or sick can return to this place and remember what a beautiful childhood to regain health and fresh spirit and those who have had a hard time in life should regain their strength for a new beginning. You all meet once a year there and take care that the family PORTNER maintains a good name in America.*

Robert and Anna Portner decided to build a new home, modeled on the many grand homes they had seen on their European travels, on their Manassas estate. The mansion had thirty-five rooms, electricity and indoor plumbing and was the first house in the United States to have air conditioning. The new house was built in 1892–94 (the same years as the Heurich House's construction) for $150,000. It was built with red

Robert Portner built the thirty-five-room Annaburg mansion in Manassas, Virginia in 1892–94. He died there in 1906. *Garrett Peck.*

sandstone from one of the two quarries that Portner owned in Manassas, and the brick may have been painted pink. The farm was beautifully landscaped and often open to the public.

In January 1899, Portner's daughter Clara died, and almost exactly a year later, his son Robbie died of typhoid at age twenty-five. Robbie was the heir apparent, the son who Portner intended to run the business. With three of his children now dead, Portner purchased a family plot in the Manassas Cemetery close to Annaburg. The next son in line, Edward, picked up more of the brewing operations as his father increasingly stepped away from the business. Robert and Anna made Annaburg their year-round residence in 1903.

Robert Portner died at Annaburg on May 28, 1906, at age sixty-nine with his wife, Anna, and ten surviving children at his bedside. His estate was valued at $1.9 million. Portner donated $15,000 to the City of Manassas, his adopted hometown, with the provision that a third of that go to support poor African Americans. Anna died six years later.

ROBERT PORTNER'S LEGACY

Robert Portner was incredibly forward thinking. He understood the changing beer market and introduced changes before others could catch up. He was foremost a savvy businessman and secondarily a brewer. He caught on quickly to the growing regional and national markets brought on by technology, and he understood the importance of branding. He stretched far beyond his local market of Alexandria and became an important player in the South.

The Deep South was too warm to brew lager, yet the brew is immensely refreshing in summer. Portner grasped this. He became the largest lager brewer for the South, providing a product much in demand. His business insight made him a millionaire. He lived the American dream, coming to the States at age sixteen with almost nothing and dying as a self-made millionaire.

The downside to Portner's business acumen was that he suffered considerable anxiety in his personal life, something he always mentioned as a nervous condition. He was a worrier. It led to him taking time off from the business and ultimately incorporating the organization so that he wouldn't have to run everything.

Portner had other business interests beyond brewing that took his time as well, not to mention a large family to govern. He had a diversified portfolio of businesses. Portner owned an Alexandria shipyard from 1873 until 1881. He was a director at four local business associations and was the president of four banks. In addition, he dabbled in real estate and built a number of apartment buildings. He bought a quarry in Manassas—the Portner Brownstone Company—which provided the redstone for many buildings in downtown Manassas, including Annaburg. He championed Manassas, helping fund the paving of its roads, building the elegant Prince William Hotel (it burned down in 1910) and rebuilding its Masonic hall after a fire.

One of Portner's real estate investments was, at the time, the largest apartment building complex in Washington. Designed by Clement Didden, the Portner Flats were built between 1897 and 1902 at the corner of Fifteenth and U Streets NW, stretching an entire city block to V Street. The building offered 123 luxury apartments with such modern amenities as a swimming pool and tennis court as well as ballroom and dining room spaces. The entire site cost Portner $350,000 to build.

Robert Portner didn't live to see his family business unravel from Prohibition, though he certainly noticed the rising temperance movement. One by one, the states where Portner distributed his beer went dry, and

One of the few architectural remnants of Robert Portner's Tivoli Brewery is the 1912 bottling plant at 615 N. St. Asaph Street in Alexandria. It has been converted into housing. *Garrett Peck*.

the Tivoli Brewery retrenched. The Portner sons briefly expanded beer distribution into Maryland and attempted to produce soda. When statewide Prohibition in Virginia shut down brewing in 1916, the Portners attempted to turn the Tivoli Brewery into a wholesale feed business. Edward Portner, who became president upon his father's death, died in 1917. Alvin Portner next became the company president and his brother Paul the vice-president. Paul died in 1919 from alcoholism.

The Virginia Feed & Milling Corporation lasted only several years before the Portners closed shop. The Tivoli Brewery soon turned into a dilapidated ruin. It began to be torn down in 1932, and by 1941, it was gone. Today, it is the site of a multiuse office and shopping complex that includes Trader Joe's. Yet unlike the Washington breweries, three ancillary building remnants remain from the Tivoli Brewery, including the 1903 bottling plant at 515 N. Washington Street, the 1912 bottling plant at 615 N. St. Asaph Street (an alley called Tivoli Passage runs behind it) and the icehouse at 705 N. St. Asaph Street.

The Portner Flats remained in the family's hands until 1945, when it was sold to investors who converted it into the Dunbar Hotel. This became

an important hotel for the African American community of U Street, as it was the place for debutante balls and visiting stars to stay while they were performing at the local jazz clubs. The hotel was razed in 1974. The Campbell-Heights apartments now stand on the site.

The Portner children and grandchildren continued to use Annaburg as a summer residence but gradually lost interest in the estate. Large old houses are expensive to maintain. The land was subdivided and sold off. In 1947, the Portner family sold the mansion. Today, Annaburg is at the center of Annaburg Manor in Old Town Manassas, a nursing facility for senior citizens (9201 Maple Street). The mansion itself currently sits idle. The Portner Tower, a romantic sandstone tower built at the same time as the house, was torn down in 1978. Besides the mansion, the gatehouse survives two blocks away.

The Portner family left the brewing business in 1916. Before Prohibition ended in 1933, all six of Robert Portner's sons had died. The Tivoli Brewery was beyond salvaging and was torn down. But that wasn't the end of Portner family brewing. Two of Robert Portner's great-granddaughters, Catherine and Margaret, would revive the tradition in 2014 with the Portner Brewhouse.

THE ARLINGTON BREWING COMPANY

Alexandria County, Virginia, renamed itself Arlington in 1920, the first year of national Prohibition, to distinguish itself from the neighboring city. The largely rural county had little need for brewing—that is, until industry began encroaching on the shore of the Potomac River in Rosslyn.

The Consumers' Brewery began construction in Rosslyn in 1895 on four acres of land and opened late the following year. The fireproof brick brewery stood prominently on a bluff overlooking the Potomac, directly opposite Georgetown University. Designed by German-born Albert Goenner, who also designed Concordia Church in Foggy Bottom, it dominated the Rosslyn skyline with its Gothic architecture, pinnacled clock tower and 125-foot-tall smokestack. A set of horse and mule shoes were placed at the top of the smokestack for good luck. The brewery stood overlooking the Aqueduct Bridge, making it easy for the brewery to get its suds to its main market: Washington. The owners also intended to build wharves so that beer could be shipped downriver.

Consumers' was quite modern for its time and had the capacity to brew 100,000 barrels of beer annually. The fermentation tanks were

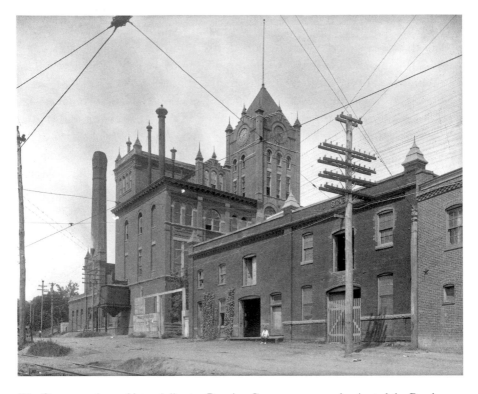

The Consumers'—and later Arlington Brewing Company—once dominated the Rosslyn skyline where the Key Bridge Marriott now stands. *Library of Congress*.

made of steel, while the plant was electrified and operated a modern cooling system. The brewery drew water from the Potomac near the Three Sisters Islands.

The brewery didn't remain Consumers' for long. It was sold in 1902 to a group of new owners led by Bernard Katz of Patterson, New Jersey, who changed the name to the Arlington Brewing Company. The brewery produced the dark Augustina Beer, the light Columbia Beer, Sparkling Ale and Stock Porter (the latter offered in both bottles and kegs). It was these new owners who took market share from Christian Heurich, which in turn resulted in the "beer war," about which you'll read later.

Although Arlington Brewing mostly sold its beer in Washington, it did have a local following in the scattered villages around Alexandria County (now Arlington). The temperance movement was doing everything in its power to make it more difficult for saloons to operate, and it got a Virginia state law passed that allowed saloons to operate only if there was sufficient

A snowy view of Rosslyn and the Arlington Brewing Company (right) taken from across the frozen Potomac River in Georgetown. *Center for Local History, Arlington Public Library*.

police protection for the public—and only then if the majority of voters living in the area endorsed a saloon's license application. In 1905, a circuit court judge ruled that there was insufficient police protection and that henceforth, Alexandria County would be dry. The court ruling should have shut down all of the saloons, but between forty and fifty speakeasies still operated without licenses, according to the *Washington Post*. The Arlington Brewing Company, however, continued to operate for years with impunity, as it was a large employer and contributed healthy tax revenues.

In 1910, Commonwealth's Attorney Crandal Mackey ordered the Arlington Brewing Company to stop selling beer at the brewery and in the county, as Alexandria County was officially dry. Threatened by the potential loss of business, the brewery sued. The company won its case in September 1911, convincing the police court that it could deliver beer to wet areas such as Alexandria City and the district.

In the early morning hours of January 1911, a fire erupted at the brewery's stable (beer was still delivered by horse-drawn wagon at that time). The fire burned so intensely that the brewery called for help from the Washington fire department, which sent three engine companies. Forty horses were saved

when brewery employees cut their halters so they could escape the fire—they ran free into Rosslyn, where citizens rounded them up. The blaze extended to the bottling house, which was likewise destroyed. The *Evening Star* noted, "The empty bottles in the bottling house were all melted." The fire cost an estimated $20,000 in damage. A similar fire had broken out two weeks before in the stable but was quickly quelled, leading some to speculate that it was arson by a disgruntled employee.

Virginia enacted statewide prohibition on November 1, 1916. This was the death warrant for the commonwealth's six breweries. As you've seen, two of them were in northern Virginia: the Arlington Brewing Company and the Robert Portner Brewing Company. The other four were the Consumers' Brewing Company in Norfolk, the Home Brewing and Richmond Brewery in Richmond and the Virginia Brewing Company in Roanoke. With Prohibition, Virginia lost a vital industry that wouldn't begin to recover until the late twentieth century.

CHAPTER 4
CHRISTIAN HEURICH:
WASHINGTON'S LEADING BREWER

F or some time now, many people have asked me to write my autobiography, but I have refused. Now that I am past ninety and my children might be interested in reading about my life, I shall try to comply with their wish." So began Christian Heurich's autobiography, *From My Life*, which he self-published in German in 1934, a year after Prohibition ended.

Christian Heurich was Washington's best-remembered and best-documented brewer, a man who owned the largest brewery in the city and who worked as a brewer for nearly ninety years. He witnessed the growth of brewing into a Gilded Age industry, engaged in a trade war against his fellow local brewers, experienced the anti-German backlash during World War I and saw his business nearly destroyed by Prohibition, only to resuscitate it afterward.

Heurich (pronounced HI-rick) was born on September 12, 1842 (the same year that Pilsner Urquell was invented) in the village of Haina in Saxe-Meiningen, now part of Thüringen. He was one of four children in an innkeeper's family and was trained as a butcher and a brewer. Heurich was orphaned at the age of fourteen, and from then on he was largely responsible for himself. In his memoirs, he described his incredible hikes throughout Europe as a twenty-something full of adventure and independence. He ended up in Vienna, where he worked for several years as a brewer.

Heurich's eldest sister, Elisabeth, had gone to the United States with family friends. She eventually married a ship's captain, Hermann Jacobsen, and invited her brother to join them in Baltimore. Heurich joined his sister's

family in 1866. This was the first of more than seventy trips across the Atlantic Ocean.

Heurich was bright and adaptable, and he soon learned English. Like many Germans, he was diligent, hardworking and very thrifty. Heurich stayed in Baltimore for eighteen months, earning good money as a brewer, before moving to Chicago and then to points west. Heurich voted for the first and only time in his life in November 1868 when he was in Kansas. He voted for Ulysses S. Grant for the presidency. (Washingtonians could not vote in presidential elections until 1961 with the ratification of the Twenty-third Amendment to the U.S. Constitution.)

Returning to Baltimore, Heurich met Paul Ritter, who proposed that they buy a brewery in Washington, where the beer market had crashed after the Civil War and thus properties were cheap. "We visited several breweries for sale, and we agreed to take over Schnell's brewery and tavern near Dupont Circle at 1229 Twentieth Street, NW, which was completely run down, in Washington, D.C. Little money was required to buy this business," he recalled. They began operations in October 1872. "It was an enormous workload. My working time averaged eighteen hours a day," Heurich noted.

Christian Heurich (1842–1945) was Washington's most prominent brewer. *Heurich House Museum.*

The Heurich-Ritter partnership lasted only a year before Heurich bought his partner out of the business in 1873. That same year he married George Schnell's widow, Amelia, the first of Heurich's three wives. He was thirty-one years old, having spent much of his life thus far establishing himself as a brewer.

Heurich found himself overworked. "I had to oversee the brewery, visit the customers, buy the supplies, keep the books as required by the tax laws and do many other things alone," he wrote. But by his enormous capacity for work, he paid off the mortgage in 1876—just four years after starting the business— and began buying real estate. The next year, he upgraded the

brewery after a fire damaged the facilities. Heurich had already surpassed George Juenemann as the largest brewer in the city.

In 1876, Heurich was persuaded to join the German-American Bank as a shareholder and director. However, the bank failed two years later. As a bank owner, he was responsible for paying off the accounts, and he mortgaged his property to settle these accounts. "Well—I have learned from it," he later wrote. "Never again have I accepted the position of director of a bank, and never again have I guaranteed other's checks." This set him apart from other brewers like Albert Carry and Robert Portner, who found success in banking.

The Heurich family began amassing land, which turned out to be a sound investment in the growing city. In 1879, Amelia Heurich bought a plot of land just south of Dupont Circle for a future house. Christian purchased lots across the street from the brewery and constructed a home. He may have assisted his nephew Charles Jacobsen in establishing the Arlington Bottling Company in 1885. In 1886, he bought a dairy farm, Bellevue in Prince George's County, where the family would spend many summers. In 1889, he acquired a thirteen-acre farm in Tenleytown and two years later bought two more nearby farms with a total of nine acres.

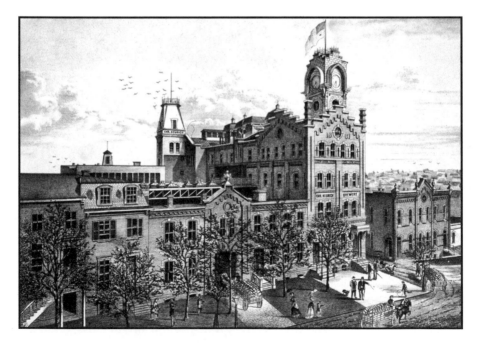

A lithograph of the Christian Heurich Brewing Company's Dupont Circle location, before it moved to Foggy Bottom. *Historical Society of Washington, D.C.*

In 1881, Heurich leveled his existing brewery and then greatly expanded it with a new four-story building, now covering the entire block from 1223 to 1235 Twentieth Street NW. He could brew fifty thousand barrels of beer annually, having invested in the latest brewing equipment and refrigerants that Robert Portner and other brewers had championed.

Heurich worked hard, but he was not immortal. He suffered a breakdown in 1881, possibly related to the stress of rebuilding his brewery. The next year, he and his wife, Amelia, traveled to Europe for the first time since coming to the United States. He went to Karlsbad (Karlovy Vary) in what is now the Czech Republic for a spa cure and then traveled to Bayreuth, where he met composer Richard Wagner and saw the inauguration of the opera *Parsifal*. After that, Heurich began traveling to Europe almost annually. He suffered from rheumatism, so he frequently visited spas for treatment. Although not an overly religious man, Heurich saw the Passion Play in Oberammergau in 1900 and 1922.

Heurich suffered a great misfortune in 1884 when his wife, Amelia, died after eleven years of marriage. They had no children. Heurich recalled in 1942 (when he was one hundred years old, and with hindsight): "Though I had prospered mightily, it seemed to me—sometimes in the bitterness of my sorrow—that the Good Lord had determined that I should always be lonely and alone; I did not know then that, in His infinite wisdom and goodness, I was to receive all that I wanted most—and in most abundant measure."

Heurich incorporated his brewery, signifying the change from a family business to a corporation. He wrote, "In 1890, a very good business year, the name of the brewery was changed to 'Ch. Heurich Brewing Co.' for certain reasons and was capitalized at $800,000. My share at that time was nine-tenths."

Fire was a constant worry to brewers, and that left Heurich with a desire to build with fireproof materials such as concrete. An 1875 fire sparked from the chimney caught the brewery roof on fire and caused some damage. A smoking worker accidentally started a fire in 1883. But the 1892 fire completely changed how and where Heurich brewed his beer.

A massive fire tore through the Heurich brewery in Dupont Circle in the early hours of July 23, 1892. The fire started in the manufacturing department of the main building. An engineer on duty quickly called the fire department from a street call box. The upper floor of the three-story main building was ablaze with burning grain, and the firemen had difficulty fighting it, finally climbing adjacent buildings to shower the fire with water from above. Several thousand people turned out to watch. Heurich estimated

his losses at $22,000, including all of the grain stored on site—but it was not a total loss. He reassured his customers that he would still supply beer, telling an *Evening Star* reporter, "But we have in our vaults a six months' supply of beer, so our patrons need not worry the least bit." Fortunately for Heurich, he was insured. He began searching for a site to build a new brewery. "The need for a fireproof brewery never left my mind," he wrote.

The Dupont Circle brewery had appreciated in value considerably as the neighborhood around it had developed, and Heurich could profitably sell the site where he had brewed for two decades. He initially considered building a new brewery in the eastern part of the city, as he wanted to be along the rail lines for ease of shipment. But that was not to be.

After a location search, Heurich chose a nearby site on the Potomac River in Foggy Bottom, a then-working-class neighborhood. The Potomac shoreline was then largely industrial, and the Christian Heurich Brewing Company would fit right in. Construction on the new fireproof brewery began in 1894, and brewing started the next year. "It has been proven that the brewery buildings are probably the most solid in the country," Heurich wrote. "I personally managed the concrete work, which can only be destroyed with dynamite!" How true that turned out to be.

The 1903 publication *One Hundred Years of Brewing* described Heurich's new modern brewery: "The brew-house is equipped with a so-called double brewing plant, the five cellars of the stock-house being in direct connection with the brew-house. In connection with the brewery there is an ice-making

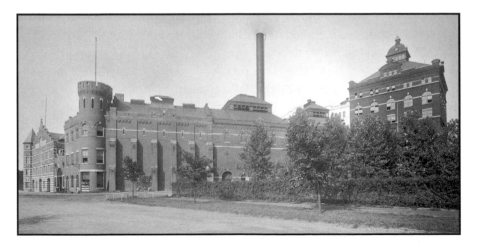

The Christian Heurich Brewing Company was Washington's largest brewery and stood prominently along the Potomac River. *Library of Congress.*

plant of a daily capacity of one hundred and twenty tons, with ample storage facilities." The new brewery had the capacity to brew 500,000 barrels of beer each year. This was a mammoth facility compared to the other local brewers, and Heurich now owned half of the city's brewing capacity.

The new Heurich brewery had been open only a year when a worker was murdered. In August 1896, a cooper named Conrad Plock was struck and killed in the stable. A young African American man named John Sites, a driver's assistant, was sought for the murder. The two men had apparently quarreled before, and Plock had either hit Sites or doused him with water from a hose. Sites returned to the brewery a week later and struck Plock with a brick, fracturing his skull. Plock was hospitalized and died three weeks later. Sites fled Washington but was arrested a month later in Maryland. He was convicted but given a sentence of only eight months in prison after agreeing to plead guilty to manslaughter. There was enough extenuating evidence to demonstrate that Plock had treated Sites harshly.

BOTTLERS

Until 1890, federal law prohibited brewing and bottling in the same facility. In Cincinnati, brewers dug tunnels under streets to connect their brewing and bottling plants; in Washington, the brewers largely outsourced bottling. Therefore bottling emerged as a secondary industry to support the brewers. There were a great number of bottlers, making for a very competitive market. The bottlers included the Arlington Bottling Company (surprisingly not in Arlington but rather near Georgetown at the old Washington Brewery site); F.H. Finley & Son (1206 D Street NW); the Jerome Bottle Company (Virginia Avenue and Sixth Street SW, adjacent to Robert Portner's depot at L'Enfant Plaza); J.F. Herrmann & Son (750 Tenth Street SE, now Tyler Elementary School), Northwestern (1601 Fifth Street NW); Richard T. Mazinger (462 H Street SW and 359 M Street SW); Samuel C. Palmer (the agent for Schlitz at the former Jerome Bottle site but who also ran his own bottling plant at 1066 Wisconsin Avenue NW in Georgetown); William N.H. Maack, who was once a brewer himself (1300 Sixth Street SW); and so on.

A small army of horse-drawn wagons delivered beer to bars and homes. Bottles were delivered for home consumption, while kegs found their way to beer gardens and saloons for tapping. As the demand for lager spiked in the summer, unlicensed "summer agents" began making deliveries,

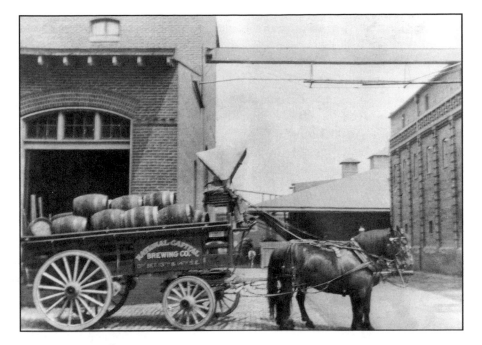

A horse-drawn National Capital beer wagon. *Ceci Didden Weiland.*

taking business from the year-round agents. A lawsuit in 1896 put a stop to these summer agents, and after that, all deliverers in Washington had to be licensed.

Bottles went through many iterations over the years as they changed enclosures, shape and size. Bottles were a way to make at-home consumption more enjoyable but also to differentiate one's beer in a highly competitive market. In 1892, the crown-top bottle cap was invented, followed in a few years by the crimped bottle cap, which is what we still use today to seal beer bottles. The various enclosures that the brewers had used came to an end as the industry standardized on the bottle cap. "The crimped bottle cap killed them all," said Mike Ciancosi of the Potomac Bottle Collectors.

Christian Heurich, the city's largest brewer, employed a number of bottling companies. An 1881 listing of bottlers and brewers in the *Washington Post* showed that James Butler, Julius Eisenbeiss and Frederick Herrmann were all bottling for Heurich. Butler had the audacity to declare that he was the "only bottler of Chr. Heurich's Lager Beer," though clearly there were others. Heurich spread his business around—or shrewdly shopped around for the best deal. With the new federal bottling law of 1890, however, the

brewers no longer had to outsource bottling. In 1897, Heurich purchased land adjacent to his new brewery on which to build a bottling plant. He was bottling Maerzen and Senate beers on premises within a decade, though he continued to outsource some bottling to Arlington Bottling and others, including companies in Baltimore, Maryland and Norfolk, Virginia, where Heurich established branches. Bottlers turned to ginger ale, mineral water and soda pop to stay in business.

Bottles may be simple to produce and inexpensive today, but in the 1890s, they were a considerable investment for the brewers, as they were customized with embossed trademarks and, later, paper labels that were glued on. The brewers went so far as to stamp each with the words "This bottle must not be sold" or "This bottle not to be sold," as they retained

"This bottle not to be sold" is stamped on many brewery-owned bottles from the 1890s. *Garrett Peck.*

ownership of the bottles. Washington's brewers went to considerable effort to retrieve and recycle empty bottles. The major brewers organized a unique institution: a bottle exchange known as the Bottlers' Protective Union at 818 4 ½ Street SW. The union even employed a detective, Charles Flinders, to track down people who were illegally selling brewers' bottles. Although some bottles ended up in illegal trade, many of the disappeared bottles simply ended up in peoples' kitchens. A spokesperson for the union remarked rather indelicately to the *Evening Star*, "But it seems that very often our bottles find their way to the pantries, where they are filled up with root beer and catsup. These people must learn that they have no right to the bottles, and must give them up, even if they have to throw away the root beer and catsup."

National brewers established a presence in the Washington market by the 1880s, shipping beer in refrigerated railroad cars and then bottling it at local distribution centers. Their offices were close to the rail lines for obvious reasons. This beer was often pasteurized for the journey, something that the local brewers did not do. Anheuser-Busch, which pioneered rail-based distribution, had its local office at First Street and Virginia Avenue SW,

Photographer Lewis Wickes Hine exposed child labor practices in a 1911 photography series. He captioned this photo: "In the Alexandria glass factories, negroes work side by side with the white workers." *Library of Congress.*

right along the railroad tracks; the site is now the Third Street Tunnel. The Philadelphia Best Brewing Company and, later, Pabst Brewing established its distribution center at 703–05 N. Capitol, just west of Union Station. The Joseph Schlitz Brewing Company purchased Robert Portner's former depot and the adjacent bottling plant at 615 D Street SW in 1890. In 1909, Schlitz moved to Third and Randolph Place NE in Eckington. This latter building still stands.

Child labor was an unfortunate side effect of the bottling business. In 1911, photographer Lewis Wickes Hine documented the children laboring at the Virginia Glass Factory, both African American and white boys, most of whom had little education. They worked both day and night shifts. Many of the bottles they produced were for Portner's beer. A fire destroyed the glass factory in 1916, the same year that President Woodrow Wilson signed a law banning child labor. The site, located in Alexandria's West End, was excavated in 1997 in preparation for the development of the Carlyle Center.

HEURICH'S FAMILY LIFE

Christian Heurich married his second wife, Mathilde Daetz, in 1887, three years after his first wife, Amelia, died. He had designs to build a great house on the Dupont Circle property that Amelia had purchased. But after having witnessed the devastating impact of three fires on his business and home, Heurich was rightfully concerned about fire. As the new fireproof brewery went up in Foggy Bottom, Heurich was also working on a fireproof mansion for his family at 1307 New Hampshire Avenue NW, just two blocks north of his old brewery site. The new house was built in the years 1892–94. The house has fifteen fireplaces, none of which have ever been lit. Although formally named the Heurich House Museum, many people today refer to it by its nickname: the Brewmaster's Castle.

Everything about the Heurich House was designed to evoke old wealth and the look of a medieval castle—even though Heurich was a self-made millionaire. Architect John Granville Meyers designed the house in Romanesque style using Hummelstown sandstone, a style that was already going out of fashion by the 1890s. The interiors are quite dark, a popular concept during the Victorian era. Crowning the mansion's tower, like the star on a Christmas tree, is a salamander. Legend has it that the animal can ward off fire.

The Christian Heurich House in Dupont Circle. *Carol M. Highsmith Archive, Library of Congress.*

In 1893, Christian and Mathilde Heurich traveled to Chicago for the World's Fair/Columbian Exposition. "The Chicago Exposition broadened the outlook of hundreds of thousands of Americans—of whom I was one," Heurich later wrote. There he saw many new innovations that he incorporated into his mansion. It was a completely modern house, but there

were some things Christian Heurich just would not do. "He never spoke on the telephone," his granddaughter Jan Evans noted. Although his house had an elevator shaft, he never installed an elevator. Even in his advanced years, Heurich chose to take the stairs instead (let that be a lesson to us all).

Christian and Mathilde had not even lived in their new mansion one year before Mathilde tragically died in 1895 at age thirty-three. Heurich was struck with grief. He was now living as a widower in a mansion designed for a large family. He was alone except for the large number of staff that the mansion required to operate the house.

Christian Heurich, wife Amelia, and their children Christian Jr, Anita Augusta, and Karla Louise, the youngest (middle). *Historical Society of Washington, D.C.*

After living as a widower for several years, Heurich decided to give marriage another try. In January 1899, he married Amelia Louise Keyser, the niece of his first wife. She was twenty-eight years his junior, but he urgently wanted children. He recalled her as being "a little flaxen-haired girl playing around the yard of my first brewery back in those days when I held a dozen jobs and when the first Mrs. Heurich kept my home, a little house next door to the plant, and toiled to feed and care for my handful of employees." Amelia was the granddaughter of German immigrants. She was born in Richmond, Virginia, but had lived most of her life in Washington. The newly married couple honeymooned in Europe. It took Amelia a while to break the habit of calling her husband "uncle."

In 1901, Heurich's wish came true when Amelia gave birth to a son, Christian Heurich Jr. A daughter, Anna Marguerite, was born in 1903 but died the following year after living fewer than nine months. Anita Augusta was born in 1905, followed by Karla Louise two years later.

Amelia made a few changes to the house. Her husband had spent many late evenings in the basement *bierstube*, a man cave in which he could drink

The bierstube in the Heurich House became the German breakfast room once Christian Heurich had children. *Garrett Peck.*

beer and play skat with his friends. The room had a closet to store a keg so they could refill their glasses. The walls were (and still are) decorated with painted murals of German drinking slogans, such as "Raum is in der kleinsten Kammer / Für den größten Katzenjammer" (There is room in the smallest chamber for the biggest hangover). When the Heurichs started having children, however, Amelia put an end to the carousing. The *bierstube* became the German breakfast room.

Amelia and Christian often spoke in German at meals. As a child, granddaughter Jan Evans thought it was so they could talk about the kids without them understanding. In actuality, however, it was because Christian's hearing had become impaired, and it was easier for him to understand his native tongue. Their written correspondence, however, was in English, as was Amelia's diary, which is preserved in the Heurich House Museum's archives.

"We always ate with the family," Jan Evans said. "We had all three meals with grandfather. Breakfast and lunch in the German room, and dinner in the dining room." They always ate dinner at 6:00 p.m. "Punctuality! You were always there at six." This was a German household, after all.

In the back of the mansion is the conservatory, a room whose walls were made to look like tree bark and which was once filled with plants. A fountain was added in remembrance of their second child, Anna, who died as an infant. The conservatory roof was first built of glass, but after the Knickerbocker Theatre collapse killed ninety-eight people in 1922 after a heavy snowfall, Amelia had the roof changed into a more permanent structure. "My grandmother was a great worrier. My mother was a bit of the same. Fortunately, I'm not," Jan Evans remarked.

Jan Evans (born Jan Allison King at Schofield Barracks, Hawaii, in 1932) is the fifth of eleven Heurich grandchildren (two were born after Christian's death, including Gary Heurich). Her mother is Karla Heurich Harrison, who, as of 2013, is still alive at age 106.

Jan's father had gone to West Point and was an army officer, so they moved to many different duty stations. Every Christmas, however, they returned to Washington—in part so that her father could go duck hunting. Her first visit to the Heurich House was when she was fifteen months old. Jan was the closest grandchild to her grandmother Amelia. "I loved going shopping with her," she said. "She'd buy me all my clothes."

By 1943, during World War II, the King family finally returned to Washington. Jan's father was killed in Normandy weeks after the D-Day landings in June 1944 and was buried there. The following year, her

grandfather Christian died. Jan attended school in the district, though she lived in Japan for a year, where she met her first husband, Ben Evans. Jan attended four different colleges (when I raised an eyebrow, she responded with a laugh, "I wasn't kicked out of any of them!").

Jan's family was long associated with the military. Her father was a West Point educated officer. Jan's first husband, Ben Evans (1924–1987), also attended West Point and worked for the CIA (their engagement was announced at the 1950 Christmas party at the brewery). Her second husband, Rear Admiral William Houser (1921–2012), was an Annapolis graduate; they wed in 2003 at the Heurich House soon after it was transferred from the Historical Society of Washington, D.C., to the Heurich House Foundation. (Some people call Jan "Mrs. Houser," though she never actually took her second husband's name.)

The Best Beer in the World

With the new Foggy Bottom brewery pumping out seemingly endless quantities of beer, Christian Heurich took out a half-page ad in the *Washington Post* in May 1901, calling his product "The Best Beer in the World." The ad was full of customer testimonials from bartenders and distributors lauding his beer, which was also cited by two professors for its excellence. Doctors prescribed it as a tonic for good health.

Gary Heurich, a Heurich grandson who became a brewer, wrote, "The brewery produced 13 different beers under 47 different labels in its 83 years of existence. The different beers were Champion, Home Brew, Boxer, Capital, Champeer Malt Liquor, Heurich's Lager, Old Georgetown Bock Beer, Old Georgetown Ale, Old Georgetown Beer, Maerzen, Bock, Senate Beer, and Senate Ale." The Heurich brewery was best known for two beers: the heavier, darker Maerzen and Senate light lager. Christian Heurich made his name from Maerzen, but as lager became ever more popular, Senate became his flagship brand. He was proud that both Maerzen and Senate won gold medals at the Exposition Universelle et Internationale in Liège, Belgium, in 1905, gaining him international recognition.

Heurich directed advertisement toward the African American community, as evidenced by advertisements in the *Washington Bee*, the main black newspaper in Washington until 1922, as well as the *Afro-American* and the *Washington Tribune*.

Heurich also advertised extensively in the other newspapers, showing that he valued a large cross-section of society as his customers.

Christian Heurich was quite philanthropic. His family wasn't churchgoing people, but they donated considerably to charities. He joined the Columbia Historical Society in 1903 and sat on the board of the German Orphans Home and the Ruppert Home for the Aged. He also donated considerably to charitable causes, both in the United States and in Germany, where he contributed to a children's home in his hometown of Haina and the public bath in nearby Roemhild.

The Gilded Age witnessed the emergence of national and regional brewers who amassed a great deal of wealth, including Christian Heurich. There was no income or estate tax yet; their customers largely footed the tax bill with beer excise taxes. Heurich invested considerably in Washington real estate, providing another major source of income for his family and descendants. The Heurich family lives on today in Washington.

CHAPTER 5

THE BEER WAR

B y the early 1890s, brewing in Washington had shifted from family-run businesses to industrialized beer production. The brewers incorporated their companies and built ever-larger facilities able to brew at least 100,000 barrels of beer each year. The small family brewers simply couldn't compete and closed shop. Meanwhile, the brewers employed ever more workers who organized themselves into unions.

Before labor unions negotiated for better hours and wages, it was not uncommon for brewery workers to work twelve-hour days six days a week—and they were often required to come in on Sundays as well. In return, they generally got unlimited free beer to drink while at work.

As breweries got bigger, they employed more people, and there was greater potential for conflict. Workers organized into labor unions. There were three main unions for the brewers in Washington: the Beer Drivers and Stablemen's Union, No. 234; the Bottlers Union, No. 231; and the Brewery Workers' Local Union, No. 118. In addition, there was the Firemen's Local No. 63. The firemen shoveled coal and tended the fires in the boilers, as opposed to putting them out.

There were so many unions—many of them competing to represent workers—that the Washington brewers decided they would recognize only the American Federation of Labor (AFL). Other unions, such as the District Federation of Labor and the Knights of Labor, were upset at their lack of recognition and began a boycott against the brewers, most notably against the Washington Brewery in 1896. The AFL lifted all the boycotts and

organized a Central Labor Union to provide a single forum for the many local union chapters.

Virginia had its own laws, and organized labor had a more difficult time establishing itself in the Old Dominion. Robert Portner's employees weren't unionized. When William Thaler agitated to get his fellow bottlers unionized in 1902, he was dismissed. About thirty men then staged a walkout in support of Thaler, but Portner refused to reinstate him. The men soon returned to work.

The Beer War

A trade war over the price of beer erupted in 1903, a conflict that dragged out for four years known as the "beer war." At root of the conflict was overcapacity. The brewers combined could annually produce nearly 1 million barrels of beer, but demand was only for about a quarter of that. In the preceding decade, the brewing market had consolidated into larger concerns that could produce at least 100,000 barrels each, finally putting the small family brewers out of business. Washington beer was now a corporate production. But there was too much of it. When there's too much supply, prices inevitably drop. And that's what happened.

Knowing that a potential strike could be crippling, the five local brewers signed a secret compact in 1896 to assist each other in the event of a labor walkout and also to work together to hash out any commercial issues. This came on the heels of a Knights of Labor boycott of the breweries. The agreement expired in February 1903 but was then extended to the end of that year. By that time, Christian Heurich had lost up to ten thousand barrels worth of business to Arlington Brewing, so he dropped the price of beer to capture the business back. Albert Carry called together the local chapter of the Brewers' Association to settle the difference, but Heurich would not accept a new agreement. "You can stand it," he told Carry. "Let us see what those fellow are doing." Heurich alone had half of the city's brewing capacity.

Once word leaked of the compact's existence, people began speculating that the brewers were attempting to form a trust, such as Baltimore had witnessed (and which ultimately failed). Albert Carry denied any misdoings. "There is nothing contained in the constitution or by-laws of that organization to control the prices of beer or any other product, or to form a trust, as is alleged," Carry told an *Evening Star* reporter. He later noted the

state of the beer market in July 1904: "At the present time this city produces and consumes 250,000 barrels of beer annually, all of the product of local breweries, of which 10 per cent is a better grade of beer and sold at $7 and $8 per barrel. The balance is sold at $4, less 10 per cent. This is below the cost price and a big loss to the brewers."

The brewers were indeed fighting over wholesale prices. Edward F. Abner of Abner-Drury blamed Christian Heurich. He noted that Heurich's company had offered to lower the price of light beer from $5.70 per barrel down to $4.50—and would soon drop it even further to $3.00 per barrel. Furthermore, he alleged that Heurich had been pressuring him to raise the price of Abner-Drury's dark Old Glory beer, "which we have positively and emphatically refused." Finally, when Heurich denied that he was part of the secret compact, Abner said otherwise, stating that that Heurich had, in fact, been a leader in organizing it. Abner told the *Evening Star* that Leon Tobriner, Heurich's attorney, "cannot deny that the secret agreement between brewers and against beer drivers and any other labor organization in the District was made in his office, type-written on his paper, bound in his yellow back, and represented his ideas on the subject."

Four of the brewers were pushing Christian Heurich to raise the wholesale price of light beer from $3.60 to $5.70 per barrel. They roped in organized labor allies, notably the firemen's union, to put pressure on Heurich by going on strike. Their argument was that unless prices rose, the brewers would go out of business and hundreds of brewery and saloon workers would be laid off. They argued that Heurich's actions were anti-competitive, as he intended to drive the other brewers out of business through a price war.

Heurich had lowered the price of beer per barrel after the saloon license fee was raised from $400 to $800 in Washington. This earned him goodwill from liquor retailers and saloon owners as he sought their favor in the dispute. Dennis Mullany, a prominent saloon owner, penned an op-ed for the *Washington Post* in support of Heurich's dropping the price of beer:

> *At most, it is but a transfer of profits from the rich brewer to the poor saloon-keeper, and why any labor organization should be engaged in battling on the side of the rich against the poor for the formation of trusts that grind the working man instead of battling to destroy them at every opportunity is something that will puzzle thoughtful people all over the country.*

The United States Brewers' Association recommended that local breweries organize local chapters and then affiliate with organized labor to

prevent labor troubles with arbitration panels. The local brewers organized the Brewers' Association of the District of Columbia and then affiliated with the Central Labor Union of the AFL. Christian Heurich was elected to the USBA national board but refused to join the local board. He was at odds with the local association, as he viewed it as being in the hands of his opponents. The night before the firemen went on strike, he said he'd meet with the labor groups but not with the Brewers' Association representative. "They have no concern with the affairs of this company," Heurich said. In fact, when Heurich met with the Central Labor Union and a Brewers' Association representative showed up, he walked out of the meeting. His attorney, Leon Tobriner, remarked, "We want nothing to do with the Brewers' Association."

The Central Labor Union hesitated to endorse a strike, rightly recognizing that this was a fight between the brewery owners rather than having anything to do with organized labor. Labor was simply a tool to force Heurich to raise his prices.

Heurich's attorney, Leon Tobriner, told reporters on July 20, 1904, that "the purpose of the Brewers' Association is to get all five of the local breweries in the combine. Four are already in, the Heurich company being considered independent. It is unusual to admit to membership in labor organizations representatives of capital, as the Washington brewers have been admitted to the inner circles of the Central Labor Union." (The Arlington Brewery was considered the fifth local brewery, even though it was across the river. The Robert Portner Brewing Company was not part of the arrangement, as it was no longer selling beer in the Washington market.)

Tobriner next lobbed a bombshell of an accusation: "The Brewers' Association is a trust formed for the purpose of advancing the price of beer and dividing the trade among the several breweries so there will be no competition or interference." This further heightened the tension between the two sides.

The fifteen firemen at the Christian Heurich Brewing Company went on strike on July 21, 1904. They had no grievance over their conditions or wages—they were striking on orders from Timothy Healy, the president of the International Brotherhood of Firemen. Fifteen workers was hardly a crippling strike. The other labor groups did not join the walkout, and Heurich found unionized engineers to fill these positions. The Central Labor Union was against the strike, so it counseled the other labor groups not to walk out. Several local unions, including the Brewery Workers', denounced Healy's actions in precipitating the strike. Heurich was the first brewer to

sign a contract guaranteeing higher wages and lowering the workday to eight hours.

Two liquor dealers, James Leonard and Samuel Stewart, immediately filed suit against the four brewers and Brewers' Association and also sought an injunction to prevent a sympathy strike from the other workers. They feared the combination of the brewers, minus Christian Heurich, would give them leverage to raise the price of beer. The Washington Brewery objected that the liquor dealers had the privilege to purchase beer but not the right. The judge sustained the objection and dismissed the retailers' case on July 26. The liquor dealers appealed; the following March, the appeals court ruled in their favor, ordering the case returned to court.

The striking firemen returned to work on July 28 after one week. The *Washington Post* called it "the most unique strike in the history of Washington." Heurich denied making any concessions and insisted that he would not raise the price of beer. He would not join the local Brewers' Association. Meanwhile, the firemen and the brewery workers' unions were at each others' throats, each accusing the other of taking bribes to go on strike (the firemen) or to support the beer war (the brewery workers).

The low-level trade war continued for several more years. Christian Heurich glossed over the beer war in his 1934 memoirs, writing only a single vague sentence about the affair: "The great four year beer war against all local and several out-of-town breweries ended in my favor." Time and Prohibition may have mellowed his memory of the dispute, or perhaps he didn't want to dwell on a trade war that he had helped instigate.

Today, such collusion among competitors would likely bring an antitrust investigation. The smaller brewers were, in fact, colluding in order to attempt to force Heurich to raise beer prices so they could all better profit from it. And Heurich was likely selling his beer below cost in a bid to recapture lost market share. Yet antitrust laws had not advanced to the point of addressing trade disputes such as the beer war.

LABOR TROUBLES ON THE EVE OF PROHIBITION

In April 1906, Washington bottle workers went on strike. Two local unions assisted the bottlers by refusing to deliver beer to plants where workers were manning the picket lines. Seventeen men were arrested and charged with

conspiracy for allegedly placing the bottling companies on the "unfair list," so as to cause maximum injury to these businesses.

In July 1906, Washington Brewery driver Timothy Sullivan was mysteriously stabbed four times. Two brewery workers found him unconscious in the washroom, suffering from a massive loss of blood. Suspicion immediately fell on a black worker, Arthur Tabbs, who was seen fleeing the scene and left his hat behind. Tabbs was arrested in Maryland. He was convicted of assault with a deadly weapon and sentenced to ten years in prison.

A threatened strike by local brewery workers in 1910 was averted with a new four-year master contract. This reduced their working hours to eight-hour shifts and limited their beer consumption to two drinks per worker each day. The earlier contract required workers to work nine-hour shifts during the summer, which they wanted to reduce, but in return they had to give up the right for unlimited fermented refreshments on the job. This agreement impacted the 350 employees of the four breweries in Washington (Abner-Drury, Christian Heurich, National Capital Brewing and the Washington Brewery), plus Arlington Brewing. Portner had its own labor contracts.

A gruesome murder took place at National Capital Brewing in September 1912. Two men, Arthur Webster and Lentte Jett, were drinking and got into an early morning fight. Then Webster mysteriously disappeared. His bones were found in the furnace a few days later, leading police to believe that Jett had murdered Webster and then thrown his body into the boiler. Wracked with guilt, Jett committed suicide with a revolver. A jury found Jett posthumously guilty.

As World War I raged in Europe, the Washington Brewers Union staged a major strike at the five major breweries in April 1915 over wages and an attempt by management to institute a longer working day. The brewers pulled in hundreds of non-union labor to fill the positions until the strike was settled. This would be the last strike before Congress mandated that the district go dry in 1917. Many of the men would lose their jobs when the breweries ceased operating.

AN OPEN-AIR CITY: BEER GARDENS AND TIED-HOUSE SALOONS

B efore Washington, D.C., was founded in 1791, drinking had already been well established as a crucial part of local culture. Townspeople and travelers met at taverns to eat and, above all, drink as the taverns often served as community gathering points. George Washington, Pierre L'Enfant and the district commissioners met at Suter's Tavern in Georgetown to plan the new City of Washington. The Indian Queen Tavern still stands in Bladensburg, Maryland, as does Gadsby's Tavern in Alexandria, Virginia.

Drinking and politics were part of Washington's culture from the very beginning. Saloons—what we would today call bars—proliferated as the city developed and drinking habits evolved. With the wave of German immigrants in the 1850s, the city got its first beer gardens. While the saloon was overwhelmingly a man's domain, the beer gardens began to open to women and families by the 1890s. City residents embraced beer as an antidote to the hot, sticky summers in an era before air conditioning. Washington became an open-air city until local Prohibition drove drinking underground in 1917.

SALOON CULTURE IN WASHINGTON

The temperance movement thought of a saloon in the same way a gentrifier might look at a crack house: it was something to be eliminated in order to

make the neighborhood better. But the saloon was more than just a watering hole; it was a fixture in the community, a club without membership fees. It's where politicians met to strike deals, where reporters met their sources and where clerks gathered after work before returning to their tiny quarters in a boardinghouse or the YMCA. It was the workingman's club and the place where the immigrant could learn English. Politicians and ward handlers met their constituents there, and labor unions organized in saloons. Madelon Powers, a saloon history scholar and author of *Faces Behind the Bar*, wrote, "The saloon was not alternative culture. It was urban culture." And this is exactly why temperance organizations such as the Anti-Saloon League and Women's Christian Temperance Union stood so stridently against them. Saloons didn't conform to their idea of a sober-eyed, middle-class Protestant America. The saloon was the headquarters for Demon Rum.

During the Civil War, the influx of Union soldiers was a boon to business—for brewers, gambling houses and prostitutes alike. Bored soldiers needed something to do. Many of the bordellos and gambling dens were concentrated in the working-class neighborhoods of Hooker's Division and Murder Bay, squeezed in between the National Mall and Pennsylvania Avenue. This lively quarter was leveled in the 1930s to create the Federal Triangle.

Washington had a great number of drinking establishments before local prohibition closed them down in 1917. German or Irish immigrants owned many of them. They had names like Abner, Buchholtz, Engel, Gerstenberg, Geyer, Hohmann, Klotz, Losekam, Mullany, Schneider and Shoomaker. Many saloons offered a free lunch to their mostly male clientele. Their spending on drinks would more than make up for the cost of the food. The food often consisted of salty goods like Virginia ham and pretzels, things that drew patrons to order more drinks. Many saloons had a ladies' entrance where wives or children could retrieve a growler of beer for their husbands and fathers.

Brewers often provided financing for a local saloon's start-up costs and in return received an exclusive right to sell beer there. This was known as a tied-house saloon. Christian Heurich took a hard line whenever he discovered a saloon was selling beer that competed with his brands. His May 1901 advertisement in the *Washington Post*, "The Best Beer in the World," stated that Heurich would pull Maerzen out of any saloon that sold a competing dark beer: "This for their own protection and the protection of the public." With his strong share of the Washington beer market, Heurich had real leverage to keep wayward saloonkeepers in check.

P. Hohmann's, a German saloon at Fourteenth Street and Ohio Avenue NW. The Washington Monument is clearly visible just a few blocks away. *Library of Congress.*

A 1912 photo of two Jewish newsboys, Herbert Solomon (left) and Sam Goldstein, working in front of a downtown saloon. Note the "Hot Free Lunch" sign on the right that brought in men to drink. Photographer Lewis Wickes Hine documented the travails of child labor. *Library of Congress.*

One of the few architectural remnants from Washington's brewing past is a Clement Didden–designed tied-house saloon for National Capital Brewing that still stands on Barracks Row. *Garrett Peck*.

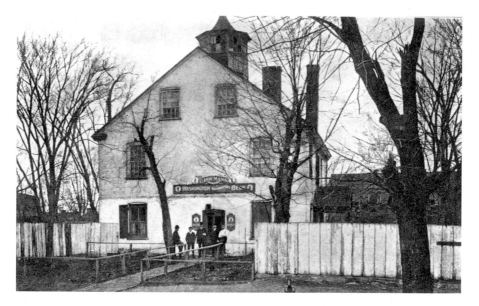

Historic Tunnicliff's Tavern became a tied-house saloon for the Washington Brewery. It was torn down in 1931 and replaced by a gas station. *Library of Congress*.

Albert Carry built a number of tied-house saloons in which to sell National Capital beer. For most of his architectural projects, Carry hired architect Clement Didden. One of the surviving Didden-designed tied-house saloons has been a lesbian bar, Phase 1, at 525 Eighth Street SE in the heart of Barracks Row since 1970.

In Washington's history, one of the most storied saloons was Tunnicliff's Tavern, built in 1795 on Capitol Hill. The site became a beer garden and tied-house saloon for the Washington Brewery. The historic building was razed in 1931 and is now a gas station at Pennsylvania Avenue and Ninth Street SE. Another bar bearing the Tunnicliff's name now stands across from Eastern Market, but this is not the original site.

In an article called "Happy Days" in the September 1927 edition of *American Mercury*, journalist Raymond Clapper waxed nostalgically about Pennsylvania Avenue, what locals used to simply call "the Avenue." "It was an Appian Way of Bacchus, with forty-seven bars to its mile," he wrote. "Probably nowhere in America were there such superb drinking facilities in equally compact form." At the center of this drinking universe was Rum Row, a block of E Street NW (now Pennsylvania Avenue) between Thirteenth and Fourteenth Streets NW. At the center of the row stood the

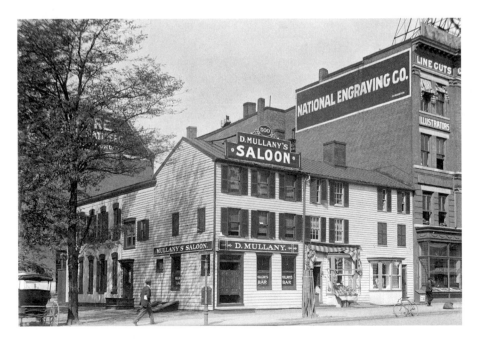

Dennis Mullany's saloon at the corner of Newspaper Row and Rum Row. *Library of Congress*.

1893 Washington Post Building, where columnist George Rothwell Brown observed the passing of the city. "Almost from the earliest days old E Street was the center of Washington's sporting life, and particularly of its night life," he wrote in 1930.

Just around the corner on Fourteenth Street was Newspaper Row, now largely occupied by the National Press Club Building, where many national newspapers had their Washington bureaus. Rum Row became the place where journalists came to meet their sources over a beer or cocktail. Nearby was the Western Union Telegraph Office where reporters could file their stories. Dennis Mullany's saloon at Fourteenth and E Streets was perhaps the most important bar for newspaper reporters as it literally stood at the intersection of Newspaper Row and Rum Row. It was known simply as "Dennis's Place."

No bar in Washington's history was as famous or renowned as Shoomaker's on Rum Row (1331 E Street NW). R.H. Otto "Charlie" Hertzog and Wilhelm (William) Shoomaker founded the saloon in 1858. The two served as officers in the Union army during the Civil War, as did many in the German community. Its original name was Hertzog & Shoomaker's, but it later went simply by Shoomaker's. Or Shoo's. Or Cobweb Hall. The place was perennially filthy and never cleaned—all part of its character and charm. Journalist Raymond Clapper described Shoomaker's in 1927:

> *Shoo's was known among well-informed bibuli the length of the land as Washington's most remarkable saloon, the birthplace of the celebrated concoction dedicated to Col. Joe Rickey, the favorite bar of Cabinet members, Supreme Court justices, generals, and politicians. But it was nothing to look at. Its appeal grew only with acquaintance. There was no more disreputable looking bar in town. Dilapidated is a better word.*

Shoomaker's was the rare bar that didn't offer a free lunch. Clapper wrote, "Every afternoon, just before the four o'clock rush, a small plate of rat-trap cheese and a bowl of crackers and gingersnaps were put out. You could take it or leave it. Shoo's depended entirely on the quality of its drinks." Shoomaker's wasn't as well known for its beer as it was for its cocktails and wine. Famed bartender George Williamson invented the Rickey cocktail there in the 1880s, named after the owner, Colonel Joseph Rickey, a Democratic lobbyist from Missouri who bought the saloon after Shoomaker died in 1883.

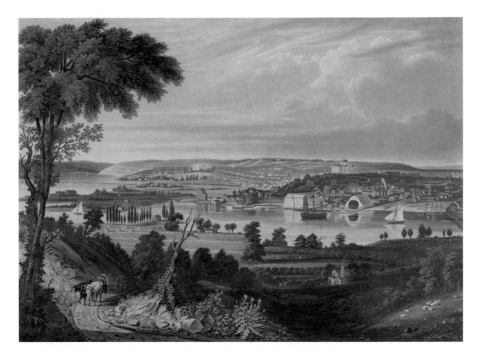

George Cooke painted *City of Washington from Beyond the Navy Yard* around 1833 and captured the earliest known image of a Washington brewery: the brick high rise (left-center) along the Anacostia River. *Library of Congress*.

Nineteenth-century Washington beer bottles from Mike Ciancosi's collection show the diversity of packaging before the crimped-cap twelve-ounce bottle became the standard. *Back row, from left*: a stonewear bottle from Arny & Shinner; lightning stopper, Edward Abner; cork or variation of a lightning stopper, Robert Portner; lightning stopper, Washington Brewery. *Middle row, from left*: Hutchinson stopper, Robert Portner; gravitating stopper, S.C. Palmer; short blob top, William N.H. Maack; malt extract, Robert Portner. *Front row*: torpedo bottle, McKeon & McGrann. *Garrett Peck*.

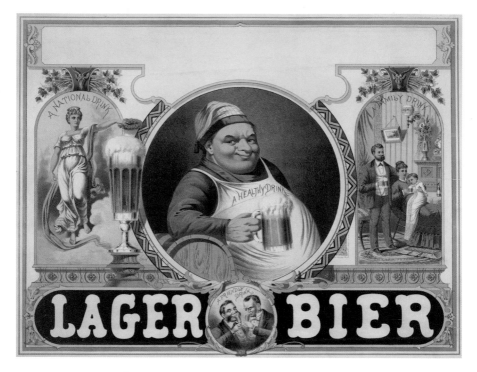

An 1879 advertisement touting lager beer as a healthy, family-friendly beverage. *Library of Congress*.

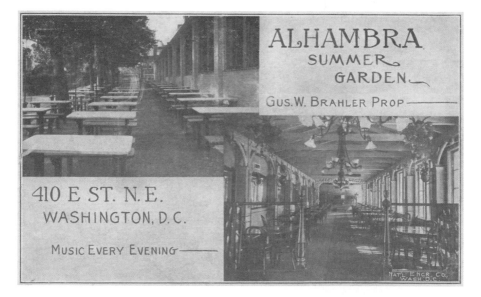

A postcard for one of Washington's largest beer gardens, the Alhambra Summer Garden. *John DeFerrari*.

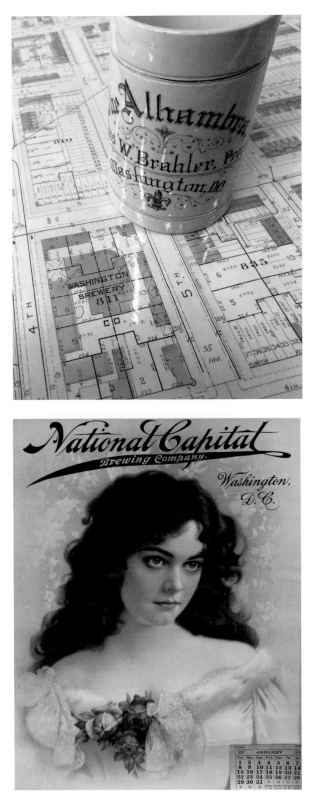

A beer stein from the Alhambra Summer Garden, juxtaposed with a Baist map showing its location adjacent to the Washington Brewery. *Jerry McCoy*.

An 1899 calendar from the National Capital Brewing Company. *Ceci Didden Wieland*.

A Washington Brewery beer label for its ruby lager. *Rayner Johnson*.

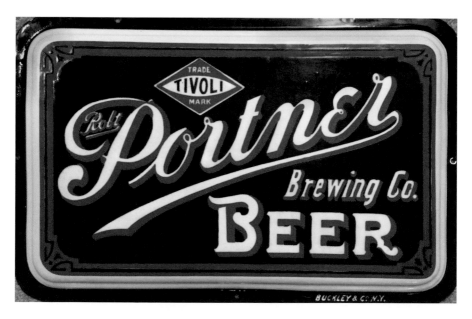

A metal plaque advertising Robert Portner's beer. *Chuck Triplett*.

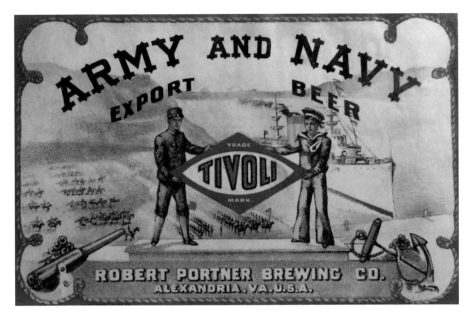

A very rare beer label for Robert Portner's Army and Navy Export Beer. *Rayner Johnson.*

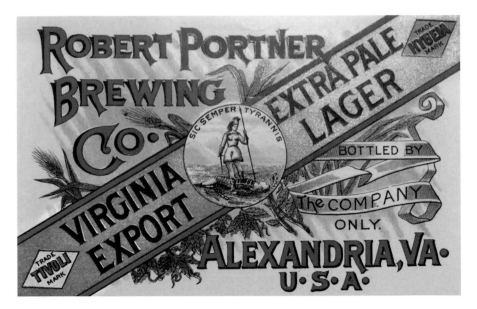

A beer label for Robert Portner's Virginia Export. *Rayner Johnson.*

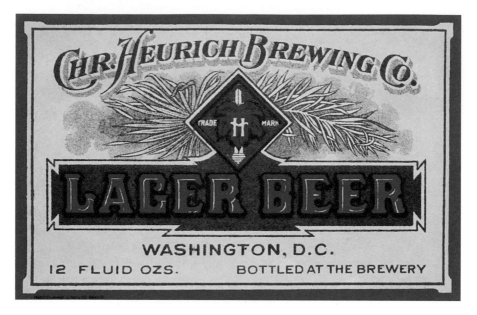

A pre-Prohibition beer label for Heurich's Lager. *Rayner Johnson.*

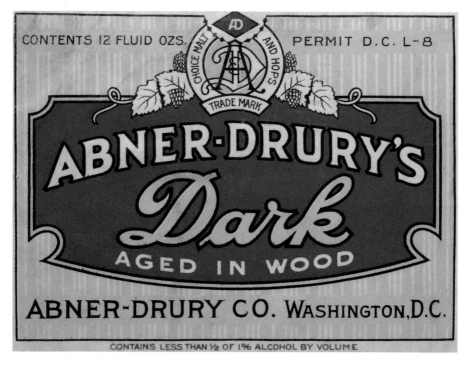

A Prohibition-era beer label for Abner-Drury's near beer. *Rayner Johnson.*

Above: A post-Prohibition beer bottle label for Congress Lager from Abner-Drury. *Rayner Johnson*.

Right: A post-Prohibition Senate beer label from Christian Heurich. *Rayner Johnson*.

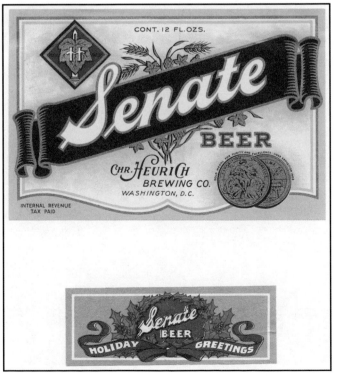

Three different beer cans from Christian Heurich, invented in the 1930s for home consumption. From the Heurich House Museum collection. *Garrett Peck.*

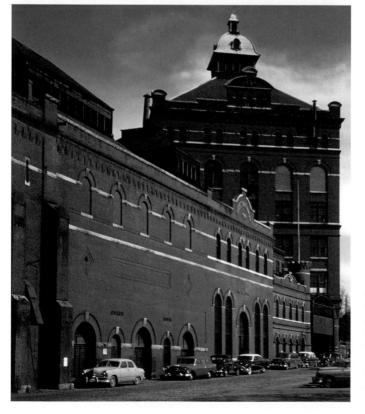

A rare color image of the Christian Heurich Brewing Company dated March 1, 1956, shortly after it closed. *Historical Society of Washington, D.C.*

The Heurich House Museum near Dupont Circle is Washington's link to its brewing past. *Garrett Peck.*

Jack Blush turned part of his basement into a museum for Heurich Breweriana. *Garrett Peck.*

Kim Bender is the executive director at the Heurich House Museum.
Garrett Peck.

The chicken sandwich and bacon-fried kale paired with Raised by Wolves pale ale at Right Proper Brewing. *Garrett Peck*.

Bill Butcher founded Port City Brewing Company in Alexandria in 2011. *Garrett Peck*.

Jeff Hancock (left) and Brandon Skall (right) of DC Brau. *Garrett Peck*.

Jason Irizarry of Chocolate City Beer, located in a Seneca redstone building. *Garrett Peck.*

Mike McGarvey (left) and Dave Coleman (right) with their painted skull mural at 3 Stars Brewing. *Garrett Peck.*

Will Durgin (left) is the brewer and Justin Cox the CEO at Atlas Brew Works. *Garrett Peck.*

Ben Evans (left) and Patrick Mullane of Hellbender Brewing Company. *Garrett Peck.*

Kristi Griner is the brewer at Capitol City Brewing. *Garrett Peck*.

Barrett Lauer is the brewer at the District ChopHouse & Brewery. *Garrett Peck*.

Opposite, bottom: Bill Madden, the owner of Mad Fox Brewing in Falls Church, got his start at Capitol City Brewing. *Garrett Peck*.

Megan Parisi, brewmaster at Bluejacket, and Greg Engert, beer director for the Neighborhood Restaurant Group. *Garrett Peck*.

Nathan Zeender (left) and Thor Cheston of Right Proper Brewing Company in Shaw. The mural by Thor's brother is painted on the surviving wall of Frank Holliday's Pool Hall, where Duke Ellington learned to love music. *Garrett Peck*.

Shoomaker's moved to another location (1311 E Street NW) just down the street in 1914, but it didn't stay in business long. When local prohibition began in November 1917, the saloon attempted to stay open as a soft drink parlor, but the public had no appetite. It closed for good the following March.

Gerstenberg's, a German restaurant that opened in 1887 at 1343 E Street NW, was another well-known establishment on Rum Row. It was often called the "University of Gerstenberg," and it stood right next to the Washington Post Building. It had a small beer garden in the back. George Rothwell Brown, a *Washington Post* columnist who published his irreverent *Washington: A Not Too Serious History* in 1930, loved Gerstenberg's. He wrote:

> *In those days Kaiser Wilhelm was very popular in Washington, for there had been from the beginning in the city a large, pleasure-loving German population, with a talent for friendship. How good the Budweiser and the Pilsner were! Oh, there was Heurich's Maerzen, and the light, Senate beer, on tap but not "drawn from the wood." It was the sole drawback.*

Gerstenberg's closed after the onset of local prohibition in 1917; people didn't want German food without beer. Many Rum Row restaurants likewise had outdoor beer gardens, including Mullany's and Perreard's, a French restaurant known for its annual Bastille Day celebration. "It was a beer and wine garden that courted the nobility," wrote John Daly in 1933.

When he was in Washington, journalist H.L. Mencken liked to drink beer at The Losekam (1323 F Street NW), a famous restaurant that opened in 1884. Its founder, German immigrant Charles Losekam, died just two years later of a stroke at the young age of thirty-nine. The restaurant continued for decades under new ownership and became one of the storied restaurants of Washington's history.

Local prohibition shut down all the storied bars along Rum Row, and eventually the newspapers closed their local bureaus as well. George Rothwell Brown noted sadly, "Twins cannot thrive when separated." All of the historic buildings along Rum Row—save for the National Theatre—were demolished and replaced by the modern J.W. Marriott Hotel. The hotel bar, 1331, retains the address of Shoomaker's in its name. Brown lamented the loss of Washington's old drinking scene:

> *Something has gone out of life with the passing of such famous old Washington institutions as Mullany's, the historic bar of the original Willard's, Shoomaker's, Hancock's and the old Whitney House, of*

an earlier day. Here were absolutely open forums for the discussion of the principal problems of the day by men who spoke freely under the inspiration of more or less strong drink, who had a tendency to promote eloquence and burst asunder the shackles of convention, conservatism, and caution.

TROUBLE IN ALEXANDRIA COUNTY

Across the river in Alexandria County (it didn't become Arlington until 1920), a distinct saloon culture developed in the wake of Washington banning gambling after the Civil War. Directly across from the city stood two of the seediest districts in the national capital area: Rosslyn, at the foot of the Aqueduct Bridge (since torn down and replaced by the Key Bridge), and Jackson City, at the end of the Long Bridge (now the Fourteenth Street Bridge). Washingtonians came here in droves to misbehave.

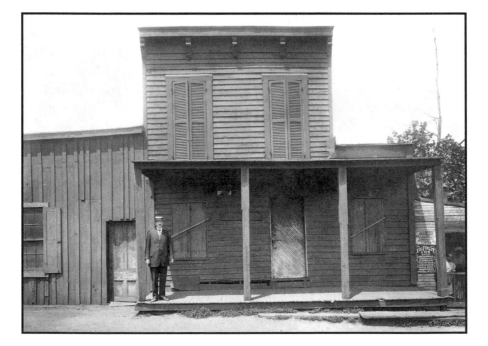

A 1904 image of Commonwealth's Attorney Crandal Mackey on the porch of Eliza Sorrel's Sunday saloon in Rosslyn, around the time that Mackey led raids on the vice districts. *Center for Local History, Arlington Public Library.*

Rosslyn at the time was an industrial adjunct to Georgetown. It was home to the Arlington Brewing Company, a cement plant, lumberyards, slaughterhouses and meatpacking plants, stockyards and numerous brothels, gambling halls and saloons. Jackson City was arguably even worse, helping give Alexandria County the nickname the "Monte Carlo of Virginia." A refreshing beverage lay right across the river—even on Sundays, as Sunday closing laws were widely flouted. These bars were known as "Sunday saloons." They appeared closed, with their doors and windows shuttered, but you only had to go through the back door to find the bartender awaiting to serve you—and gangs ready to rob you if you lingered after dark.

With the county sheriff unwilling to take action against the saloons, newly elected Commonwealth's Attorney Crandal Mackey gathered a posse of determined men on May 30, 1904, and struck. Armed with axes, shotguns and sledgehammers, Mackey's men raided the vice districts, destroying the gambling tables, demolishing the furniture and smashing the barrels and bottles of alcohol. Mackey forced the saloons to close at the barrel of the shotgun. But speakeasies would continue in the county as long as men still had desire to drink.

BEER GARDENS

The German immigrants brought not only their love of lager but also the sense of drinking conviviality, *Gemütlichkeit*, which manifested in summer and winter beer gardens. The beer garden was a distinctly German import that Americans embraced, one that was noticeably different from the male-only saloon. Entire families—fathers, mothers and children—would go together to the beer garden. It was normal for children to drink a little beer from their parents' glass. Americans discovered how pleasant it was to sit outdoors with friends and sip suds fresh from the tap.

The beer garden wasn't always garden-like, but it did have big communal tables for people to gather around and often featured live music. Germans have never been given to boisterous drinking. The beer garden was a family place, a place for pleasant conversation—not a dive for drunken college students.

The first Washington beer gardens opened in the 1850s, including George Beckert's on Capitol Hill. Ernst Loeffler opened one near North Capitol Street just prior to the Civil War. It served frothy mugs of beer

for more than two decades. Owen Humphreys and George Juenemann opened their pleasure garden in 1857. For the 1858 season, which began on May 4, they posted an advertisement with three rules for patrons:

> *No political discussions whatever will be permitted.*
> *Boys will not be admitted, unless accompanied by their parents or guardians.*
> *No intoxicated person* [is] *permitted to enter the gates or remain on the premises.*

Given that the beer garden opened just three years before the Civil War, the sectional tension between slaveholding Southerners and free-soil Northerners was quite high. One can understand why the proprietors banned political discussions. For those who violated the rules, police officers were stationed on premises and would presumably haul away offenders.

For a time, beer gardens went out of favor, seen as perhaps an old-fashioned tradition from the Civil War era. But they came roaring back in the 1890s as gardens and restaurants raced to expand to make room for the buzzing crowds—some of whom fashionably arrived by bicycle. Sipping beer in summer gardens shifted from the working class to more highbrow society. It gave people a chance to dress up and be Bohemian for an afternoon or evening. Women were welcome at beer gardens, and young men often took dates there. The *Washington Post* recorded in 1896:

> *The German beer garden has something of a different atmosphere. There is more of a healthy and home-like quality about it. Whole families come to spend the evening and to drink beer. Stout-faced fraus and plump frauliens* [sic], *immense herrs with large waist lines and prodigious long-stemmed pipes hanging from their mouths—there they sit and drink tankard after tankard of beer with smiles of happiness wreathing their faces. The German beer pot of stone seems an immense affair to a beginner, but its size does not trouble the German herr.*

The *Post* raised the question of temperance, noting that one saw fewer drunken people in beer halls than in saloons. It concluded, "The presence of the women and girls inspires a sense of refinement which makes it impossible to introduce anything degrading. If Washington gardens are conducted on the same line as the German gardens they will have the same chance of being patronized by the respectable, if liberal, class of society."

In 1933, *Washington Post* reporter John Daly wrote a nostalgic retrospective of beer garden life before Prohibition. "An open-air city, it was but natural

that Washington should take to this form of beer drinking in the summer," he wrote. "There were bands aplenty, and orchestras, and the beer garden became a diversion of the masses before the advent of the movies."

Edward Abner became quite the name in the Washington hospitality scene (you may remember him as the man who suggested to Robert Portner that he open a brewery). Abner ran the Washington Schützen Park (a shooting and social club) and owned a restaurant, Abner's Winter Garden, at 413 and 415 Ninth Street NW. In 1880, he demolished former mayor William Seaton's home to open Abner's Winter and Summer Gardens, a year-round beer hall at 708 E Street NW, directly south of the post office (the beer hall is now the site of the Lansburgh Building in Penn Quarter). Just a block from Abner's was Kolb's at 811 E Street NW, where beer and vaudeville were the chief attractions.

As his health declined, Edward Abner decided to downsize. He sold the beer garden and moved to Capitol Hill, where he opened Abner's Restaurant at 415 East Capitol Street. He lived directly next door at 413. Both buildings still stand—one of them is home to Riverby Books.

The summer garden emerged as a place to grab a beer outdoors, whether in a garden or on a rooftop deck. These gardens often served crabs, such as Hall's Summer Garden on the Waterfront, which opened in 1885. John Daly recalled of Halls, "It was a place where gentlemen took off their coats, stretched them over the backs of chairs, and went to the serious work of shelling Chesapeake Bay hard-shell crabs, with foaming seidels on the side."

Much of the beer brewed and sold in Washington was tapped from kegs. Unlike the emerging national brands, it wasn't pasteurized, as it didn't travel far. Most local beer was consumed in beer gardens and saloons, though the home market became increasingly important, and many breweries offered home delivery. The demand seemed insatiable.

Beer gardens were a major retail outlet for the breweries, and like the tied-house saloons, many could only sell a particular brewery's beer. The most famous of the Washington beer gardens was the Alhambra Summer Garden (410 E Street NE), adjacent to the Washington Brewery. Owen Humphreys and George Juenemann opened a beer garden there in 1857, and later both Albert Carry and the new owners of the Washington Brewery continued the tradition. The garden often featured concerts and dancing, with the music usually performed by orchestras rather than oompah bands. In 1933, John Daly of the *Washington Post* noted that some called the Alhambra the "Last Chance." He added, "Night after night the swains and lassies gathered there and quaffed golden brew. They danced to the strain of a Germanic

orchestra playing good Teutonic music—and popular American tunes, 'The Sidewalks of New York,' and 'Auf Wiedersehn.'"

THE RISE OF TEMPERANCE

Temperance in Washington stretched back to the early nineteenth century. In November 1857, Washington passed a Sunday closing law (also known as a blue law), handing a victory to Sabbatarians and the temperance movement. The message was that people were supposed to be in church, not carousing in beer gardens and saloons. Keep in mind that people had a six-day workweek in the nineteenth century; Sunday was their only day off. The penalties were stiff for the proprietor caught selling on Sunday: a twenty-five dollar fine for the first offense, a fifty-dollar fine for the second offense and a loss of liquor license for the third offense. This was a conflict with the German immigrants, who were happy to spend their Sunday afternoons sipping beer and socializing. Many saloons, of course, remained open on Sunday, just not legally. Places like Dennis Mullany's left the back door open. Customers in the know could come in and drink for free. Others would make their way to Rosslyn, Virginia, which was crowded with Sunday saloons.

Not everyone was pleased with the Sunday closing law. Someone under the pen name "Geo. Swamp, of Swampoodle" (the working-class neighborhood where Union Station now stands) published a March 1860 poem in the *Evening Star* after fruitlessly searching for a glass of lager for two hours on a Sunday. His poem, called "Liberty and Lager Beer," began:

> *Arouse ye Dutch! Our right's invaded!*
> *Strike for Freedom and Lager Beer!*
> *Never submit to be degraded—*
> *Robbed of our glorious Sunday cheer!*
>
> *Chorus: Oh, the foaming glasses,*
> *And blue eyed lasses*
> *Lighten the cares of Labor's band;*
> *While sparkling beer,*
> *So mild and clear,*
> *Bespeaks the moral, happy land.*

A HEADY HISTORY OF BREWING IN WASHINGTON, D.C.

Sons of Lager, assert your rights!
Bereft of justice shall we be?
No! We'll battle in a hundred fights
For Lager Beer and Liberty!

The Metropolitan Police Department periodically cracked down, catching proprietors in the act of selling beer or liquor on Sundays and ensuring they would have their day in police court. The city adjusted the law to make it even more stringent: anyone convicted of selling on Sunday would lose his liquor license for a year, though this was rarely enforced. A temperance-minded group, the Independent Order of Good Templars, touted a lengthy list of saloons in the *Washington Post* that had been caught selling liquor on Sundays in 1882 and 1883 and demanded that they be closed. This would have shut the majority of bars in the city.

Organized in Ohio in 1893, the Anti-Saloon League (ASL) rose as a powerful and righteous force to challenge the very existence of the saloons. It established local offices around the country, including one in Washington, and had its first national convention at Calvary Baptist Church on December 17, 1895. As beer gardens rode the wave of fashion in the 1890s, the ASL tut-tutted about their existence and did everything possible to shut down Washington's drinking culture. It was this group that pushed through the Eighteenth Amendment, ushering in national Prohibition (1920–33).

As light beer prices had dropped so much from the "beer war" between Christian Heurich and the other brewers, the Anti-Saloon League in 1905 proposed banning growlers (the buckets of beer that men took home from a bar). This was met by howls of protest from workingmen across the city. The ASL's desire was to raise the price of beer so that people would drink less—and to tackle the brawling that resulted from men who drank too much. The ASL even accused women of drinking from growlers, according to the *Washington Post*: "The Anti-Saloon League representatives say the children of these women roam the streets, are shamefully neglected, and grow up into vicious boys and girls."

Brewer Albert Carry denounced the ASL proposal in an *Evening Star* interview, stating, "There prevails among a certain class of people a prejudice against beer which is wholly unjustified…The well-to-do have bottled beer sent to their houses, an article the poor man cannot afford. To deprive the latter of the growler seems to me to be unjust to them." Growlers remained legal.

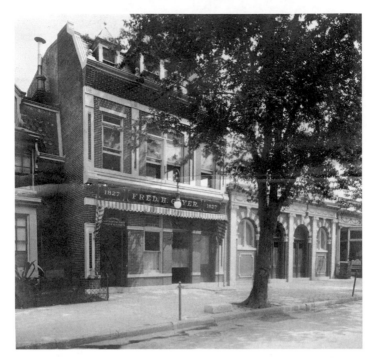

Kozel's and, later, Geyer's beer garden stood at 1825–1827 Fourteenth Street NW. *Chris Kozel.*

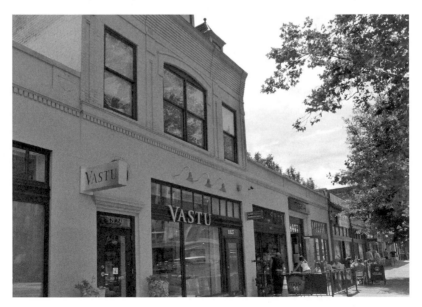

Most buildings from Washington's brewing history were redeveloped, but Kozel and Geyer's beer garden still stands. It's now a furniture store and a restaurant. *Garrett Peck.*

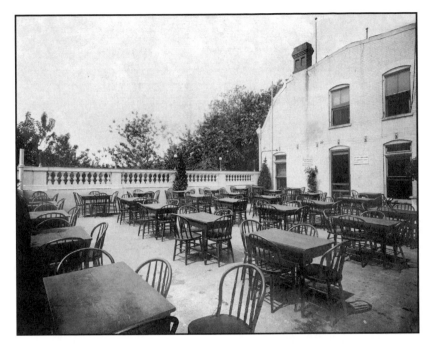

The roof deck at Geyer's beer garden was a relief from Washington's hot summers. *Chris Kozel.*

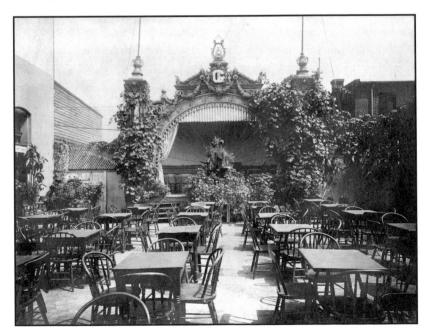

Geyer's offered a bandstand with live music on its roof deck. *Chris Kozel.*

The ASL was a considerable thorn in the side of the beer garden and saloon owners, publicly challenging any permit for expansion or renewal that came before the excise board—and for any reason, such as a saloon being within one thousand feet of a church, public square or school. For example, one popular beer garden, Kozel's stood at 1827 Fourteenth Street NW. George Kozel, son of the brewer John Kozel, realized that family breweries were no longer sustainable and so he sold off the brewery to focus on the beer garden and restaurant. Chicken was such a popular dish on the menu that Kozel purchased a chicken farm in New York. In 1896, the ASL challenged Kozel's license renewal on the grounds that it was within four hundred feet of an orphanage. When he expanded into the adjacent space at 1825 Fourteenth Street, the ASL complained that, against the stipulation of his license, he had turned the roof into a summer beer garden. Kozel's customers rallied to his defense. The German American Union provided a petition signed by 1,700 people who supported the beer garden, calling it a "place of recreation for hundreds of law-abiding people, who were compelled to remain in the city during the heated term." Kozel's remained open.

George Kozel later moved to New York, where he died in 1907. Frederick Geyer took over the beer garden. In a 1933 *Washington Post* article, John Daly called it "the dandy of all beer gardens." He added, "Geyer's was the Mecca for young love; for the young blades of the day. It was packed and jammed nightly." The Anti-Saloon League remained a threat to Geyer, just as it was to Kozel before him, challenging his license annually at renewal. In 1916, for example, it challenged Geyer on the grounds that women drank in his beer garden. Geyer declared bankruptcy in 1914 but managed to keep the beer garden open. He closed the business for good with the onset of local prohibition in 1917.

American brewing and beer consumption reached a peak in 1915. Christian Heurich wrote, "Business was good, kept getting better and better; but I could see the finish, just around the corner," as the temperance movement gained tremendous political power. The United States declared war on Germany in 1917 and simultaneously declared war on alcohol. Prohibition was at hand and with it the near destruction of the brewing industry.

THE ROAD TO PROHIBITION

Nothing so threatened American brewers as the temperance movement. This Progressive Era movement sought to improve American society by eliminating alcohol, creating a sober, upright country. It saw alcohol as a societal evil, and true to its evangelical roots, it saw the brewers and distillers as tools of the devil.

The brewers had right to be concerned. Temperance had started in the early nineteenth century and had turned into a national movement in the decades after the Civil War, its goal being to dry up the country. The movement started because of the whiskey binge in the 1820s, but beer found itself in the temperance crosshairs as well. Brewers attempted to position their products as befitting temperance—that is, moderation. The U.S. Brewers' Association even produced several editions of *A Text-Book of True Temperance* to make the case that beer was a temperance beverage.

A Pabst Blue Ribbon advertisement found in a July 1907 issue of the *Evening Star* claimed that its beer had "a very low percentage of alcohol—less than 3 ½ %—strictly a temperance beverage." This missed the mark, however. The temperance movement wanted no moderation; it wanted outright abstinence. There was no middle ground. A Christian Heurich ad from that same year noted in the fine print, "Delivered in unlettered wagon if desired," in case one needed to escape the glare of tut-tutting neighbors.

In 1909, the Washington Brewery came up with a non-alcoholic "temperance beverage." It offered $100 in gold to the person who could come up with a name for the new brew. "The name must be short, catchy,

appropriate and easily remembered," a company advertisement read. The winner was the groan-inducing Noalco. As it had less than one-half of one percent of alcohol, it did not have to pay federal beer excise taxes. Three years later, three brewery officials were arrested for violating internal revenue

An 1882 *Puck* cartoon showing a temperate beer drinker caught between two evils: the intemperate drunkard and the intemperate teetotaler. *Library of Congress.*

regulations, as they had supposedly shipped real beer in Noalco bottles to army posts in other dry areas.

Christian Heurich offered no apologies for being a brewer. He wrote in a letter to a friend, "Since the bible teaches that Christ changed water into wine, I do not have to make excuses for the selection of my trade." Heurich wasn't without a sense of humor. At an All Fools meeting in 1912, he delivered a speech denouncing the temperance movement as "busily engaged in crippling our business." He mockingly proposed a new business: a cat farm. "Profits will be enormous," he declared before going to on to explain that the pelts of the quickly reproducing cats would be quite profitable. (Heurich was apparently not a cat lover; he had several Great Danes.)

The brewers and distillers were often at odds, unable to cooperate as this looming threat to their business grew. Both responded too slowly to the temperance movement. The brewers comprised a much larger industry; many brewers felt that the distillers were to blame for heavy drinking.

Brewers thought they had a trump card to protect their industry—they paid high federal excise taxes that funded a significant part of the federal budget. Prohibiting alcohol would gut the government. Progressives came up with an alternative: the income tax, which went in effect after the Sixteenth Amendment was ratified in 1913.

Historian and *Washington Post* columnist George Rothwell Brown noted that the city of Washington was perhaps a bit naïve as the dry cause stormed the country: "It can not be said that the temperance movement made any very deep impression on the people of Washington until after prohibition had surprised them and was actually an accomplished fact." Even with Prohibition, many people still expected that beer and wine would be legal—they didn't realize that the Anti-Saloon League, the leading proponent behind the Eighteenth Amendment, stood stridently against any alcohol in its crusade for a dry utopia.

Brewer Edward F. Abner spoke out in 1908 against the temperance movement, noting how important drinking was to American society: "It enters too deeply into the life of the people, and cannot be rooted out—even were there a real necessity—without a great political and commercial upheaval." It would indeed take a great upheaval to foist Prohibition on the country (the Great War) and another to repeal it (the Great Depression).

WORLD WAR I

When the Great War broke out in July 1914, Christian Heurich and his family were taking the cure in Karlsbad, as they had often done. As the continent tripped into war, the Heurichs decided to head home to America but found themselves stranded for three weeks in Nuremberg, Germany, with many other Americans who wanted to leave the continent as well. Finding a train proved difficult. They managed to get to Amsterdam, but the ship *Rotterdam* was overbooked. After waiting several more weeks, they took quarters in a foul-smelling cabin aboard the *New Amsterdam*, considerably less than the fine accommodations to which they were accustomed. English warships stopped the steamer several times, and as Heurich later wrote, "the English officers took great liberties," singling out Heurich for being German-born. The family wasn't able to reach Washington until September 21.

Heurich was clearly upset at his treatment at the hands of the British and took action that would have negative consequences several years later when the United States entered the war. He wrote, "I pondered a lot over the war, particularly about the falsehoods printed in the English papers. I came to the conclusion that England had contrived the war. I therefore canceled all my insurance with British companies and transferred my coverage to American firms. This transaction may have contributed to the fact that during the war, great crimes were imputed to me."

Imperial Germany had unleashed unrestricted submarine warfare in order to cut off Great Britain's supply lines. This resulted in the sinking of the ocean liner *Lusitania* off the Irish coast in 1915 with many Americans aboard. Although Germany apologized, it created a rift with the United States, which was trying to stay neutral in the war. In 1917, Germany secretly sent the Zimmermann Telegram to Mexico, asking Mexico to make war against the United States. British intelligence intercepted and decoded the telegram and provided it to President Woodrow Wilson. The United States now had cause for war.

As Congress debated entering the war, a wave of anti-German hysteria swept the country in early 1917, making things difficult for German Americans. Anyone born in Germany was suspected of sedition and/or treason. Wayne Wheeler of the Anti-Saloon League openly insinuated that the brewers were in league with Germany's Kaiser Wilhelm as part of a propaganda war to marginalize German Americans (the largest ethnic group in the country in the time, a group that was also the brewers). Drinking beer became unpatriotic despite the fact that it had been the de facto national

beverage since the time of the Civil War. The brewers were thrown on the defensive and never recovered.

Federal agents from the Department of Justice searched Christian Heurich's brewery, farm and house in March 1917, three weeks before the United States declared war on Germany. The *New York Times* insinuated that Heurich had installed concrete foundations at his Bellevue Farm so that German artillery could shell the capital (he was actually building the family mausoleum). "It was also reported that a wireless station had been established to transmit important news to the enemy," he wrote disdainfully in his 1934 memoirs. "After the public got tired of hearing and reading about such crimes, the report circulated that I had committed suicide. This ended the entire affair."

"Christian Heurich stated that his loyalty as a citizen was so far beyond question that he regarded the sensational rumors as being beneath his notice," the *Washington Post* reported on March 29, 1917. Yet the insinuations clearly did bother Heurich, and he was under a lot of stress and possibly depressed. Amelia's diaries from this period note that Christian was wracked with grief and hardly got out of bed. He later called it a period of "complete misery of spirit." The prospect of war against his birth country seemed unfathomable.

Although born in Germany, Heurich knew which side he stood on in the Great War. "Germany was and is my mother, and I was against the war. But America is my bride, and if I have to choose between the two, then I must leave my mother and go with my bride," he wrote. "My whole existence is with my bride, America."

With the brewers like Heurich pushed aside, the Anti-Saloon League pushed through the Eighteenth Amendment to ban the manufacture, sale and transportation of alcohol. The country quickly backed the measure, believing it needed to save grain to support the troops and that Prohibition would help win the war. They didn't think about the consequences or how impossible Prohibition would be to enforce in a populous, urbanizing country where most adults drank and never intended to stop.

Virginia enacted statewide prohibition on November 1, 1916. It temporarily allowed breweries within the state to continue operating as long as they exported their entire production to other states, though that lasted only two years. Both breweries on the Virginia side of the Potomac opposite Washington shut down. The Robert Portner Brewing Company closed the Tivoli Brewery for good in 1916. The plant was demolished in the 1930s and is now the site of the Trader Joe's on Washington Street.

Meanwhile, the Arlington Brewing Company continued brewing beer until its main market—Washington—went dry a year after Virginia. William McGuire, the brewery's last president, got the honor of closing down his business. In 1920, the shuttered brewery was sold to the Cherry Smash Company of Richmond, which produced the non-alcoholic sugary beverage until 1930. Dixie Brewing purchased the site in 1933 as Prohibition was coming to an end and planned to invest $1 million in upgrading the plant. However, the new brewery never opened, and it instead became a printing shop and warehouse. The complex was torn down in 1958 to make way for the Key Bridge Marriott Hotel. The horse and mule shoes that were placed at the top of the smokestack for good luck were retrieved shortly before the smokestack was demolished.

The District of Columbia was a congressional fiefdom until home rule in 1974, and so it was Congress's right to mandate laws for the city. Senator Morris Sheppard of Texas sponsored the Sheppard Act, which declared the district dry as of November 1, 1917. All four breweries within the city shut down. It should be noted that in the year previous, district residents had consumed 7.2 million gallons of beer, or more than 232,000 barrels, far eclipsing whiskey and wine.

Christian Heurich installed a massive icehouse at his brewery in 1914 – and ice kept him in business during Prohibition. The icehouse operated until 1940. *Library of Congress.*

The Christian Heurich brewing plant sat idle with the onset of Prohibition. *Library of Congress.*

"Exit the brewers of America, a guild of reputable, honest men schooled, many of them for generations, in the fine art of making hops into a palatable, refreshing and healthful drink," recalled Christian Heurich. "The field was open for coca-cola and for the gangsters." Heurich had added an icehouse to his brewery in 1914, and thus his business turned to ice making, which allowed the brewery to survive during Prohibition. His workers took a pay cut, but he laid no one off. Nor did he go into the business of making near beer. "Beer could not possibly come back in my time, thought I," Heurich later wrote. "I bent my energies to real estate and to voracious reading."

In September 1917, shortly before Washington went dry, Christian Heurich began an experiment in making a non-alcoholic apple drink called Liberty Apple Champagne. He spent $100,000 on apples, pressed and pasteurized them and then stored the juice in beer barrels. It was briefly sold on the market, with even the White House sending over a car to buy some. "Within eighteen months something extraordinary happened, like nothing else before. Despite sterilization, the cider fermented, on the average, to six percent alcohol, so we had to take the drink off the market," he wrote. "This apple wine surpassed everything in

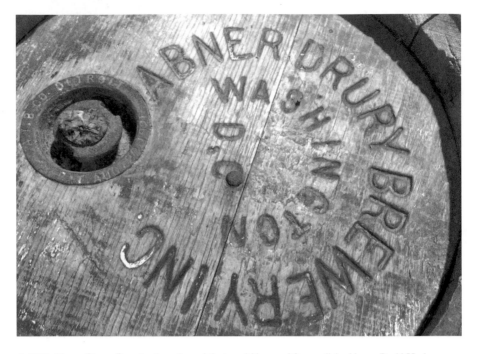

A 1921 Abner-Drury Brewing beer barrel that could be used for medicinal beer. *David Hagberg.*

quality; however, because of its alcohol content, we could not sell it." He put the barrels in storage, and there they sat during the entire duration of Prohibition. As we'll see, this did not end well.

A few blocks away, Abner-Drury shifted to making ginger ale and near beer (though the Volstead Act, the law that enforced Prohibition, forbade the use of that term). In order to make near beer, you first had to brew real beer and then use reverse osmosis to remove the alcohol. It's no wonder that beer leaked from surviving breweries around the country and ended up in the hands of bootleggers. Journalist and beer drinker H.L. Mencken wrote in *Heathen Days* that he got a regular supply from a Pennsylvania brewery. In 1921, Abner-Drury received a federal license to make real beer for medicinal purposes. Yes, medicinal beer.

Prohibition closed 267 licensed bars and saloons when Washington went dry. This cost the city $500,000 in tax revenue alone from annual licenses, as well as costing real estate owners considerable sums to repurpose their former saloons. The brewery owners weren't compensated for the loss of their investment either. Christian Heurich complained, "The buildings have been idle since 1917 when prohibition began in the District of Columbia,

but I still have to pay high taxes on them." He later added, "I will not speak of the 'blessing' of prohibition and the confiscation of several million dollars connected with it." Prohibition harmed the brewers considerably.

What to do with the two massive idle breweries on Capitol Hill became a central question. The Washington Brewery was demolished in 1924. In its place rose Stuart-Hobson Middle School, which opened three years later. National Capital Brewing had an ice plant, and Albert Carry decided to produce ice cream when local prohibition put an end to brewing in 1917. After just one year, he sold off Carry's Ice Cream and the facilities. The National Capital Brewing plant became the Meadowgold Dairy for four decades. It was demolished in the early 1960s, and a Safeway grocery store was built on the site in 1965. Carry died in 1925 at age seventy-two.

As I wrote in *Prohibition in Washington, D.C.*, the nation's capital was expected to be the "model dry city" for the rest of the country. But it was anything but a model. The city widely ignored dry law, and its inhabitants opened up to three thousand speakeasies while thousands of men and women bootlegged. Unfortunately, few of them bootlegged beer. The money was far better for gin and whiskey. As a result, Washingtonians got a taste for cocktails and forgot about beer.

Walter Davenport, a reporter for *Collier's*, came to Washington to investigate the drinking scene. In his subsequent article, "Bartender's Guide to Washington," published two days after the Valentine's Day Massacre in 1929, he noted that the city didn't have the big speakeasy nightclubs like New York and that the bootlegging culture was largely composed of amateurs and open to everyone. Davenport also noted that it was very hard to get a beer in the district. "Beer was noticeably absent from Washington's wetness," he wrote. He asked around, including a gentleman who was in the know, about where to get a drink. The man's response: "'Listen, kid,' said he loftily, 'this ain't no beer town. That's all.'"

We have thousands of stories of raids and arrests from Prohibition, but almost all of them involved distilled spirits like bathtub gin and moonshine. Few raids dealt specifically with beer. One of them was Hammel's lunchroom, a fixture in what later became the Federal Triangle at 922 Pennsylvania Avenue NW. Federal agents raided the place in April 1923, pulling barrel after barrel of beer out of the cellar. They returned in August 1932 and tested seventy gallons of ostensible near beer that Hammel's was selling. Upon discovering that it was the real thing, they demolished the restaurant and removed all the fixtures. Hammel's was acquitted on a technicality. It reopened and operated for decades more.

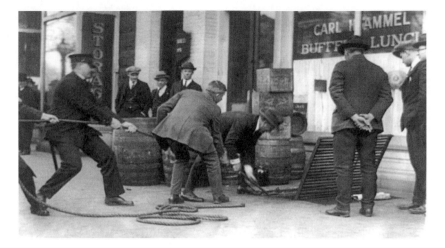

Federal agents remove beer from a raid on Carl Hammel's lunchroom in April 1923. *Library of Congress*.

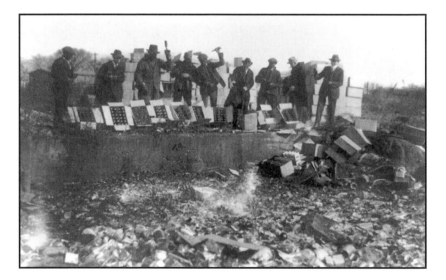

Some eighteen thousand bottles of intercepted Philadelphia beer being destroyed in the Arlington dump during Prohibition. *Library of Congress*.

In November 1923, a shipment of 749 cases of real beer was intercepted en route to Washington from Philadelphia. The judge overseeing the case ordered the 17,976 bottles destroyed. Prohibition Bureau agents took them to the Arlington dump and smashed them one by one.

In 2013, a new restaurant, Beuchert's Saloon (623 Pennsylvania Avenue SE), opened on Capitol Hill. While building the restaurant, the contractor found dozens of empty bottles and a pocket door leading to a "little back room" where liquor would have been dispensed during Prohibition. It was a common practice in many Washington businesses. John Ignatius Beuchert, a German immigrant, had opened a restaurant at the same site in 1880. It later became a Singer sewing shop, which served as the speakeasy's front during Prohibition. Sadly, the contractor threw the bottles away before telling the owners about what he found. You can imagine what heartbreak that caused a certain local author.

3.2 BEER AND THE END OF PROHIBITION

Prohibition had passed as a wartime measure, a Constitutional amendment whose disastrous consequences were not thought through. It took a second crisis—the Great Depression—and a wholesale political shift in Congress from dry Republicans to wet Democrats to change the Constitution back. The Democrats ran on a repeal platform in 1930 and 1932. Franklin Delano Roosevelt, the Democratic presidential candidate, made a campaign promise that he would legalize beer as soon as he got in the White House. Roosevelt was true to his word.

Congress passed the Cullen-Harrison Act, declaring that 3.2 percent beer was non-intoxicating and therefore didn't violate the Volstead Act. Roosevelt signed the law on March 22, 1933, and it would go into effect at midnight on April 7, giving brewers two weeks to get their beer ready. Yuengling delivered the first two cases of beer to the White House at 12:05 a.m., and the National Press Club soon got its first consignment, followed by clubs, hotels and restaurants throughout the city. People crowded the streets in the early hours of April 7, eager for a taste of legal beer. Most of the beer came from Baltimore—neither Abner-Drury nor Christian Heurich were ready to restart brewing.

The public elation at 3.2 beer demonstrated just how tired the country was of Prohibition. The noble experiment was doomed. The first state, Michigan, voted for repeal three days later. It would take only eight months to get the Twenty-first Amendment ratified by thirty-six states. The country eagerly wanted Prohibition to end.

Prohibition had shut down all six of the Washington area's breweries. Only two of them reopened after repeal: Abner-Drury and Christian

President Franklin Delano Roosevelt signs the bill legalizing 3.2 percent beer. *Library of Congress.*

Heurich, both of them in Foggy Bottom. The breweries quickly stocked up on bottles, hops and malt as they jump-started their brewing operations after so many years of idleness.

When Prohibition ended in 1933, Christian Heurich was ninety-one years old. He was very proud of having received a telegram from German president Paul von Hindenburg on the occasion of his ninetieth birthday the year before. Heurich was still running the business, and he began again in May 1933. Gary Heurich, a grandson to the brewer, later wrote, "He said that he wanted to make it good, not fast. His first beer was not put on the market until August 2, 1933, his 60th anniversary as a brewer" in Washington.

Heurich had to make an agonizing business decision, as he had sixty thousand gallons of alcoholic apple cider (Liberty Apple Champagne) stored in his cellars for the past sixteen years. At 6 percent, it was too high in alcohol to sell on the market, yet Heurich needed the cellar space to age his lager. He ordered the drink poured down the drain to make room for beer. "It was an enormous loss," Heurich wrote ruefully.

Two months before Prohibition ended on December 5, 1933, *Washington Post* commentator John Daly wrote optimistically that with beer now legal, beer gardens might spring up again. "It seems on the verge of coming back," he wrote. Alas, that was not to be. You might be thinking that repeal brought in a new wave of beer drinking, but no. The market had permanently changed. Brewers were in for a rude surprise.

CHAPTER 8
THE FIZZ FALLS FLAT

Most American brewers had gone out of business because of Prohibition. Those few that remained found other ways to make do during the "noble experiment." Some made malt extract or near beer, while others switched to ice cream or soft drinks and still others, such as Christian Heurich, made ice. Anheuser-Busch survived by making yeast.

When Prohibition ended, there were about 750 remaining breweries around the country. Over the next two decades, this number shrank significantly because of consolidation, declining consumer demand for beer and the rise of national marketing that squeezed the local brewers. By the time the Christian Heurich Brewing Company closed in 1956, there were only about 350 breweries still operating—and that number shrank to 89 by 1978. The local brewers were a dying breed, replaced by three big national brewing companies—Anheuser-Busch, Pabst and Schlitz—that competed fiercely on price. Consumers who swore they drank only local brews were gradually drawn to the big three.

What emerged after Prohibition was a fizzy, tasteless, watery beer known as light lager. Budweiser and the others were once quality beers, but over the years, the national brewers learned ways to shorten the brewing process and to cut corners. Their products became ever more bland in order to reach the lowest common denominator. Light lager is still the majority of what you find in the grocery store today. It is more known for being refreshing than for its character or taste.

The two surviving Washington breweries, Abner-Drury and Christian Heurich, rapidly discovered that consumer tastes and the Great Depression had permanently changed the beer market. The expected surge in demand just wasn't there. Abner-Drury filed for bankruptcy on July 1, 1935, less than two years after repeal. It attempted to reorganize as the Washington Brewery, but business didn't improve. The owners closed the doors in 1937 and auctioned off the plant the following year. The facilities became the Gichner Iron Works during World War II but were demolished in 1962 to make way for the street grid near the Watergate complex and the Kennedy Center.

The other surviving brewer, Christian Heurich, was astonished to see that the beer market had been fundamentally altered. "We made every effort not to have a shortage of beer, but soon we discovered that the public had forgotten about drinking beer!" he wrote. "Our sales increased slowly, but they were nothing in comparison to our sales before prohibition."

Why had the demand for beer declined so much? The United States was a greatly changed country in 1933 compared to 1917. Consumers had fundamentally changed their drinking habits during Prohibition, and their old habits wouldn't return. They had gotten a taste for rotgut gin-based cocktails and had discovered other non-alcoholic beverages to drink, such as Coca-Cola and RC Cola. People also had other ways to enjoy their evenings, such as going to the movies. The beer gardens were permanently closed, and that was where much of the beer had been consumed. Consumers were more likely to drink at home and buy beer at the supermarket, and to further that along, brewers introduced canned beer in 1935. It was now forbidden for most Americans to drink alcohol during the workday, meaning that working-class men at construction sites and in factories were no longer sipping suds with their baloney sandwiches. And with the Great Depression, many consumers simply didn't have the money to spend on beer. It was an unaffordable luxury, even at five cents a pint.

After Prohibition, most states and the District of Columbia established a new way to regulate alcohol. They wanted greater control to end the vertical integration of the industry. It was called the three-tier system, as it involved producers, wholesalers and retailers. Producers had to sell to a wholesaler, which then distributed the beer to retailers, who then sold it to consumers in a bar, restaurant or store. Brewers could no longer sell directly to consumers—the tied-house saloon model was deliberately shattered.

Complicating things in Virginia is that there is no such thing as a standalone bar. In the effort to ensure that saloon culture would not reemerge after

Prohibition, the state banned bar-only establishments. Any bar must get a portion of its revenue from selling food. In other words, if you want to have a bar, it must be part of a restaurant.

HEURICH'S FINAL YEARS

The Heurich brewery had its own Bonnie-and-Clyde moment when it was held up in October 1933 while the World Series was being played at Griffith Stadium. Christian Heurich Jr. had just returned to the brewery after watching the game when the chief engineer ran out shouting, "There's a holdup in the office!" Heurich had just missed the robbery. Two men had forced their way into the office at gunpoint and stole the canvas bag with that day's cash earnings of $1,600.

The stickup was led by Arthur "Big Dutch" Misunas, a leader in the Tri-State gang. He was later arrested and turned state's witness against the other gang members. Accompanied by two detectives, he visited the Heurich brewery, signed the guest registry and had a beer while explaining how he had cased the brewery and pulled off the heist. Misunas was convicted in 1934, along with the other members of the gang.

Heurich was one of the largest private employers in the city. He did employ African American workers, but largely in low-wage jobs. The Brewery Workers Union was whites-only at the time, and the better paying jobs were reserved for their members. In 1940, however, the New Negro Alliance protested that black workers weren't given the same opportunities for good paying jobs. Heurich agreed to open 140 positions to black truck drivers.

When Germany invaded Poland on September 1, 1939, starting World War II, Heurich found himself in Europe on his annual vacation, just as he had been at the outbreak of the First World War. He made his way to Denmark and boarded a ship to the United States. He returned home to a country that had changed considerably in the two decades after Prohibition started. When World War II broke out, there wasn't the anti-German hysteria that Heurich and others experienced during the previous war. No one accused the brewers of being unpatriotic or treasonous (instead, the racial mistreatment was directed toward the Japanese), and the brewers themselves were expected to brew beer for the war effort.

Christian Heurich Jr. was running more of the operations, though his father remained involved in the day-to-day management. The *Washington Times-Herald*

Christian Heurich (left) and son Christian Heurich Jr. at their brewery. *Heurich House Museum.*

celebrated Heurich's seventy-fifth year in brewing with a special section in the newspaper on June 6, 1940. He shut down the ice plant, the facility that had kept him in business during Prohibition, that same year.

In 1942, at age one hundred, Heurich engaged writer W.A.S. Douglas to write down his life reminiscences, a three-volume unpublished manuscript called *I Watched America Grow* that now sits in the Heurich House Museum archives. It covered surprisingly little about brewing, focusing more on his impressions of economic development, political crises, social change and war. Much had changed over the course of Heurich's century.

Christian Heurich died on March 7, 1945, at his Dupont Circle home, just shy of his 103rd birthday. He had spent nearly ninety years brewing beer, and he had worked until nine days before his death. "That I was six times engaged and three times married, each time happily, is more than good luck," he wrote. He concluded in his memoirs, "This is my life, and if it was much, it was trouble and work."

Heurich had owned considerable property, and the estate taxes were high. He left his wife, Amelia, $5,000 in annual annuity to run the Heurich House, which wasn't nearly enough to cover the costs of an aging mansion. In 1951, Amelia sold the family's dairy farm, Bellevue, to a developer; the site is now Prince Georges Plaza. Her husband had been buried there six years before, so she moved the family vault to Rock Creek Cemetery.

Christian Heurich Jr. took the reins of the company. He ran the brewery for the next ten years. Jan Evans believes it was her grandmother Amelia who pushed Christian Jr. (who went by Chris) into brewing, which he may have not been suited for. He rolled out several new brands in the 1940s, including Capital Beer, Champeer Malt Liquor and Old Georgetown.

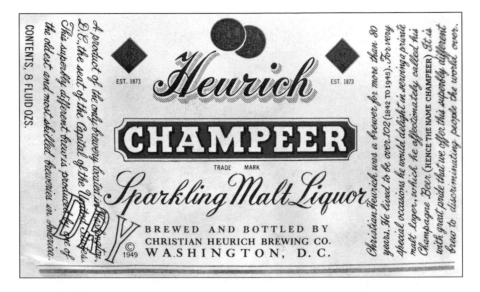

A rare label from Christian Heurich's short-lived Champeer malt liquor. From the Heurich House Museum collection. *Garrett Peck.*

Knowing that beer has been (and sadly, still is) largely viewed as a man's beverage, Christian Heurich Jr. attempted to bring a product to market in 1949 that might appeal to women. Champeer was born, a sparkling malt liquor that was effervescent like champagne. Heurich advertisements claimed, "If you haven't tasted Champeer, you haven't enjoyed the most exciting different drink since Repeal." The problem was that it potentially infringed on a trademark. Champale, made by the Metropolis Brewing Company of Trenton, New Jersey, had introduced its malt liquor in 1939. Champeer sounded too close to Champale, so the company attempted to place a court-ordered injunction against Heurich. Heurich won in court but agreed to cancel production the following year.

Baseball and beer are as American as mom and apple pie, but Washington Senators owner Clark Griffith though otherwise. An ardent prohibitionist, he banned beer sales at Griffith Stadium, stating that "beer and baseball don't go together." He died in 1955, and in August 1956, a beer garden opened in the stadium bleachers in time for a game against the Boston Red Sox. This left Philadelphia and Pittsburgh as the only two remaining Major League baseball stadiums that didn't sell beer.

Sportscaster Bob Wolff got his seven-decade-long career started in 1947 by announcing Washington Senators baseball games for WTTG-TV. He began his memoirs, *It's Not Who Won or Lost the Game—It's How You Sold the*

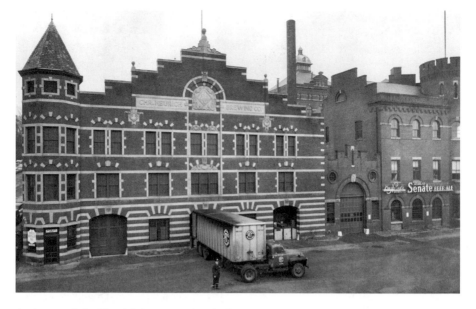

An image of the Heurich brewery taken in January 1956—its last month of operation. *Reprinted with permission of the DC Public Library, Star Collection,* © Washington Post.

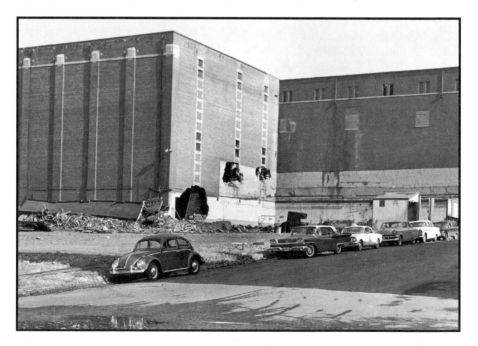

Heurich's icehouse was built so strong that it resisted the wrecking ball in November 1961. Demolition experts resorted to dynamite. *Reprinted with permission of the DC Public Library, Star Collection,* © Washington Post.

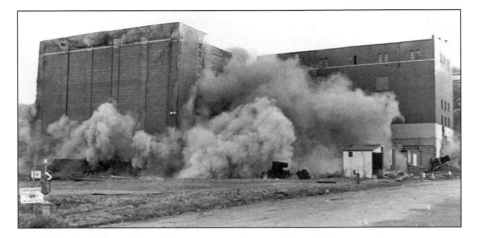

Dynamite explodes at Heurich's icehouse, the building that helped the brewery weather Prohibition. *Reprinted with permission of the DC Public Library, Star Collection,* © Washington Post.

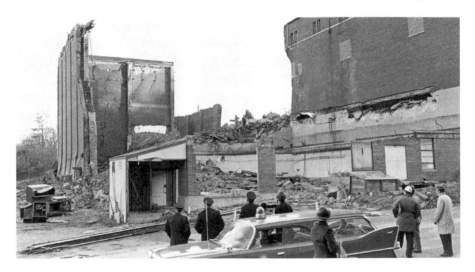

Three days of dynamiting took down Heurich's icehouse in November 1961. *Reprinted with permission of the DC Public Library, Star Collection,* © Washington Post.

Beer (1996), by telling how beer nearly became his undoing. Christian Heurich ran commercials for Old Georgetown, and announcer Johnny Batchelder demonstrated how delicious the beer was at the end of each inning by drinking half a glass on camera. A single game was fine, but double-headers in August became problematic. "By the middle of the second game (and after a dozen

or so beer commercials), John would be holding the glass of beer in one hand and gripping a rail for support with the other," Wolff wrote.

Wolff came up with an idea that is commonly used at wine tastings: a spit bucket. Batchelder would take a swig of beer, wait until the camera turned off and then spit the beer out. This worked fine until Batchelder spit while the camera was still rolling. "Viewers who had just heard his glowing endorsement of Old Georgetown now watched in amazement as Johnny spat a stream of amber suds into the bucket," Wolff wrote. "I don't remember who won the game, but I know we lost the sponsor. Those suds went right down the drain and took us with them." Fortunately, they found a new sponsor, Baltimore-based National Brewing Company, which made National Bohemian ("Natty Boh").

Allowing retail beer sales at Griffith Stadium came too late for local beer as Heurich closed in 1956. The company was having a difficult time competing against the national beer brands, with their deeper pockets and national marketing campaigns, and beer consumption kept declining. The federal government had its eye on the brewery property for a new bridge into the city (the Theodore Roosevelt Bridge) and would later add a performing arts center along the Potomac. Amelia Heurich, Christian's widow and the family matriarch, told her son, "If you think poppa would do that, go ahead." The board yielded to the inevitable and voted in the fall of 1955 to close the company the following January.

The Heurich family donated and sold the brewery property along the Potomac River to the federal government. For five years, Arena Stage made its home in the vacant brewery (the theater was nicknamed the Old Vat). The brewery would make way for the John F. Kennedy Center for the Performing Arts. The icehouse was dynamited over three days in November 1961, as its walls were so thick that they resisted the wrecking ball. The brewery itself came down three months later. The following year, the remains of the Abner-Drury Brewing Company were torn down as well. And with that, the last brewing structures were destroyed.

The breweries were striking facilities. Not only were they large in size, but often their architecture was Romanesque Revival, one of the chief styles of the Victorian era. These were anything but plain factories. For a glimpse of pre-Prohibition brewing facilities, you'd have to travel to Boston to see the Boston Beer Company's flagship site in the old Haffenreffer Brewery; to St. Louis to see Anheuser-Busch's headquarters; or, above all, to Cincinnati to see the Over-the-Rhine District, with its dozens of former breweries in an amazing time capsule. Washington unfortunately preserved almost none of its brewing architecture.

A Heady History of Brewing in Washington, D.C.

There is little trace of Washington's brewing past or how important the industry was to a city where the brewers were the second-largest employer after the federal government. Besides old photographs, all we have left are the Heurich House Museum, the old Schlitz bottling plant in Eckington and three ancillary buildings near the Tivoli Brewery in Alexandria—and the bottles, cans, trays and advertising artwork that collectors cherish. These were all artifacts from another era, that of the tied-house saloon.

When a company or an industry dies, anything produced by that company becomes finite and very collectable. There is an entire cottage industry devoted to collecting brewery treasures; it's known as Breweriana. In the Washington area, several groups exist that focus on our brewing past. The DC Collectors meet informally in members' homes, sharing their latest finds and trading objects. They find many collectors items at antique stores, trade shows and online stores such as eBay. One member, Jack Blush, turned part of his basement into a Heurich museum with what is probably the largest Heurich Breweriana collection around. He graciously allowed the Heurich House Museum to catalogue his collection. Another group, the Potomac Bottle Collectors, collects the beer and soda water bottles that the brewers so fastidiously retrieved from their customers.

Adventures in East Germany

In 1979, Jan Evans wanted to visit the sites where her grandfather Christian Heurich grew up in Haina and Roemhild. Both towns were in East Germany, and the Cold War was on. She took her daughter Louise to do the driving. At the border crossing, they were interrogated for more than two hours before being told where to stay. They were followed.

Jan and Louise visited Haina first. "The buildings were all in terrible condition," she remarked. Jan spoke to the minister at the town church, a one-armed World War II veteran, who was pleased to meet them and showed them around the little town. She saw the modest castle where Christian had learned to wait tables for minor nobility as a teenager. They then visited Roemhild and the museum that he had founded. "I didn't identify myself—I was scared," Jan said. The building was heated and in good condition, unlike many other buildings they saw.

Somehow along the way, they lost their security tail. When Jan and Louise arrived at the hotel, the innkeeper told them that the police wanted

to know where they were. Four policemen guarded the premises, giving them a feeling of being under constant surveillance. They woke early the next morning. It was snowing. Jan determined to drive straight to West Berlin without stopping, so eager was she to get out of East Germany. "We were so glad to get there!" she said with audible relief.

"When we got to the United States, there was a real 'hurrah!' on the plane," Jan said before tearing up. She explained how much Americans take their freedom for granted when people like the Germans were repressed by their own regime for so long. The Berlin Wall came down peacefully ten years after her visit, and now Haina and Roemhild are easy to visit for anyone who wants to make the Christian Heurich pilgrimage to Germany.

SAVING THE HEURICH HOUSE

Amelia Heurich donated the Heurich House to the Columbia Historical Society in 1955 before she died on January 24, 1956, at age eighty-nine. The Christian Heurich Brewing Company closed seven days later. The house remained the historical society's headquarters until 2003, when it relocated to the former Carnegie Library at Mount Vernon Square as the Historical Society of Washington, D.C. (HSW).

Amelia's gift didn't provide any money for the house's upkeep. "I realized I'd better go on the board of the historical society to make sure they didn't sell it," Jan Evans said. She remained on the board for forty-seven years.

Gary Heurich, Jan Evans's cousin, was also on the board, serving as the chairman. When the historical society moved to the Carnegie Library in 2003, it put the Heurich House up for sale. Jan had rotated off the board by then, but she quickly mustered her resources to preserve the mansion. "Gary Heurich and I were the only two in the family who cared about the house," she remarked. Together the cousins established the Heurich House Foundation, a nonprofit organization that owns and operates the house as a museum. "If I hadn't had his help, I couldn't have done it myself."

In the years since then, Christian Heurich's descendants and former brewery employees have donated furniture and personal items to the Heurich House Museum, such that it now has quite the collection from Washington's leading brewer. It's a unique house in Washington, with its Victorian architecture and original furnishings. It shows how much money

there once was in brewing. The house is open to the public for tours and special events.

The Heurich House Museum is now a nonprofit organization with a board of directors. Kimberly Bender became the museum's executive director in 2011. "I was a miserable lawyer," she joked. Her tenure as director began at a fortunate time, just as the first production breweries were reopening in the city. This has helped spur interest in the Heurich House and has allowed the house to showcase the many local brewers and businesses that have emerged. "A museum can't be alive unless it's part of the community," Bender said.

In an era when house museum tours are considered blasé and unengaging to a younger generation that grew up with smartphones and video games, the Heurich House has succeeded in bringing in a diverse audience. "We're trying to present all this information in a fun and interesting way," said Bender. It helps that public interest in beer and local brewing history has grown.

Bender and her staff organize public events that are authentic to Christian Heurich's interests. The monthly History & Hops program features craft beer tastings and local history ("Obviously because he was a brewer," Bender pointed out), live music, movies, Oktoberfest, a German Christmas market and craft fair and even yoga. (Heurich was a bit of a spiritualist and believed in holistic healing.)

"The longer that I'm here, the more I get to know the Heurichs," Bender said. "It took me a while to realize that Mathilde [Heurich's socialite second wife] designed the house." Heurich's third wife, Amelia, had little patience for the social scene and instead wanted a structured domestic life. "People think it's such a formal house. But that's not what this place was like," Bender said. Today, the Heurich House Museum is part of the fabric of Washington's unique identity.

When the Christian Heurich Brewing Company closed in 1956, brewing in Washington came to an end. The nation's capital became known for cocktails and wine, and its once-famous beers were forgotten. Yet that isn't the end of the story. It would take fifty-five years before another brewery appeared in the city. Resurrecting a dead industry would be anything but easy.

CHAPTER 9

WHERE ARE THE BREWERS BURIED?

The many brewers from Washington's extensive brewing history are buried in cemeteries throughout the city, although the lion's shares are in Congressional Cemetery and Prospect Hill. In 1852, the City of Washington passed an ordinance banning new cemeteries from being created within the city limits. New cemeteries had to be established beyond Boundary Road (now Florida Avenue).

This is by no means a comprehensive list. The final resting places of many brewers aren't known, as not all cemetery records have been digitized. And not all brewers are buried locally. For example, the city of Washington's first brewer, Dr. Cornelius Coningham, is buried in Cedar Grove Cemetery in New London, Connecticut.

DISTRICT OF COLUMBIA CEMETERIES

Congressional Cemetery
1801 E Street SE

Founded in 1807 as Washington's unofficial national cemetery, Congressional Cemetery is the final resting place for many of the early Capitol Hill brewers.

George (1810–1859) and Theresa Beckert (1813–1889) ran Beckert's Park on Capitol Hill, and Theresa ran Beckert's Garden after her husband's death. George may have been the first brewer to produce lager in Washington. (R82/220 and 219)

Hattie Berkley (died 1895), thirteen years old, was riding a bicycle on April 4, 1895, when she collided with a National Capital Brewing delivery wagon at Ninth and Pennsylvania Avenue SE, fractured her skull and soon died. (R3/115)

Moses T. Bridwell (died 1892) was a bottler in Southwest. (R98/226)

George Rothwell Brown (died 1960), was a *Washington Post* columnist and author of *Washington: A Not Too Serious History* (1930), which told the history of many bars and saloons in the city. (R45/83)

John W. Collet (died 1814) was the second owner of the Washington Brewery near the Navy Yard and thus the second brewer in Washington. (R26/20)

Clement T. Coote (1784–1849) was an English immigrant, the fourth operator of the Washington Brewery near the Navy Yard and a city alderman. (R54/59)

Francis Frommell (died 1866) operated a brewery at 504 D Street SE from 1864 until his death two years later. (R82/187—no headstone)

James Greenleaf (1765–1843) was Dr. Cornelius Conningham's business partner for the Washington Brewery, the first brewery in the city of Washington. (R49/23)

Thomas Gunton (died 1853) was born in England and brewed beer at the Washington Brewery with his brother William from 1826 to 1832. (R51/163)

William A. Gunton (died 1854) was born in England, ran a drugstore at Pennsylvania and Ninth Street and brewed beer at the Washington Brewery with his brother Thomas from 1826 to 1832. (R51/155)

Daniel Rapine (died 1826) was Washington's second mayor, lived on Capitol Hill and owned a bookstore that sold Washington Brewery beer. (R54/6—no headstone)

Herman Richter (died 1874), whose white obelisk is just inches away from Theresa Beckert's grave, was one of the two Beckert sons-in-law who took over the brewery after George died. (R82/217)

Jacob Roth (died 1888) ran a Capitol Hill brewery at 318 First Street NE. (R83/228)

Edwin Ryther (died January 20, 1875) purchased the Arlington Brewery with a business partner in 1874 and briefly ran it until his death less than a year later. (R82/280)

The remains of Henry Schoenborn (1833–1896), another Beckert son-in-law and business partner to Herman Richter, were placed in the Public Vault briefly after his death and then relocated to Oak Hill Cemetery in Georgetown.

William Seaton (1785–1866) was a former mayor of Washington whose mansion Edward Abner tore down to build a beer garden. (R57/165)

William Sydnor (died 1872), a driver for Whitney & Lander's Brewery, was conducting his daily rounds on July 5 when he died from the heat. (R91/251)

George Wilson (died November 15, 1910) ran the Arlington Brewery in 1873–74. He moved to Washington from Massachusetts during the Civil War. (R138/181)

William Zanner (died 1911) owned first a brewery, then a beer bottling operation in Southwest. (R12/114)

The graves of George and Theresa Beckert in Congressional Cemetery. Their son-in-law Hermann Richter's grave is the obelisk to the right. George may well have been the first brewer to produce lager in Washington, D.C. *Garrett Peck.*

Glenwood Cemetery
2219 Lincoln Road NE

Ernst Loeffler (1822–1885) was a brewery owner and beer garden purveyor.

Mount Olivet Cemetery
1300 Bladensburg Road NE

Established in 1858, Mount Olivet is a Catholic cemetery on a prominent hill overlooking Washington. It has a remarkable view of the city. A number of Catholic brewers were buried there.

Albert Carry (1852–1925) and his family are buried in a large Greek-style mausoleum. Carry owned the National Capital Brewing Company. (41/2)

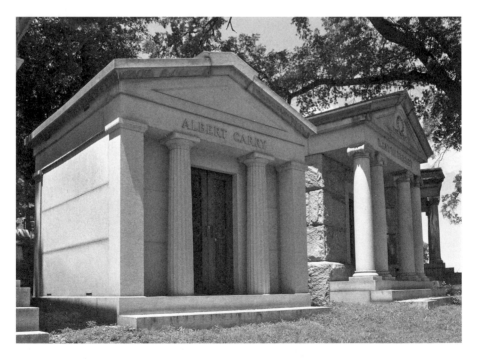

The Albert Carry family vault in Mount Olivet Cemetery. *Garrett Peck.*

Peter Drury (1864–1942) and his family are buried in a large vault just three down from the Carry family. Drury co-owned the Abner-Drury Brewing Company in Foggy Bottom. (41/9)

George (1823–1884) and Barbara Juenemann (1832–1904) and son George Jr. (died 1889) have a white obelisk marking their family grave. They operated the Mount Vernon Lager Beer Brewery and Pleasure Garden. (25/11)

Oak Hill Cemetery
3001 R Street NW

Henry Schoenborn (1833–1896), a son-in-law of George and Theresa Beckert, ran the Beckert's brewery with Herman Richter after George died. His remains were briefly kept in the Public Vault at Congressional Cemetery before final burial at Oak Hill.

Prospect Hill Cemetery
2201 North Capitol Street NE

Prospect Hill was founded in 1858 as a German American cemetery. It is testament to nineteenth-century German immigration to the United States. In addition to brewers, a large number of Germans who ran restaurants and saloons are buried at Prospect Hill.

Edward Abner (1834–1913) was a Union army caterer during the Civil War and became a partner in Robert Portner's first brewery before openeing a series of beer gardens and restaurants in Washington. (C-28-15)

Edward F. Abner (1864–1912) purchased the Albert Brewery in Foggy Bottom in 1897 and expanded it into the Abner-Drury Brewing Co. His uncle was Edward Abner. (D-203-1)

Louis Beyer (1827–1904) purchased the Metropolitan Brewery in 1864, only to see it go bankrupt in the post–Civil War brewing slump. (C-29-16)

John Eller (1849–1929) owned Kozel's Brewery in the 1880s. (D-253-6)

Charles E. Engels (1866–1912) was a Rum Row restaurateur and nephew of Edward Abner. (C-20-2)

Ernst Gerstenberg (1888–1955) was a Rum Row restaurateur and beer garden purveyor. *Washington Post* columnist George Rothwell Brown called Gerstenberg's restaurant the "University of Gerstenberg." (H-73-16)

John Guethler (1847–1888) ran the Navy Yard Brewery from 1882 to 1886. (D-97-3)

Henry A. Kaiser (1836–1900) was a restaurateur and owned a Civil War–era brewery in Georgetown. (B-156-6)

John Kessel (1830–1873) ran a Civil War–era brewery with Ferdinand Stosch. (B-136-8)

Edward Kolb (1844–1919) was the purveyor of Kolb's Beer Garden at 811 E Street NW. (E-1-1)

John Kozel (1821–1881) operated Kozel's Brewery at 143 N Street NW, which was known for its Weiss beer. He was one of the first to brew lager in Washington. (C-31-4)

Charles Losekam (1846–1886) was born in Worms, Germany, and ran a well-known restaurant, The Losekam, at 1323 F Street NW. (I-28-13)

Louis Schoeplen (1833–1877) ran a brewery on Seventh Street NW. (B-122-3)

William Shoomaker (1834–1884) owned the most storied saloon in Washington's history, Shoomaker's. (C-66-12)

Rock Creek Cemetery
201 Allison Street NW

Rock Creek Cemetery is known as the burial ground for many of Washington's elites and includes the famous Adams Memorial by sculptor Augustus St. Gaudens.

In 1951, Christian Heurich's family vault was moved to Rock Creek Cemetery from the family farm in Prince George's County, Maryland. *Garrett Peck.*

William Hayman (died 1842) partnered with Daniel Bussard to operate the Georgetown Brewery. He was initially interred in the Presbyterian Burying Grounds (now Volta Park) but was reinterred at Rock Creek Cemetery in 1890. (C/146)

Christian Heurich (1842–1945) was the owner of Washington's largest brewery. Heurich built the vault for his second wife, Mathilde, at his Bellevue Farm in Prince Georges County, but the family had it moved to Rock Creek Cemetery in 1951. His third wife, Amelia, was interred there in 1956 and son Christian Jr. in 1979. His daughter Anita is buried next to the mausoleum. (30/43)

Charles Jacobsen (1860–1953) was Christian Heurich's nephew and ran the Arlington Bottling Company. (G/18/3)

George F. Kozel (died 1907) briefly owned Kozel's Brewery and later ran a successful beer garden on Fourteenth Street. His home at 2233 Thirteenth Street NW still stands. (M/181/4)

St. Marys Catholic Cemetery
2121 Lincoln Road NE

John Ignatius Beuchert (1844–1914) was the proprietor of Beuchert's Saloon on Capitol Hill.

Anton Danhakl (1871–1916) owned the brewery at 124 N Street NW in its final years.

Christopher Dickson (1821–1914), a German immigrant who came to Washington in 1855, ran a brewery in Southwest until 1883.

VIRGINIA CEMETERIES

Christ Church Episcopal Cemetery
Wilkes Street Cemetery Complex
Alexandria, Virginia

James Irwin (1805–1857) jointly owned Irwin's Brewery with William Irwin.

Ivy Hill Cemetery
2823 King Street
Alexandria, Virginia

John Klein (died 1865) owned Klein's Brewery in Alexandria from 1858 to 1865 and, along with Alexander Strausz, was the first to brew lager in Alexandria. (G-85-1B)

Manassas Cemetery
Center Street
Manassas, Virginia

Robert Portner (1837–1906) ran the largest brewery in the South, the Tivoli Brewery in Alexandria, Virginia. He, his wife and many of their children are buried in a family plot directly opposite the Confederate Monument.

Robert Portner, wife Anna and many of their thirteen children are buried in the family plot at the Manassas Cemetery. *Garrett Peck.*

Old Presbyterian Meeting House
323 S. Fairfax Street
Alexandria, Virginia

Andrew Wales (ca. 1737–1799) opened the first brewery in Alexandria around 1770 and thus became technically the first brewer in the District of Columbia. He and his wife, Margaret, are buried in an unmarked grave in the churchyard.

St. Mary's Catholic Church Cemetery
S. Royal Street
Alexandria, Virginia

Henry Englehardt (1833–1898) owned Englehardt's Brewery in Alexandria until it burned down in 1893.

St. Paul's Episcopal Church Cemetery
Wilkes Street Cemetery Complex
Alexandria, Virginia

Isaac Entwisle (1772–1821) ran Entwisle's Brewery in Alexandria. (12–1)

James Entwisle Sr. (1796–1876), an English immigrant, inherited the Entwisle Brewery in Alexandria from his father, Isaac. (1–12)

Carl Strangmann (1860–1915) was Robert Portner's nephew and worked for the brewer. When Portner incorporated in 1883, Strangmann was added to the board and later served as secretary to the National Capital Brewing Co. board. He later purchased his own breweries, first in Cleveland and then in Buffalo. (3–109)

Washington Street United Methodist Church Cemetery (Union Cemetery)
Wilkes Street Cemetery Complex
Alexandria, Virginia

George Steuernagel (1828–1889) owned the Steuernagel Brewery in Alexandria.

CHAPTER 10

THE CRAFT REVIVAL

The craft beer revival stormed the country in the 1980s after President Jimmy Carter legalized home brewing. There were only ninety-two breweries in the country in 1980, but that number exploded to 2,347 by 2012, according to the Brewers Association. Craft beer makes up about 7 percent of the American beer market, but it is growing at a healthy clip while the legacy national brands like Budweiser and Miller Lite are stagnating or shrinking.

Modern craft brewing began in Northern California in the 1970s with brewers such as Fritz Maytag of Anchor Steam and Ken Grossman of the Sierra Nevada Brewing Company. The most successful craft brewer is Jim Koch, founder of the Boston Brewing Company, which makes Samuel Adams Boston Lager. The Brewers Association definition of a craft brewer is a brewer that produces no more than 6 million barrels of beer each year. That number was raised in recent years to keep the Boston Brewing Company as a craft brewer.

Unlike the major brewers, microbreweries aren't as concerned with market share. They know they'll never have much of it, yet they can certainly run a successful business by pleasing their local consumers. Local brewers do little advertising due to budget restrictions, though they do utilize social media (what I call the "poor person's publicist"). They rely on brewery tours, events, tastings and word-of-mouth marketing to develop their fan base.

Craft breweries don't compete on price—you will pay more for, say, Port City Optimal Wit than for Miller Lite. They use better and more expensive ingredients, and their cost model is different from that of a national brewery.

"People are looking for more flavor. It's not about getting drunk," remarked Bill Butcher of Port City. "They're truly interested in the process and learning how it's made." When local breweries open for tastings and tours, they can be mobbed with crowds.

Craft brewers have stayed away from the "light" or "lite" beers, the low-calorie beers made by the national brewers like Bud Light and Miller Lite. Instead, microbreweries sometimes produce session beers—beers that are lower in alcohol or not so heavy, allowing the consumer to have more than just one or two. Bars once offered only a handful of beers, often just the national brands. "Now you can't find a place that doesn't have craft beer on tap," said Brandon Skall of DC Brau.

Today's craft beer tastes different than yesterday's beer, as palates have changed considerably. Beer evolves to match what consumers want. Consumers are increasingly rejecting bland beer for full-flavored, complex brews, whether they be hoppy IPAs, clean and zesty pilsners, coffee-flavored porters, funky barnyard-flavored Belgians or malty, copper-colored ales. Character counts.

WASHINGTON'S SLOW BREWING REVIVAL

The District of Columbia legalized brewpubs in 1991. The following August, entrepreneur David von Storch opened the first brewpub in the nation's capital since Prohibition: Capitol City Brewing. It opened where it still stands today, at 1100 New York Avenue NW. One of von Storch's crucial hires was brewer Bill Madden, who designed the brewing facilities and introduced the city to Kölsch (or Kolsch, as Cap City spells it). His layout for the glassy Shirlington brewhouse is still in use.

"When Cap City opened in August 1992, we were part of an explosion of brewpubs opening across the country," von Storch recalled. "It was a time when a lot of ill-conceived brewpubs were opening, and closing, all over the country and in D.C. as well. By the end of the 1990s, the bloom was definitely off the rose, and the craft brewing industry in D.C. was pretty dormant." Bill Madden (now at Mad Fox Brewing) noted how much has changed over two decades: "We've seen a lot come and go. There was a lot that went on that we've forgotten."

When I first moved to the Washington area in 1994, there was a singular, quirky destination to drink craft beer: Bardo Rodeo, an Arlington brewpub

in the cavernous former Oldmstead Oldsmobile dealership at 2000 Wilson Boulevard. To complete the car theme, it looked like a Plymouth Fury was driving through the front entrance; the car doubled as the jukebox. A beer-sipping totem pole stood out front ("It's art!" owner Bill Stewart told the county when challenged for having inappropriate signage; the totem pole remained). Arcade games, picnic tables and pool tables covered the floor, which could hold more than nine hundred people. The brewing equipment was stored outside, and the place could brew two thousand barrels of beer each year.

Bardo was a large facility, and the rent was high (Stewart paid $16,000 per month for a decaying building). He felt harassed by the county, which sent building inspectors to document problems. He ended up closing Bardo in 1999 when the back half of the property was condemned. Stewart reopened the brewpub as Dr. Dremo's Taphouse on a smaller footprint but removed the brewing equipment, making it a bar. The property values then rose so dramatically that Dr. Dremo's closed for good in 2008 to make way for luxury apartments. Stewart is still bitter, noting that "Arlington County drove Bardo

The beer-sipping totem pole that stood outside Bardo and Dr. Dremo's Taphouse in Arlington. *Thomas Cizauskas.*

out of Arlington County." He put his brewing equipment in storage and left the United States. But that would not be the end of Bardo.

Another high-profile brewing venture was founded by none other than Gary Heurich, one of Christian Heurich's grandchildren. In 1986, he opened the Olde Heurich Brewing Company. The beer wasn't brewed locally but rather contract brewed in upstate New York. It offered Foggy Bottom, Old Georgetown and Senate beers, harkening back to the era when the Christian Heurich Brewing Company once thrived. When baseball returned to Washington in 2005, Olde Heurich's beer was offered at RFK Stadium. Gary closed the business in 2006 after twenty years. He left Washington, frustrated with the experience. "It's a sad thing," he told the *Washington Post*. "I kept it going because I was dedicated to the idea that we should have a hometown thing. But we lost money every year for 20 years." Craft beer seemed to fail to take hold in the city despite the explosive growth of craft brewers around the country.

A lone outpost kept the dream alive for good beer options: the Brickskeller. It opened near Dupont Circle in 1957, one year after the original Heurich brewery closed. It earned the Guinness World Record for the largest beer menu. The Brickskeller's owner, Dave Alexander, sold the location in 2010, at which time it became the Bier Baron—though little about the bar changed, including its massive collection of antique beer cans on the walls.

Greg Engert, who started with the Neighborhood Restaurant Group in 2006 and oversees the beer program at their locales, worked at the Brickskeller earlier in his career. He noted that it is one of the most influential beer bars in the country. "It was an opportunity for me to meet everyone in the beer world. Everyone came to the Brickskeller," Engert said. "The brewers and the writers were really important," he noted, as they educated customers on the nuances of craft beer. Added to that was the fact that the city's population began to rise again in the 2000s as young, well-paid, college educated adults settled in the city (we refer to them as "hipsters").

Barrett Lauer of the District ChopHouse likewise credits the Brickskeller for introducing Washingtonians to better beer. The Brickskeller was where he drank his very first beer in a bar, and he remembers the experience quite well. "The Brickskeller helped elevate palates and feed the craft beer movement," he said.

In recent years, other craft beer–oriented bars opened, giving consumers more options to sample good suds. Pizzeria Paradiso became a Belgian beer and home-brew destination, thanks to Thor Cheston. Meridian Pint opened in Columbia Heights, the Iron Horse became a downtown craft

beer taproom and Rustico widened craft beer's appeal in Alexandria and Arlington. Barrett Lauer noted that Washington's beer market "has grown enormously with depth and breadth. You can almost get anything you want from around the world."

Beer festivals began popping up around the city, such as the DC Beer Festival, DC Beer Week, Savor, Snallygaster and the ubiquitous Oktoberfest celebrations. What is missing, however, is a good springtime Bock festival.

Bill Stewart of Bardo calls the current revival Beer 2.0, a period similar to the period after the Internet crash of 2000. Breweries are now founded on more realistic business objectives. "In the past five years, interest in craft brewing at the local level has rebounded and taken off at an even higher velocity than when the brewpub craze was in full swing," observed David von Storch of Capitol City.

National brewpub chains established themselves in the Washington area to tap into the demand. Founded in 1988, Hops Restaurant Bar & Brewery was the first national brewpub chain. Others followed, such as John Harvard's, Gordon Biersch and Rock Bottom. The latter two are owned by CraftWorks, which also owns the District ChopHouse & Brewery.

Craft beer's popularity rebounded as an outgrowth of the Great Recession. Washington had long been a cocktail and wine city, especially for those with clients and expense accounts, but the recession reined in that behavior. People began looking for less expensive luxuries, and they found it in craft beer. Some restaurants now employ a "cicerone," the brewing equivalent of a sommelier.

Interest in beer had a strong undercurrent, even if it wasn't always obvious. In 2007, the beer columnist for the *Washington Post*, Greg Kitsock, started Beer Madness, freely borrowing from college basketball's March Madness. This places thirty-two beers in category brackets in which they compete against each other with a blind taste-testing panel until a winner emerges. In 2013, for the first time ever, every beer was locally made (if you include the District of Columbia, Delaware, Maryland and Virginia as local). It showed how much Mid-Atlantic beers have risen to prominence in just a few years. Kitsock dryly noted, "Washington isn't Milwaukee-on-the-Potomac. Not yet."

A signature moment occurred in 2009 when Greg Engert opened his dream bar ChurchKey in Logan Circle. It had 555 different craft labels and the first three-gauge temperature-controlled distribution system for draft beer in the city. Hundreds of people lined up along Fourteenth Street NW to get in. It was obvious that Washington had a strong, untapped demand for good beer. Bill Madden noted, "D.C. is still underserved in the beer business."

D.C.: BETTER LATE THAN NEVER

Washington, D.C., was quite late to the craft revival, not getting its first production breweries until 2011—fifty-five years after the Christian Heurich Brewing Company closed. And even that came two decades after brewpubs were legalized in the city.

Washington was surrounded by great breweries, yet the city didn't produce any beer of its own outside of brewpubs. The Washington area had one craft brewery for a number of years: Old Dominion, located in an office park in Ashburn, Virginia. When Old Dominion shifted operations to Delaware, some of its employees started the Lost Rhino Brewing Company in 2011. Dogfish Head of Milton, Delaware, is famously experimental and quirky, best known for its 60 Minute IPA. Flying Dog Brewery moved to Frederick, Maryland, from Colorado in 2007. And Baltimore supported a thriving craft brewing scene with such breweries as Heavy Seas.

The year 2011 was truly a landmark year for beer in the Washington area. Historians will look back and note that this was the year that locally produced beer returned to the district. In that year, Port City opened in Alexandria, and three craft breweries opened in Washington: DC Brau, Chocolate City and 3 Stars.

The demand was immediate and strong—consumer interest in craft beer and in all things locally produced had been growing for years. As soon as these new beers appeared on tap, the craft brewers had difficulty keeping up with demand. It was a sight to see how much Washingtonians embraced this new part of local culture. Jason Irizarry of Chocolate City noted, "The niche was filled fast and furious, all at the same time."

To which we also have to ask a very genuine question: What took Washington so long to reintroduce production brewing?

It's a question for which there is really no satisfying answer. From a practical standpoint, the brewers point out that it takes time to raise the capital to open a brewery and that it can be difficult to find proper real estate. A production brewery requires industrial space, something that Washington has in short supply. Thus breweries have tended to open in what Jason Irizarry calls the "fringes of the city," outlaying areas that are off the beaten path and where the rent is also lower. The old industrial areas of the city—Foggy Bottom, Georgetown and the Navy Yard—have long since been redeveloped and gentrified. Breweries need a fair amount of space and access to a water supply. You can smell a brewery from a ways away—it smells like bread baking in the oven. Although a pleasant scent, not everyone wants that in his

or her neighborhood. Brandon Skall of DC Brau observed the difficulty of operating in Washington's tight real estate market as he searched for a home for his brewery: "There's not that much to choose from."

The year 2011 proved historic in that so many brewers overcame the business challenges and opened their businesses. They soon lobbied the D.C. City Council to legalize growlers, the sixty-four-ounce bottles that allow customers to take beer home with them. The district accommodated the brewers and their customers.

So many breweries have opened that you just can't keep up with them all. "I used to know everyone in the brewing industry in the Mid-Atlantic. Not anymore," quipped Bill Madden of Mad Fox Brewing.

Fritz Hahn of the *Washington Post* wrote in July 2013, two years into the explosion of craft breweries across the district, "In my role reviewing bars and clubs for the *Washington Post*, I'm out five to seven nights a week. I can say unequivocally that it is easier to find great beer than it has ever been."

Brewing's moment arrived in Washington when President Barack Obama home-brewed beer in the White House in 2012, generating tremendous publicity. Home brewers petitioned the White House to release the recipe, and Obama obliged with the recipes for honey brown ale and honey porter. Temperance advocates would roll over in their graves. The fact is, nearly every president has consumed alcohol while in the White House, and most regularly. The handful that didn't include Calvin Coolidge, Jimmy Carter and George W. Bush. Yet it was Jimmy Carter who legalized home brewing in 1978, and his brother Billy briefly marketed canned Billy Beer.

One thing that is difficult to find in the modern brewing scene is lager—the beer that made brewing so successful in Washington but that takes much longer to brew. Kristi Griner of Capitol City said, "Any self-respecting lager needs a minimum of five to six weeks" or longer. For start-up companies, it's something they have largely avoided so far, as time equals money. "I can make two to three batches of ale in the same time that it takes to make a lager," said Brandon Skall of DC Brau. "I have to think about what makes sense for my business." Looking for a lager alternative that can suit the bill, especially on a hot summer day? Try Kölsch or pale ale.

The explosion of microbreweries is perhaps even more prevalent in the suburbs of Maryland and Virginia, where the rent is less expensive. In the Maryland suburbs, you can find Franklin's Restaurant, Brewery & General Store in Hyattsville, Baying Hound Aleworks in Rockville and Denizens Brewing in Silver Spring. Growler's in Gaithersburg is a personal favorite

(every year after the Gaithersburg Book Festival, one of my favorite traditions is to have a beer there with the festival organizers).

And in the Virginia suburbs? The list is staggering: Adroit Theory in Purcellville, BadWolf Brewing in Manassas, Beltway Brewing in Sterling, Corcoran Brewing in Waterford, Crooked Run in Leesburg, Forge Brew Works in Lorton, Heritage Brewing in Manassas, Lost Rhino in Ashburn and Old Ox Brewery in Loudoun County. Then there are brewpubs like City View Brewhouse, Dogfish Head Ale House, Sweetwater Tavern and Vintage 50. The town of Leesburg has become a serious craft-brewing destination.

So what's the difference between a brewery and a brewpub? A brewery is an industrial-scale facility that produces beer for retail sale at bars, grocery stores and restaurants. Brewpubs produce beer for consumption on site— essentially a restaurant that brews its own beer. There is a difference in commercial zoning as well. Breweries are zoned for industrial areas, whereas brewpubs are zoned and licensed more like restaurants.

With apologies to the suburbs, there are so many breweries that have exploded onto the scene in recent years that I've had to focus on those inside the original boundaries of the District of Columbia, the one hundred square miles that encompassed Alexandria, Arlington and the city of Washington.

As I mentioned in the book's introduction, journalism is the first draft of history. As you read this in subsequent years, new breweries may open up and existing ones may close, consolidate, expand or move. This is a snapshot of Washington brewing as of early 2014. In fairness, I've listed the breweries in order in which they opened.

BREWERIES

Port City Brewing Company
3950 Wheeler Avenue, Alexandria, VA

"Do you want a beer?" asked Port City founder Bill Butcher as we sat down in his brewery's tasting room, which resembles a winery tasting room. Before opening Port City, Butcher spent most of his earlier career in the wine business, where he learned the importance of brand building and distribution, which equally applies to brewing. He also grasped the importance of tourism: people want to visit breweries and taste the goods. Butcher joked that he

wanted to build "a winery that makes beer." He added, "People treat craft beer now like they treat fine wine."

It took Butcher three years from inception to opening Port City's doors in February 2011. This unfolded during the Great Recession of 2007–08. With the credit markets locked up, it seemed impossible to get financing to start the business (he spoke with eleven banks). "The timing couldn't have been worse trying to open during the recession, but the recovery programs worked in our favor." He got a Small Business Administration (SBA) loan with waived fees, thanks to the American Recovery and Reinvestment Act.

Butcher found a good location in an Alexandria business park, one that could expand as his business grew. He chose the Jones Point Lighthouse as the logo, which is set on a diamond field that harkens back to the Tivoli Brewery. And the name? Port City is Alexandria's nickname.

Port City's flagship beers are Essential Pale Ale, Monumental IPA, Optimal Wit and Porter. Optimal Wit won a gold medal at the Great American Beer Festival in 2013. Port City also makes seasonals such as Downright Pilsner, an Oktoberfest Märzen and Revival Stout made with oysters (oysters and stout are a counterintuitive culinary delight). Will those be the flagship brands ten years from now? "I don't know," Butcher replied. "If people are still screaming for it, we'll make it." He noted that the flavor pendulum swings. In 2013, people are eager for heavily hopped beers, but the pendulum will swing back. "Balance and harmony—that's where happiness lies," Butcher said.

Port City opened in 2011 and soon expanded with larger fermentation tanks. As of 2013, it was brewing twelve thousand barrels per year, and it had the room to double that capacity. "It made sense that we got this larger facility we could grow into rather than grow out of," Butcher said. By 2013, the business was profitable.

Demand was strong for Port City beer from the outset. Many bars, restaurants and grocery stores were excited about offering locally sourced beer. Butcher noted that most craft breweries begin distribution with bars, where the ideal formula is to package 80 percent of the beer in kegs and 20 percent in bottles. Over time, that ratio flip-flops as consumers discover the beer and start purchasing it for home consumption. But from the outset, Port City was bottling a much higher proportion. "We sell more bottled beer than we should," Butcher noted, which is a good problem to have.

A violent, fast-moving thunderstorm called a *derecho* hit the Washington area on June 29, 2012. Port City was fermenting thirteen thousand gallons of ale and pilsner when the power was knocked out—for five days. The

ale was mostly finished, and besides, it ferments at a higher temperature. But lagers such as pilsner require low temperatures to ferment. Butcher decided to turn the partly fermented pilsner into a California common or "steam" beer, which could be made at higher temperatures. "No one had ever heard of the word *derecho* before," Butcher remarked, so he named the beer Derecho Common. Word got out. "People got excited about the beer, and it sold out in two weeks." He added, "It ended up being the one good thing that came out of the storm."

A year later, as the anniversary of the *derecho* approached, Port City decided to brew another Derecho Common—this time deliberately. And wouldn't you know it? A thunderstorm knocked the power out again. Fortunately, most of the brewing was already complete, and the power was out for only twelve hours.

President Barack Obama's reelection campaign contacted Butcher in order to film a video about a successful small business that opened during Obama's first term. Although initially resistant (Butcher was concerned about being viewed partisanly), he eventually agreed to do the video. Soon after that, he was invited to speak at the Democratic National Convention in Charlotte, North Carolina, in September 2012. "That was a big surprise," Butcher said, "but I consider it a great honor to do something so unique." He spoke about the importance of small businesses to America and had a prime time slot at 9:00 p.m. His speech followed Colorado governor John Hickenlooper, himself a brewer. The speech "got our name out there on a national level. It got our name into the brewing industry," Butcher said with pride.

DC Brau Brewing Company
3178 Bladensburg Road NE

DC Brau was the first brewery to open in the District of Columbia since Christian Heurich closed in 1956. It paved the way for the other Washington brewers. "It was frustrating, but it wasn't as terrible a process as we thought it would be," said founder and CEO Brandon Skall. The D.C. City Council was helpful, as it wanted to see brewing return to the city.

DC Brau sits in a converted warehouse space in a strip mall near the Maryland border. "We looked at twenty to twenty-five spaces," head brewer and co-founder Jeff Hancock said. "Aside from putting paint on the wall, this was move-in ready."

Skall is dark haired and heavily tattooed. He got his start in sales and marketing for wine but kept dreaming of starting his own business. He teamed with Hancock, who had brewed for more than a decade. They met while DJing. "We were both the other side of the puzzle we were looking for," Skall noted.

DC Brau opened on April 15, 2011. The bar Meridian Pint hosted the opening night party, and the line stretched down the street, showing how excited people were for production beer to return to Washington. The party went through fifteen kegs in six hours. Skall recalls being hungover the next day for a flight with his parents to a Passover seder.

DC Brau produces ales and lagers of many styles. Its flagship beers include Public Pale Ale (the majority of what the brewery produces), Citizen Belgian Pale Ale, Corruption IPA and Penn Quarter Porter. It also makes a number of seasonal beers. It's on track to produce ten thousand barrels of beer in 2013 and as of this writing was completing its fourth expansion and installing a new canning line. Even though we met on a Monday, the phone rang off the hook and the two business partners buzzed around the brewery,

Political beer at its finest. DC Brau's slogan is a riff on the district's unofficial slogan: "Taxation without Representation." *Garrett Peck.*

solving problems. "We're having some of the growth problems when you grow rapidly," Skall said.

Alongside its growler-filling station, DC Brau sells plenty of merchandise. One of the T-shirts reads, "Fermentation without Representation," a riff on the city's unofficial motto, "Taxation without Representation" (the city has no voting member in Congress).

In 2013, DC Brau teamed up with the DC Homebrewers and the Heurich House Museum to re-create Heurich's Lager. Mike Stein, a home brewer and blogger at DC Beer, combed through Christian Heurich's ingredient receipts archived in the National Museum of American History while trying to reassemble Heurich's recipe. Stein created a beer using more modern ingredients that he felt represented Heurich's pre-Prohibition lager. Jeff Hancock then oversaw its production at DC Brau. The beer was released during DC Beer Week at the Heurich House Museum. It was rich and higher in alcohol than most lagers today; as the beer warmed, the Saaz hops emerged, giving it a lovely citrus flavor (one participant commented that it was like sipping a zestier Kölsch). Jan Evans, Heurich's granddaughter, attended the event and noted that her grandfather often preferred his beer a little warmer—he would put his lager on the radiator to warm it.

Chocolate City Beer
2801 Eighth Street NE

I took one look at Chocolate City and realized my research worlds had collided: the brewery is in a Seneca redstone building (my previous book was *The Smithsonian Castle and the Seneca Quarry*). The unique structure was built as a shed in which to cut stone for nearby Catholic University. It sits along the railroad tracks, where the stone could be easily hauled in—and likewise where beer was transported from the national brewers to the Washington market.

In September 2010, the newly formed Chocolate City Beer got the keys to the dilapidated building and went to work. The brewery opened the following August, making it the second brewery to open in Washington in 2011. Chocolate City is the district's smallest brewery. Some call it a "nanobrewery"—smaller than a microbrewery. "I guess we're bigger than that," co-owner Jason Irizarry laughed. It has the capacity to produce just over one thousand barrels per year. The brewery self-distributes to bars, and that enables it to be profitable. "I wear a lot of hats," Irizarry said.

Chocolate City has, hands down, the coolest brewery logo: a clenched red fist, echoing the black power movement of the 1960s. Few African Americans are involved in Washington brewing, but Chocolate City is one of the exceptions. The business partners are Brian Flanagan, who is black, and Jason Irizarry, who is white.

Chocolate City produces malt-forward beers in small seven-barrel batches. It has two flagships brews: Cerveza Nacional de la Capital (a lager) and Cornerstone Copper Ale. It also brews seasonals such as its Big Chair IPA. The business partners recognize that their building is quite small and that if they want to expand, they'll have to find a new facility. Irizarry still hopes to keep the distinct redstone building, at least as a lab.

3 Stars Brewing
6400 Chillum Place NW

If any Washington brewery takes the cake for full-flavored, experimental beer, it's 3 Stars. The third brewery in the district to open in 2011, 3 Stars is housed in a converted auto repair shop near the Maryland border. It gets its name from the three red stars on the district flag.

"This is the most challenging job I've ever had—and it's the most rewarding," remarked Dave Coleman, who has a beard like Abraham Lincoln's. He founded the company with Mike McGarvey. "I'm thirty-seven, and I own a brewery with my best friend," Coleman said.

A tour of the fifteen-thousand-square-foot brewery starts off with a mock-up of the home brewing lab that Coleman and McGarvey started four years before opening. It includes many pasta pots. They toiled in their lab, experimenting with beer recipes until they had the formulas just the way they wanted. The Pandemic Porter took sixty-five tries to get right. "We first want to make a product that we're happy with," said McGarvey. The two friends put far more than just sweat equity into the brewery—McGarvey even sold off his BMW to purchase fermenters to prove to investors that they were serious about starting the business.

3 Stars has produced an eclectic twenty styles of beers so far, all of it kegged and self-distributed (McGarvey calls it "non-traditional American-style" beer). Flagships include The Movement (a pale ale) and Peppercorn Saison (a Belgian farmhouse ale). The rest are all seasonals, including From Russia with Love, which is a Russian imperial stout, and Citra & Lemon Peel Saison. The Southern Belle brown ale will make you wish it were always

winter so you could drink it year round. "The reality is, D.C.'s tastes change," McGarvey said, and so he constantly experiments with new seasonals. The brewery produced one thousand barrels of beer in 2013, and with new tanks, it aims to hit three thousand barrels in 2014. It certainly has the floor space to expand. Coleman hopes one day to offer bottled beer but not cans. As Steve Martin said in *The Jerk*, "He hates these cans."

New Columbia Distillers
1832 Fenwick Street NE

Brewing wasn't the only thing that returned to Washington in 2011—the city got its first distillery in more than a century with New Columbia Distillers. The company began distilling Green Hat Gin in the summer of 2012 and added a Ginavit the next year. It sits in an Ivy City warehouse, just down the street from the Art Deco Hecht's building, in a budding brewing and distilling district.

Fred Cassiday receives the first case of Green Hat Gin from John Uselton (left) and Michael Lowe (right) of New Columbia Distillers. *Garrett Peck.*

There is a clear link between brewing and distilling: to make any spirit, you first have to brew a beer. It comes as no surprise, then, that many craft distillers got their start as brewers. John Uselton, the co-owner and distiller at New Columbia, was the beer buyer at Schneider's of Capitol Hill. He teamed up with his father-in-law, Michael Lowe, a retired telecom lawyer, to open New Columbia.

In my 2011 book, *Prohibition in Washington, D.C.*, I wrote a chapter called "The Man in the Green Hat" about congressional bootlegger George Cassiday. Michael Lowe and John Uselton liked the story so well that they wanted to name their gin after Cassiday. They contacted me, and I put them in touch with Cassiday's son Fred, who was thrilled. He asked only for the first case of gin to share with his family. On a fine October day, we gathered at the distillery for a bottling party, filling the bottles with the "gin cow" bottle filler and affixing the labels on them. And Fred took his case home.

Atlas Brew Works
2052 West Virginia Avenue NE

Just a block from New Columbia Distillers in Ivy City is Atlas Brew Works, which opened in September 2013 as the city's fourth production brewery. It stands directly across the street from Mount Olivet Cemetery, where a number of historic brewers are buried. Like the other modern breweries, it occupies a former industrial space.

Justin Cox is the CEO and runs the business side of the house, while co-owner Will Durgin is the brewer. Justin, who went to law school like so many Washingtonians, became an avid home brewer after his girlfriend (and now wife) bought him a home brewing kit.

Named after the nearby Atlas District, Atlas Brew Works can produce 2,500 barrels per year and has room to expand to 13,000 barrels. On the floor are wine barrels for making sour beer. "Belgian beers are my passion and my specialty," said brewer Will Durgin. He worked for brewers in California and Oregon and attended the brewing school at UC Davis. "My brewing philosophy is restrained. I appreciate a simple, modest beer." Flagship beers include the District Common (a California common, which is an ale brewed with lager yeast) and Rowdy (a rye ale). The other beers in the lineup are rotating seasonals.

Hellbender
5788 Second Street NE

Washington's fifth brewery to open since 2011 is Hellbender, located on a quiet Riggs Park cul-de-sac near the Fort Totten Metro station. It's a short drive to 3 Stars Brewing. The quiet surroundings and unassuming warehouse belie an expectedly large interior space with plenty of room for expansion—up to five thousand barrels per year if need be. Hellbender opened in early 2014.

What is a hellbender, you ask? It's a kind of giant, endangered salamander, which the company uses as its mascot. Legend has it that the salamander is fireproof and was born of fire. Christian Heurich used it on the weathervane of his house, which is appropriate since Heurich is buried near Hellbender in Rock Creek Cemetery.

Ben Evans is the brewer, while Patrick Mullane handles the business side of the house. Both men started off as home brewers and, after becoming friends, began making batches together. "It got more frequent over the years," Evans remarked, so they decided to do it for a living.

Flagships include American red ale, an IPA and a Kölsch. The brewery also produces seasonals like Belgian saison, Hefeweizen, nut brown and pumpkin ale. The brewery, which is open for tastings and growler fills, has a unique filter pad system that uses far less electricity, grain and water than other brewing systems, proving a bonus for the environment.

VISITING THE BREWERIES

All of the breweries in Washington have visiting hours and offer beer samples. The samples are small, so you probably won't need a designated driver. In addition, you can get a sixty-four-ounce growler of beer filled. The breweries sell the bottles on site—or you can bring your own.

For those who want to tour the D.C. breweries on a single day, it may be easiest to "divide and conquer" the destinations. Start at DC Brau, then journey to Chocolate City and then Atlas Brew Works before ending at Bardo with a well-deserved pint. These breweries are fairly concentrated. If you have time to venture farther afield, Hellbender and 3 Stars are near each other. Keep in mind that the busiest visiting hours are Saturdays.

Port City in Alexandria is worth a separate trip on its own as it offers a more formal tasting experience. In addition to beer samples, it has a full bar

where you can grab a pint after a tour. Like the Washington breweries, it can also fill growlers.

An alternative to driving is taking a bicycle tour. Bardo organizes a Mashtown Bicycle Tour that visits a number of breweries in Northeast and ends at Bardo. Bike rental places such as BicycleSPACE sometimes offer guided tours.

If touring breweries isn't your style, a pleasant alternative is to find a local bar with a good selection of local craft beers on tap, such as the Bier Baron, the Big Hunt, ChurchKey, Granville Moore's, Iron Horse, Meridian Pint, Pizzeria Paradiso, RFD, Rustico and the Westover Beer Garden. Or you can visit any of the brewpubs listed in the following section.

BREWPUBS

Capitol City Brewing Company
1100 New York Avenue NW
4001 Campbell Avenue (Shirlington)

The District of Columbia legalized brewpubs in 1991. The first brewpub in the city since Prohibition opened the following year: Capitol City Brewing Company. Like Albert Carry, Christian Heurich and Robert Portner before him, founder David von Storch does more than just brewing. He has a diversified lifestyle business called Urban Adventures Companies, from the Bang hair cutting salons to the high-end VIDA Fitness gyms.

Capitol City opened at 1100 New York Avenue NW, a site that is still serving up the suds, though that location stopped brewing in 2003, instead sourcing the beer from its Shirlington brewpub. There is another location in Baltimore. Bill Madden, a storied figure in Washington brewing history, designed the glassy, sunlight-drenched brewhouse at Shirlington that is still in use today.

Capitol City once had a brewpub in the Post Office Museum near Union Station. I remember attending the 1997 episode of the *Ellen* sitcom where Ellen DeGeneres came out. The place was packed with what seemed like seven hundred or eight hundred fellow gays and lesbians in a viewing party hosted by the Human Rights Campaign. That location closed in 2011 when the lease wasn't renewed.

Kristi Griner is Capitol City's brewer. Much of her career was spent in the restaurant industry before turning to brewing. She started as a brewer with

Hops Restaurant Bar & Brewery in Potomac Yards, a 7-barrel operation, in 2007, and then attended a brewing program in Chicago before a stint at Vintage 50 in Leesburg and ultimately landing the Capitol City brewmaster position in February 2013. She runs a 2,500-barrel-a-year operation with big plans to expand into the basement and to offer more packaged products, such as cans and bottles.

There are four flagships always on tap: Kolsch (spelled without the umlaut), which is by far their biggest seller, thanks to Bill Madden establishing its popularity in the early 1990s); Pale Rider; Amber Waves; and Prohibition Porter. Cap City usually has seven to ten beers on tap, and Griner strives to keep an IPA and a wheat beer on hand and often has a lager style as well. The style is eclectically American. "I really like kitchen-sink beers," she said—the kind of beer that pulls from the spices, coffee, malt and yeast and whatever else she has on hand. "I don't want to put anything in my beer I can't eat." Then she has to put a name to the beer. "That's where I put my literature degree to work on something clever." (See? Literature degrees *are* useful.)

"The good news is that we have been around for twenty-one years and ridden through at least two economic downturns, so we are confident that we will be a survivor when the next wave of challenges comes to the local craft brewing scene," said founder David von Storch. "Obviously it's built to last," added Griner. "Cap City has maintained and done well for itself."

Mad Fox Brewing Co.
444 W. Broad Street, Suite I, Falls Church, VA

Mad Fox opened in July 2010 in a modern office and retail complex in Falls Church. This came on the heels of the Great Recession, when obtaining financing was difficult. But the brewpub's investors knew of founder Bill Madden's extensive experience in brewing and stayed by him. He found a vacant property and a landlord eager for a tenant.

Madden once worked in sales at TRW in San Francisco. He began home brewing, and this in turn led him to the brewing course at UC Davis. He graduated in 1995, and Capitol City hired him. He worked there for ten years, building the brewpub's strategy for a central brewing facility in Shirlington that would support the other restaurants.

"It's a brewer's dream to start your own place. Fortunately, I have a wife who supported me," Madden said. The name Mad Fox is a play on his last name (Madden) and his wife, Beth's, last name (Fox).

Although Mad Fox produces many different styles of beer, Kölsch is always on the menu. "We sometimes refer to D.C. as 'Cologne by the Potomac,'" Madden said, referring to the German city of Köln (Cologne), in which Kölsch originated. "Kölsch is the perfect light golden ale." You can also find cask ale on tap.

Mad Fox has a capacity of 1,600 barrels per year, and Madden can double that. "The brewery is way over capacity for this location," he noted. He sells into accounts in Washington. As of this writing, Mad Fox is planning to expand into Glover Park using the model that Madden established at Capitol City Brewing: one site to brew and supply the beer for the others. He is considering bottling beers, which would make Mad Fox not just a brewpub but also a production brewery.

District ChopHouse & Brewery
509 Seventh Street NW

Bourbon stout: two words that make the District ChopHouse & Brewery a delicious destination. Barrett Lauer, who has been the brewer since 2005, ages the stout in bourbon barrels. He lives in Baltimore and commutes to Washington. Lauer got his start as a brewer at the Wharf Rat in Baltimore's Fells Point, where he met his wife and learned English-style brewing, followed by a stint at Baltimore Brewing, where he learned German-style brewing.

Lauer normally brews on Tuesdays and Thursdays, when he does double brews. Having five fermenters at the ChopHouse gives him flexibility in responding to changing demand. The brewpub even has a grain silo atop the building, which is unusual given that it's located on busy Seventh Street in the Penn Quarter entertainment district. Museums and theaters are nearby, and Clara Barton's Missing Soldiers Office, which opened in 2013, is just a half block away.

The District ChopHouse has the capacity to brew eight hundred barrels per year, all of it sold on tap. Lauer always offers amber ale, bourbon stout, nut brown ale, IPA, light lager, oatmeal stout and what he calls a "marker" (the brewer's choice, such as a Velvet beer that uses nitrogen rather than carbon dioxide). "March is our busiest month," he notes. With spring, people end winter hibernation and seek out bars to watch the March Madness basketball games. One thing you won't find is cloudy beer. "I like filtered beer," Lauer said. "I like the flavor better."

Being one of the earlier brewers in modern Washington, Lauer notes the community support the brewers provide one another. "Bad beer doesn't do anyone any good," he said. They all benefit from rising public interest in good beer.

The ChopHouse is owned by CraftWorks Restaurants and Breweries, a national business that also owns Gordon Biersch and Rock Bottom (there are ChopHouses in Boulder and Denver, Colorado). Just a few blocks away is Gordon Biersch (900 F Street NW), located in the historic Riggs Bank Building, a granite building built for the ages. It's really quite stunning, and the effort to convert a former bank into a brewpub while keeping the building's historic character is nothing short of amazing. CraftWorks operates another Gordon Biersch at the Navy Yard, as well as a Rock Bottom in Ballston.

Bardo
1200 Bladensburg Road NE

After closing Dr. Dremo's Taproom in Arlington, Bill Stewart put his brewing equipment in storage and moved to Australia and, later, India. He returned to Washington in 2011 after he learned that the brewing market had changed considerably. He began searching for a place to restart Bardo. "I'm just glad I had all this stuff left over. This stuff is expensive!" Stewart said.

In 2013, Stewart reopened Bardo at 1200 Bladensburg Road NE in the Trinidad neighborhood. He initially opened it as just a pub but began making his own beer again in early 2014. Bardo is once again a two-thousand-barrel-a-year operation where brewing takes place outside. It makes twenty kinds of beer that Stewart calls "weird shit." He has a taste for the unconventional yet acknowledges that beer fanatics alone won't pay the bills. "We've gotta keep Muffy and Skipper happy"—his name for middling beer drinkers who form the bulk of beer sales.

Today's Bardo has fifteen thousand square feet. Unlike the old space in Arlington, Stewart owns the land under the brewpub. Trinidad has, at times, had an unsettling history, but like the broader city, the amount of violence has ebbed significantly since the 1990s. Stewart has had few problems since employing a guard dog named Bardawg. "What you need is a dog," he said. "It'll solve all your problems in D.C."

Bluejacket
300 Tingey Street SE

Bluejacket opened in October 2013 in the old boilermaker building at the Navy Yard. It stands less than two blocks from the historic Washington Brewery site (1805–36) at the foot of New Jersey Avenue and what was once the Washington Canal. Nearby is Nationals Park.

"Bluejacket is something that Michael [Babin] and I were discussing since 2006," said Neighborhood Restaurant Group beer director Greg Engert, who joined NRG that same year. The group specializes in creating restaurants that pair quality food with innovative drink menus. They wanted something "beyond wings and beer," Engert noted. Babin and Engert had their eye on the dilapidated boilermaker building at the Navy Yard when Nationals Park opened in 2008.

Megan Parisi is the brewmaster at Bluejacket. Her husband got her hooked on homebrewing—an interesting case of opposites (many brewers remarked that they got started when their girlfriends or wives bought them a home brewing kit). "I took to it like a fish in water," she said, and she home-brewed for the next ten years. Parisi was a clarinetist with the United States Navy Band stationed, ironically, at the Navy Yard. When she was ready for a career change, she decided to take coursework in brewing and worked at the Cambridge Brewing Company in Massachusetts. Greg Engert hired her in 2011 to run the brewing operations at Bluejacket—two years before the place actually opened. "We met Megan, and we knew this was going to be it," he said.

Bluejacket is a beautiful space that harkens to the neighborhood's industrial past. It's named for the blue-jacketed sailors of the U.S. Navy. The brewery is stacked vertically, with the restaurant, Arsenal, below offering incredible views all around. Brewer Megan Parisi called it "a dual-purpose brewery—we put it in the air where nothing existed."

One thing you'll see almost nowhere else is Bluejacket's coolship (from the Flemish *koelschip*), a bathtub with a long surface area for the newly boiled wort to quickly cool while wild yeasts float in through the air to start fermentation.

Bluejacket is part brewery, part brewpub. The five-thousand-barrel-a-year operation has ambitions to distribute 60 percent of its beer to bars, restaurants and retailers around the region. At that point, Bluejacket will no longer be a brewpub but a full-fledged production brewery.

At any given time, twenty beers are offered. Often they are experimental, such as the spicy and nearly black Doppelbock called The Butcher for its use

of meat seasonings. Having such a diversity of beer ensures that most people can find something they want to drink. "We have something for every palate and something for every plate," said Parisi, noting the importance of pairing the beer with Arsenal's food. "The menu isn't a sideshow to the beer," she said.

Right Proper Brewing Company
624 T Street NW

Right Proper is located next to the Howard Theatre, the cultural centerpiece of the African American community in the historic Shaw neighborhood. On the brewery's site once stood Frank Holliday's Pool Hall, where Duke Ellington met many of his musical mentors when he was young and, later, where he performed. The original building no longer stands, other than the west wall, on which co-owner Thor Cheston's brother painted a mural that ties the brewpub to its musical past. The bar's logo reads, "Made in Shaw."

Right Proper opened in December 2013. It evokes an English pub's name, but Cheston got the name from a southern relative who is fond of saying, "That's right nice." He worked for Belgian restaurateur Robert Wiedmaier and Pizzeria Paradiso, where Cheston established the *birrerria*. Because of a quirk in local law, alcohol producers and restaurants in the district can self-distribute alcoholic beverages. This allowed Cheston to assemble a wide range of Belgian-style beers at Paradiso by going directly to the brewers, as well as offering select home brews. Paradiso was the concept that introduced Belgian beer to Washington.

After working for others for more than a decade, Cheston wanted to start his own brewpub, a concept that took two years to bring to fruition. He teamed with co-owner John Snedden. "I wanted to build a brewery that was yeast focused," Cheston said. "Nathan [Zeender] was the first person I turned to." Zeender was an avid home brewer who had brought a sample by Paradiso, and Cheston was stunned at how good it was. Zeender echoed, "We're very much from the cult of yeast."

Right Proper has the capacity to produce one thousand barrels per year. It specializes in Belgian ales and sour beers, particularly those of the Flanders region. Given its small size, the brewpub is sticking with "hot fermentation" beers that can be crafted quickly. At its opening, Right Proper offered Being There (an unfiltered Pilsner), The Duke (a golden ale, named after Duke Ellington), Ornette (a low alcohol, open fermentation session beer) and Raised by Wolves (a dry-hopped pale ale). It has two brewing "workshops:"

a standard room with copper kettles that you usually see at brewpubs and a separate room where Zeender ferments with wild yeasts and crafts sour ales in casks. The brewpub rotates beers every few weeks. "I'm brewing flavorful beers—soulful beers that have character," Zeender said.

Women in Brewing

To be a brewer in Washington these days requires a big scraggly beard and as many tattoos as can fit on your arm. Brewing has long been a man's world—but it wasn't always so historically, and there are some working to improve diversity across the industry. Yes, women are getting back into brewing.

For most of history, women were the brewers, making beer at home for family consumption. It was a cottage industry. "Brewing isn't dissimilar from cooking," observed brewer Nathan Zeender. With the Industrial Revolution, brewing left the home and became a male-dominated trade. "Brewing is heavy manufacturing, and the physical strength required could be more than what many women would or could handle," remarked Catherine Portner of Portner Brewhouse.

Gallup, which has conducted a survey on American drinking almost every year since 1939, has consistently noted that men prefer beer, while women prefer wine. Both enjoy cocktails equally. Beer also suffers a false reputation as being fattening and therefore unappealing to women in a beach bikini wearing era. (Want fattening? Try a calorie-laden margarita.) But in recent years, you'll find more women who proudly identify themselves as being "beer girls."

When Bill Madden went to brewing school at UC Davis, there was just one woman in his class of twenty-six people. "It's a very male-dominated industry that is difficult for women to break into," he said, noting the long hours and the need to carry fifty pound bags of grain to the mash tun. "It's gotten easier over time. Personally, I welcome it." He added, "It'd be great if we had more. It'd be a good counterpoint to all of this macho stuff."

Washington's brewing community is still largely staffed by men, but the ranks of women joining the fold ("putting on the boots," in brewers jargon) are increasing. In fact, there's even a Pink Boots Society to help advance women in brewing. "Women are being more high profile, hopefully inspiring the next generation of brewers to put on the boots," encouraged Will Durgin.

As of 2013, Washington has two women brewmasters: Kristi Griner of Capitol City and Megan Parisi of Bluejacket. Two more are joining in 2014:

Robert Portner's great-great granddaughters, Catherine and Margaret Portner of Portner Brewhouse. That probably puts the Washington area ahead of most other cities. "Ten years ago, this would be all guys—and all white guys," said Bill Butcher. Today, the brewing community is growing more diverse. "It makes me happy to see the great diversity of people," he added.

Kristi Griner noted how many young women in particular grew up during the craft beer upswing and took to drinking good beer. "I don't like making a big deal about being a woman brewer," she said. "I've never felt, 'What is that woman doing here?'" If anything, she felt more hostility while working in the restaurant industry. Griner pointed out that beer hasn't been marketed toward women, and that is a factor in why fewer women than men drink beer. "The business hasn't beckoned to us. They use us to sell it but not to buy it."

"I already see it changing a lot," Megan Parisi said about the entrance of women into brewing. When she started judging at beer festivals, she was often the only female judge, but now there are many more at the table. The consumer base is changing as well; more women are coming into craft beer bars on their own, and not just with their boyfriends or husbands. She also noted that the business of beer distribution was once limited to men but that now there are many women who sell and market beer. Has Parisi ever run into sexism on the job? She shook her head. "The brewing community is pretty progressive. Very few judge on gender," she said.

Both brewers and beer-drinking customers are becoming more diverse, though "the customer base is progressing faster than the brewers," remarked Justin Cox, noting that it's still largely men making the beer. "As more women become visible in the industry, this also provides role models and mentors for young women to follow," added Catherine Portner. "I don't expect there to ever be more women than men in the industry, but it is definitely increasing."

BEER AND BASEBALL

Professional baseball returned to Washington in 2005 for the first time in thirty-three years when the Montreal Expos moved to the city. The newly renamed team, the Washington Nationals, played its first three seasons at decrepit RFK Stadium before moving to the brand-new Nationals Ballpark in 2008.

Despite the growing craft beer movement, most of the beer presence at baseball games is represented by the two leading global brewers: Anheuser-Busch InBev and MillerCoors. Even the craft (or more like "crafty," as craft

beer drinkers snidely call them) brands like Blue Moon, Shock Top and Stella Artois are from the behemoths. I'm always a little stunned at witnessing how many people drink Bud or Miller Lite at baseball games despite the obvious affluence of the audience. Cost is the same at the ballpark, whether for a Bud or a craft beer, yet many people—mostly men—choose an inferior product. In truth, you have to search to find the stands that sell craft beer. It takes effort to drink well.

The beer options have at least been improving in recent years. Dogfish Head, Flying Dog, Heavy Seas and Samuel Adams were offered at the stadium in 2012, though these aren't brewed in Washington. The 2013 season marked the first year that locally produced beer established a presence in the ballpark. Bill Butcher of Port City lobbied the Nationals, and that year a kiosk opened for the local brewers offering Atlas Brew Works, DC Brau, Mad Fox, Port City and 3 Stars. Baseball and beer do, in fact, mix.

And good news got even better: people can drink beer near Nationals Park even if they don't have a ticket. Gordon Biersch opened nearby in the spring of 2013, while Bluejacket opened in the fall, shortly after the season ended. Patrons can grab a beer before or after the game—or during if there's a rain delay (I speak from experience).

MORE BEER GARDENS, PLEASE!

One thing still missing is the plethora of beer gardens that once existed before Prohibition. The brewers had wonderful beer gardens that could seat hundreds of people. Only a handful have opened, including Biergarten Haus in the Atlas District, Café Berlin on Capitol Hill, Garden District on Fourteenth Street (coincidentally on the same block as Kozel's/Geyer's beer garden), the Wonderland Ballroom in Columbia Heights, Dacha in Shaw and Social Haus and the Westover Beer Garden in Arlington. All are small and crowded. "It'd be nice to have an actual beer garden," Greg Kitsock quipped. "Today, it's more like a patio."

Why are there so few beer gardens? We can point to several issues: real estate is expensive, permits may be difficult to obtain and neighbors will complain about the noise. None of the beer gardens match the thousand-seat places that operated before Prohibition. Thankfully, though, Bardo has reopened, and a temporary beer garden called the Half Street Fairgrounds stands near the center-field gate of Nationals Park.

You know what would be awesome? A beer garden on the National Mall. Yeah, I know, it isn't going to happen—the National Park Service frowns on drinking on their properties. But if you've ever been to the Englischer Garten in Munich, you know what a delight having a beer garden in a public space can be.

In the coming years, as Washington redevelops the L'Enfant Plaza area and Waterfront, it may be "right proper" (as Thor Cheston would say) to include zoning that supports a beer garden in the area. These could be within a few blocks' walk from the Mall and close to Metro stations. And who knows? Maybe someone will reopen the storied Washington Brewery near the Navy Yard.

Raise Your Glass for the Last Word

Just prior to Prohibition, the Washington area had a brewing capacity of 1 million barrels of beer per year and brewed almost 250,000 barrels of beer. Even with the recent revival in craft brewing, we have a long, long way to go before we can ever catch up to that quantity. But perhaps catching up isn't that important if it means brewing mass-produced beer that is uninteresting to the public. What is most important is producing inspiring beers that capture our imagination while carrying forward the tradition of Washington brewing. History is made with every batch of beer.

Beer builds community. And where do people get together over a beer? At the bars and brewpubs that are staples for thriving neighborhoods. We share both good and bad times over beer, and we catch up with long-missed friends over beer. We network for new jobs over beer. We go to baseball games and hold a hotdog in one hand and a beer in the other. Responsible drinking is simply a part of our lives.

We live in a modern, consumer-friendly time where you can enjoy a beer seven days a week. There is no longer a state-sanctioned Sabbath that shakes its finger at Sunday drinking, nor is there a temperance movement to shame imbibers into drinking underground. We have the freedom and even the constitutional right to enjoy a nice glass of suds. In all of human history, we've never had better drinking choices than right now. May our city ever be blessed by good beer.

Cheers!

BREWERIES IN WASHINGTON'S HISTORY

The following charts list Washington-area breweries and brewpubs in the chronological order in which they opened. The listing includes only local brewers, not out-of-town brewers who only bottle locally, such as Anheuser-Busch, Pabst and Schlitz, nor the bottlers themselves.

ALEXANDRIA, VIRGINIA

Brewery and Years of Operation	**Location**
Wales Brewery —Andrew Wales, 1770–74	Foot of Duke Street at the Potomac River (public warehouse on Point Lumley)
Wales Brewery —Andrew Wales, 1774–98 Alexandria Brewery —Cornelius Coningham, 1798 —William Lacey, 1798–99 —William Billington, 1799–1802	Wales Alley (100 block of S. Union Street, stretching two blocks west to Fairfax Street)

Brewery and Years of Operation	Location
Potomac Brewery —James Kerr, 1792–96 —John Towers, 1798–99 —Henry Keppell, 1800–01 —William Billington and Thomas Cruse, 1802–04 —Thomas Cruse, 1804–07	Foot of Oronoco Street at the Potomac River
Union Brewery —Abraham Morhouse, 1794–95 —Robert Smock and Daniel Ketcham, 1795 —Robert Smock, 1795–97 —Charles Young, 1797	Union and Wolfe Streets, southwest corner
William Oates, 1817–18	Quaker Lane, now Episcopal High School
Alexandria Brewery/Entwisle Brewery/Irwin's Brewery —Isaac Entwisle, 1805–21 —James Entwisle, 1821–31 —James and William Irwin, 1831–39 —William Irwin, 1839–54	Union Street between Wolfe and Wilkes Street, southeast corner
Alexandria Brewery/Martin's Ale Brewery —Henry S. Martin, 1856–71	King & Fayette & Commerce Streets
Shuter's Hill Brewery —Alexander Strausz and John Klein, 1858–60 —John Klein, 1860–65 —Francis Denmead, 1865–72 —Leased to Robert Portner, 1865 —Henry Engelhardt, 1872–92	Duke Street, West End, opposite Diagonal Road
Portner & Co. —Robert Portner, Frederick Recker, Edward Abner and Kaercher, 1862–65 —Robert Portner, 1865–68	King and Fayette Streets, northeast corner
Christian Pogensee, 1865–66	King Street—West End
George Steuernagel, 1865–68	200 block of King Street, north side
Robert Portner, 1869–83 Robert Portner Brewing Co., Tivoli Brewery, 1883–1916	Block of St. Asaph, Pendleton, Washington and Wythe Streets
Shenandoah Brewing Co., 1996–2011	652 S. Pickett Street
Hops Restaurant Bar & Brewery, 2001	Jefferson Davis Highway

Brewery and Years of Operation	Location
Virginia Beverage Co., 1995–2002 Founders Restaurant & Brewing Co., 2003–06	607 King Street
Port City Brewing Co., 2011	3950 Wheeler Avenue

ARLINGTON, VIRGINIA

Brewery and Years of Operation	Location
Little Falls Brewery —Philip Richard Fendall, property owner, listed for lease in 1796 and then for sale in 1802 and 1805	At the Little Falls of the Potomac River, near Chain Bridge
Consumers' Brewing Co., 1890–1902 Arlington Brewing Co., 1902–16 Dixie Brewing Co., 1933 (never opened)	Lee Highway, Rosslyn (now Key Bridge Marriott)
Bardo Rodeo, 1993–99 Dr. Dremo's Taphouse, 1999–2008	2000 Wilson Boulevard 2001 Clarendon Boulevard
Blue-N-Gold Brewing Co., 1995–98	3100 Clarendon Boulevard
Capitol City Brewing Co., 1997	4001 Campbell Avenue (Shirlington)
Rock Bottom, 1999	4238 Wilson Boulevard
Mad Fox Brewing Co., 2010	444 W. Broad Street (Falls Church)

CITY OF WASHINGTON

Brewery and Years of Operation	Location
Washington Brewery —Dr. Cornelius Coningham and James Greenleaf, 1796–97 —Dr. Cornelius Coningham and John Appleton, 1797–1805	Square 129: Constitution Avenue and Twentieth Street NW, near the Potomac River

Brewery and Years of Operation	Location
Washington Brewery —Dr. Cornelius Coningham and John Appleton, 1805–11 —John Collet, 1811–14 —Thomas Coote, 1817–24 —Clement T. Coote, 1825–26 —William and Thomas Gunton, 1826–32 —Clement T. Coote, 1832–36	Square 744: Foot of New Jersey Avenue SE at Anacostia River along Washington Canal
Henry Herford, circa 1805–15	Pennsylvania Avenue at Ninth Street NW
Georgetown Brewery (opened in 1809) —Daniel Bussard and Mr. Renner, 1809–13 —Daniel Bussard and William Hayman, 1813–30 —William Hayman, 1830–42 —Jacob Harman and N.P. Gordon, 1842–46 Washington Brewery —Joseph Davison, 1850–60 —Clement Colineau, 1860–65 —Harvey North, 1865–67 —John North, 1867–71 —George and William North, 1871 Arlington Brewery —Henry S. Martin and George B. Wilson, 1872–74 —C.H. Sawyer and Edwin Ryther, 1874–75 —Dewitt Ogden, 1876–77 —Francis Denmead, 1877–78 —Thomas C. Trafford, 1879–? Arlington Bottling Co. —Charles Jacobsen, 1885–1949	Uncertain location before William Hayman built his new brewery in 1830 at Twenty-sixth and K Streets NW
Island Brewery, circa 1840s–58 —John Boyd and Mason	Maine Avenue between 4½ and Sixth Streets SW

Brewery and Years of Operation	Location
Beckert's Park —George Beckert, 1850–59 —Herman Richter and Henry Schoenborn, 1860–63 Beckert's Garden (beer garden, renamed from Beckert's Park around 1863) —Theresa Beckert, 1859–89 Richter's Brewery —Herman Richter, 1863–70 —Alexander Adt, 1870–73 —Francis Adt, 1873–82 Navy Yard Brewery —John Guethler, 1882–86 —Francis Denmead, 1886 Washington Brewery —Carl Eisenmenger and Henry Rabe, 1886–88 —Henry Rabe, 1888–90 National Capital Brewing Co. —Albert Carry and Robert Portner, 1890–1906 —Albert Carry, 1906–17	Fourteenth Street NE between D and E Streets SE
Anarga Fisher, 1855 John Kozel, 1858–61	572 L Street North, old address convention
Charles Gerecke, 1856	Pennsylvania Avenue at Nineteenth Street NW
Juenemann Brewery —Owen Humphreys and George Juenemann, 1857–63 Mount Vernon Lager Beer Brewery —George Juenemann, 1863–84 —Barbara Juenemann, 1884–86 Albert Carry's Brewery —Albert Carry, 1886–89 Washington Brewery, 1889–1917	Block encompassing Fourth and Fifth Streets NE between E and F Streets NE
William N.H. Maack, 1860–77	1304 4½ Street SW

Brewery and Years of Operation	Location
Paul Baumann, 1858–64 Francis Frommell, 1864–66	1858 Boyd's Directory lists Baumann at 21 East Capitol. Most other citations refer to a brewery at 504 D Street SE
Charles Erbach, 1860–67	330 Maryland Avenue (old address convention)
Metropolitan Lager Bier Brewery —Ernst Loeffler, 1860–64 —Edward Abner, Louis Beyer, Frederick Hugle and Charles Mueden, 1864–66 Abner & Mueden Brewery —Louis Beyer (owner) and Edward Abner and Charles Mueden (proprietors), 1866–69	New York Avenue between First and Second Streets NW (115 New York Avenue NW)
Henry A. Kaiser, circa 1862–70	42 Greene Street (now Twenty-ninth Street NW between M and C&O Canal, Georgetown
Ruppel & Cook, 1864	Green's Spring, Georgetown
Alexander Grambush, 1863–64 Henry Haag, 1866–67	509 Eleventh Street NW (old address convention)
Frederick Holzer, 1863–67	Pennsylvania Avenue at C Street SE
Paul Baumann, 1864–66 Catherine Baumann, 1866–68	Pennsylvania Avenue and Ninth Street SE
George Schnell, 1864–72 Christian Heurich and Paul Ritter, 1872–73 Christian Heurich, 1873–90 Christian Heurich Brewing Co., 1890–92	1229 Twentieth Street NW
Henry Volkman, 1864 Joseph Widmann, 1865–68	487 Tenth Street NW (old address convention)
Frank Hicks, 1865	Sixth Street and Maryland Avenue SW
Edward Bowman, 1865 Katharina Bowman, 1866	South Carolina Avenue and Ninth Street SE
Jacob Elm, 1865	619 Seventh Street NW
Lackner & Schneider, 1865	D Street and Sixth Street NE
Charles Mueden, 1866	Fifth Street East, B Street North (old address convention)
Joseph Widmann, 1866–69 John G. Cook, 1874–80	45 N Street NW

Brewery and Years of Operation	Location
First Ward Brewery —John Cunningham, 1867–68	Nineteenth Street at L Street NW
Ferdinand Stosch and John Kessel, 1866–67	169 Seventh Street west, between O and P Streets NW (old address convention)
Kozel Brewery —John Kozel, 1867–81 —George Kozel, 1880–81 —Leo Ewald, 1881–82 —John Eller, 1883–90	43 N Street NW
Christopher Dickson, 1867–83	713–719 4½ Street SW
Joseph Widmann, 1870	Seventh Street and Wallach Place NW
John Albert, 1870–95 Albert Brewing Co., 1895–98 Abner & Drury, 1898–1901 Abner-Drury Brewing Co., 1901–35 Washington Brewery, 1935–37	2431, 2445 F Street NW
John Nass, 1870–80	821 4½ Street SW
Simon Dentz, 1874–76 Catherine Dentz, 1876–circa 1881	38/40 Greene Street (now Twenty-ninth Street NW between M and C&O Canal, Georgetown Catherine Dentz operated a saloon a block north at 1123 Twenty-ninth Street NW
George Kernwein, 1874–84 Maurice Kernwein, 1884–1900 Anton Danhakl, 1904–10	124 N Street NW The Kernweins leased part of 115 New York Avenue NW (the old Metropolitan Brewery) in 1877
Jacob Roth, 1874–84 Henry G. Roemheld, 1884–88	318 First Street NE
William Zanner, 1874–80	524, 526 4½ Street SW
Louis Schoeplen, 1877	812 Seventh Street NW
Thomas Van Buren, 1877	1317 Seventh Street NW
Charles Grainer, 1878	1812 Seventh Street NW
William Massey Brewing Co., 1888–93	615 D Street SW
Henry Lerch, 1889	1346 E Street SE
Julius Eisenbeiss, 1890–93	Eighth and L Streets SE
Joseph Widmann, 1890–91	624 Eleventh Street NE

Brewery and Years of Operation	Location
Banner Brewing Co., 1892–96	421 Tenth Street NW
Everard's Brewing Co., 1893	1005 B Street NW
Christian Heurich Brewing Co., 1894–1956	Block encompassing Water Street between Twenty-fifth and Twenty-sixth Streets NW
Capitol City Brewing Co., 1992 (ceased brewing in 2003)	1100 New York Avenue NW
Capitol City Brewing Co., 1996–2011	2 Massachusetts Avenue NE
Dock Street Brewing Co., 1996	1299 Pennsylvania Avenue NW
John Harvard's Brew House, 1997–2006	1299 Pennsylvania Avenue NW
District ChopHouse & Brewery, 1997	509 Seventh Street NW
Gordon Biersch (Penn Quarter), 2001	900 F Street NW
DC Brau Brewing Co., 2011	3178 Bladensburg Road NE
Chocolate City Beer, 2011	2801 Eighth Street NE
3 Stars Brewing Co., 2011	6400 Chillum Place NW
Gordon Biersch (Navy Yard), 2013	100 M Street SE
Bardo, 2013	1200 Bladensburg Road NE
Atlas Brew Works, 2013	2052 West Virginia Avenue NE, #102
Bluejacket, 2013	300 Tingey Street SE
Right Proper Brewing Co., 2013	624 T Street NW
Hellbender, 2014	5788 Second Street NE

BIBLIOGRAPHY

Albright, Robert C. "Bill Signed; Capital Gets Beer Tonight." *Washington Post*, April 6, 1933.

Alexandria Gazette. "Alexandria Brewery for Rent or Sale." July 20, 1843.

———. "Lager Beer Brewery." December 1, 1858.

Benbow, Mark. "The Old Dominion Goes Dry: Prohibition in Virginia." *Journal of the Brewery History Society* 138 (Winter 2010): 20–53.

Briney, John. "Old Heurich Brewery to Close January 31." *Washington Post*, January 10, 1956.

Brown, George Rothwell. *Washington: A Not Too Serious History*. Baltimore, MD: Norman Publishing, 1930.

Casey, Phil. "Old Heurich Brewery Scene of Blast Mighty in Sound But Only Near Beer." *Washington Post*, November 26, 1961.

Centinel of Liberty. "A Very Valuable Merchant Mill, a Distillery and Brewery, and Sundry Stone Quarries to be Let." September 6, 1796.

Cincinnati Commercial Tribune. "The Going of Campbell into the British Trust." September 18, 1889.

City of Washington Gazette. "Washington City Brewery." August 28, 1819.

Clapper, Raymond. "Happy Days." *American Mercury*, September 1927. Published in *American Mercury Reader*. Garden City, NY: Country Life Press, 1944.

Clark, Percy. "The Art of Brewing Beer." *Washington Post*, March 30, 1891.

Coffin, John P. *Washington: Historical Sketches of the Capital City of Our Country*. N.p., 1887.

Crabill, Jean Bischof. *Families of Prospect Hill*. Washington, D.C.: Prospect Hill Cemetery, 1997.

———. *The Immigrants and Their Cemetery: The Story of Prospect Hill*. Washington, D.C.: Prospect Hill Cemetery, 1995.

Crabill, Jean Bischof, and Carol M. Holler. *Prospect Hill Cemetery Adult Burial List*. Washington, D.C.: Prospect Hill Cemetery, 2003.

Critic-Record. "Manufactures—The Arlington Brewery." February 10, 1973.

———. "The Raid on Stove-Pipe Liquor Saloons." January 25, 1883.

Croggon, James. "Port of Washington." *Evening Star*, December 12, 1907.

Daily National Intelligencer. "An Act Prohibiting the Sale of Certain Liquor and Drinks on Sundays, and for Other Purposes." November 28, 1857.

———. "Alexandria Brewery for Rent or Sale." April 26, 1843.

———. "Brewery." March 3, 1814.

———. "Brewery Fixtures, Horse, Cart, &c, at Auction." June 13, 1843.

———. "Brewery in Washington City to be Sold or Let." July 9, 1813.

———. "Destructive Fire." November 6, 1854.

———. "Fire." January 23, 1815.

———. "Hayman's Brewery." October 3, 1830.

———. "Hayman's Brewery at Auction." October 27, 1842.

———. "Hayman's Brewery at Private Sale or for Rent." August 14, 1843.

———. "Lager Beer Frauds Unveiled." August 1, 1867.

———. "The Loeffler Metropolitan Brewery Company." January 20, 1864.

———. "Malting and Brewing Establishment for Lease or Sale." September 2, 1836.

———. "Marshal's Sale." December 15, 1824.

———. "Note, Clement T. Coote." February 14, 1826.

———. "Notice, Thomas Coote." February 14, 1826.

———. "Proposals." September 7, 1820.

———. "Trustees' Sale of Machinery and Fixtures of the 'Island Brewery.'" July 7, 1858.

———. "Trustees' Sale of Valuable Brewery." July 22, 1847.

———. "Trustees' Sale of Valuable Brewery." February 4, 1869.

———. "Trustees' Sale of Valuable Improved Property and Brewery." May 29, 1868.

———. "The 'Washington Brewery.'" July 4, 1860.

———. "Washington Brewery." October 18, 1865.

———. "Washington Brewery." November 3, 1826.

———. "Washington Brewery, District of Columbia." April 2, 1850.

———. "Washington Brewery Notice." January 29, 1825.

————. "Washington City Brewery." August 20, 1819.

Daly, John J. "Beer Gardens of Old Capital Added Froth to Life." *Washington Post*, October 22, 1933.

Davenport, Walter. "Bartender's Guide to Washington." *Collier's*, February 16, 1929.

DeFerrari, John. "The Celebrated Alhambra Summer Garden." Streets of Washington, June 10, 2013.

————. *Historic Restaurants of Washington, D.C.: Capital Eats.* Charleston, SC: The History Press, 2013.

————. *Lost Washington, D.C.* Charleston, SC: The History Press, 2011.

Dennée, Timothy J. *Robert Portner and His Brewing Company.* Alexandria, VA: Parson Engineering Science, 2002.

Evening Star. "Alleged Conspiracy: Local Brewery Workers Placed on Trial Today." May 15, 1906.

————. "A Big Brewing Establishment." July 25, 1891.

————. "A Big Enterprise: A Brewery to be Erected Across the Aqueduct in Virginia." August 3, 1895.

————. "Brewery Officials Held." February 29, 1912.

————. "The Brewery Workmen." April 13, 1897.

————. "Charged with Keeping Unlicensed Bars." February 3, 1883.

————. Christian Heurich advertisement. July 6, 1907.

————. "The Consumers' Brewery." July 1, 1897.

————. "The Courts." September 2, 1881.

————. "The Deed Was Murder." September 3, 1896.

————. "Demurrer Sustained." July 26, 1904.

————. "'Export' and 'Culmbacher': Fine Beers Brewed by the Washington Brewery Company." December 14, 1899.

————. "Fire in a Brewery." July 23, 1892.

————. "The Firemen's Strike." July 22, 1904.

————. "Gathering Bottles: How the Local Brewers Protect Their Property." August 15, 1896.

————. "Georgetown Affairs." December 26, 1857.

————. "The Herbert Case." July 10, 1856.

————. "The Heurich Brewery Site." January 3, 1891.

————. "High License Issue." October 24, 1905.

————. "Humphries & Junniman." June 17, 1857.

————. "Humphries and Juenemann's Pleasure Garden." April 24, 1858.

————. "Important Seizure of a Lager Beer Brewery." July 30, 1867.

————. "The Kozel License." January 15, 1897.

————. "Lager Beer." June 21, 1856.

————. "Lager Beer Brewery." December 4, 1856.

————. "Liberty and Lager Beer." March 8, 1860.

————. "Loss Put at $20,000; Stables of Arlington Brewing Company Burned." January 12, 1911.

————. "Merry War in Progress." July 21, 1904.

————. "A New Departure." May 5, 1907.

————. "One Hundred Dollars in Gold for a Name." April 24, 1909.

————. Pabst Blue Ribbon advertisement. July 25, 1907.

————. "Portner's Brewery on Fire." September 9, 1891.

————. "Problem of the Brewers." June 1, 1907.

————. "A Projected Strike." July 20, 1904.

————. "Real Estate Gossip." October 14, 1893.

————. "Real Estate Gossip." September 13, 1890.

————. "Shrouded in Mystery." July 9, 1906.

————. "Striking Brewers Return to Work This Morning." July 3, 1902.

————. "Trustee's Sale of 890 Barrels of Lager Beer." October 8, 1868.

————. "Trustee's Sale of Brewery, Horses, Wagons, Bar Fixtures, Household Furniture, &c., &c., at No. 487 Tenth Street West." November 5, 1867.

————. "Trustees Sale of Valuable Improved Property and Brewery, on Pennsylvania Avenue and 9th Street East." January 6, 1868.

————. "Trustees Sale of Valuable Improved Property and Brewery on South D Street, Between 5th and 6th Streets East." January 6, 1868.

————. "Two Drinks Each Day for Brewery Workers." May 3, 1910.

————. "Two-Story Frame Dwelling House, Brewery and Fixtures, on the Corner of 19th Street West and L ST, North at Auction." January 9, 1868.

————. "Unusual Commotion Arouses Citizens at Late Hour." July 30, 1902.

————. "Warrants Issued Against Wholesale Liquor Dealers Charged with Selling by the Glass." January 25, 1883.

————. Washington City Garden advertisement. July 15, 1870.

Fisher, Marc. "Last Call for the District's Hometown Beer." *Washington Post*, March 4, 2006.

Gaines, Michael. *The Shortest Dynasty, 1837–1947: The Story of Robert Portner; A History of His Brewing Empire and the Story of His Beloved Annaburg*. Bowie, MD: Heritage Books, 2002.

Goode, James M. *Capital Losses: A Cultural History of Washington's Destroyed Buildings*. 2nd ed. Washington, D.C.: Smithsonian Books, 2003.

Green, Constance McLaughlin. *Washington: A History of the Capital, 1800–1950*. Princeton, NJ: Princeton University Press, 1962.

Bibliography

Hahn, Fritz. "Beer Tour." *Washington Post*, April 24, 2013.

————. "Brewed Awakening: D.C.'s Beer Scene Is Close to Greatness." *Washington Post Magazine*, July 13, 2013, 16–19.

Heurich, Christian. *From My Life: 1842–1934.* Transcribed and edited by Eda Offutt. Washington, D.C.: privately published, 1934.

————. "I Watched America Grow." As told to W.A.S. Douglas, Washington, D.C., unpublished manuscript, 1942.

Heurich, Gary F. "The Christian Heurich Brewing Company, 1872–1956." In *Records of the Columbia Historical Society*, 604–15. Washington, D.C.: Columbia Historical Society, 1973–74.

H.S. Rich & Co. *One Hundred Years of Brewing.* Chicago: H.S. Rich & Co., 1903 (reprinted 1974).

Independent American. "Georgetown Brewery." December 19, 1809.

Jones, Jeffrey M. "U.S. Drinkers Divide Between Beer and Wine as Favorite." http://www.gallup.com/poll/163787/drinkers-divide-beer-wine-favorite.aspx.

Juriscola. "To the Cultivators, the Capitalists and the Manufacturers of the United States." *National Intelligencer*, April 1, 1810.

Kasper, Rob. *Baltimore Beer: A Satisfying History of Charm City Brewing.* Charleston, SC: The History Press, 2012.

Kerr, K. Austin. *Organized for Prohibition: A New History of the Anti-Saloon League.* New Haven, CT: Yale University Press, 1985.

Kitsock, Greg. "A Maryland Brew Is This Year's Top Dog," *Washington Post*, April 24, 2013.

————. "Beer Madness 2013: At Last, a Bracket Full of Beltway Brews." *Washington Post*, March 20, 2013.

————. "The Statue of Brewery: The Brewer, and His Beer, Who Helped Build Washington." *Washington City Paper*, December 20, 1991–January 1, 1992.

Krepp, Tim. *Capitol Hill Haunts.* Charleston, SC: The History Press, 2012.

Liggett, Walter W. "How Wet Is Washington?" *Plain Talk*, December 1929.

May, Eric Charles. "Growing Up on Tales of Washington Brew." *Washington Post*, October 1, 1987.

Mencken, H.L. *Heathen Days, 1890–1936.* Baltimore, MD: Johns Hopkins University Press, 1996.

The Metropolitan. "Proposals Will Be Received." September 5, 1820.

————. "The Storm." August 17, 1820.

Mullany, Dennis. "Labor and the Breweries." *Washington Post*, July 21, 1904.

National Intelligencer. "Advertisement." April 18, 1803.

————. "Advertisement." November 15, 1802.

———. "A Brewery for Sale." September 6, 1805.

———. "New Store." November 5, 1812.

———. "Valuable Property for Sale." September 17, 1806.

———. "Washington Brewery." January 18, 1812.

———. "Washington Brewery." October 15, 1812.

———. "White Flannels." November 8, 1808.

Ogle, Maureen. *Ambitious Brew: The Story of American Beer*. New York: Harcourt, 2006.

Peck, Garrett. "The Greatest Gang of Criminals." *Arlington Magazine*, January/February 2012, pp. 60–66.

———. *Prohibition in Washington, D.C.: How Dry We Weren't*. Charleston, SC: The History Press, 2011.

———. *The Prohibition Hangover: Alcohol in America from Demon Rum to Cult Cabernet*. Piscataway, NJ: Rutgers University Press, 2009.

Pope, Michael Lee. *Shotgun Justice: One Prosecutor's Crusade Against Crime and Corruption in Alexandria & Arlington*. Charleston, SC: The History Press, 2012.

Povich, Shirley. "This Morning…with Shirley Povich." *Washington Post*, February 19, 1956.

Powers, Madelon. *Faces Along the Bar: Lore and Order in the Workingman's Saloon, 1870–1920*. Chicago: University of Chicago Press, 1998.

Rorabaugh, William J. *The Alcoholic Republic: An American Tradition*. New York: Oxford University Press, 1979.

Sismondo, Christine. *America Walks into a Bar: A Spirited History of Taverns and Saloons, Speakeasies and Grog Shops*. New York: Oxford University Press, 2011.

Sullivan, Patricia. "Alexandria Boat Club Wins Va. Supreme Court Decision on Access to Wales Alley." *Washington Post*, October 31, 2013.

Tana, Daniel. "The Last Call: Preserving Washington's Lost Historic Breweries." Final project, master of historic preservation, University of Maryland, May 2013.

Templemann, Eleanor Lee. "Rosslyn Is Regional Gateway." *Northern Virginia Sun*, November 8, 1957.

Van Wieren, Dale P. *American Brewers II*. West Point, PA: Eastern Coast Breweriana Association, 1995.

Virginia Glass Company Bottle Factory, Site 44AX181. Bethesda, MD: Dames & Moore, 1999.

Washington Herald. "Old Brewery to Be Rebuilt." January 13, 1933.

Washington Post. "Abner Drury Brewery Is Sold at Auction; Old-Timers Sorry." August 18, 1938.

————. "Alexandria Annals." June 7, 1880.

————. "Anti-Saloon League and Liquor Interests Are Locked in Death Struggle." September 27, 1908.

————. "Ban on the Growler." October 21, 1905.

————. "Beaten and Left to Die." April 10, 1889.

————. "Beer Case Sent Back." March 8, 1905.

————. "Beer Garden Has Friends." January 16, 1897.

————. "Beer Made from Malt and Hops Exclusively." June 12, 1912.

————. "Begin Strike at Noon." July 21, 1904.

————. "The Best Beer in the World." May 19, 1901.

————. "Bleacher Beer Garden Opens Tonight for Griffith Stadium's Thirsty Ones." August 10, 1956.

————. "Brewers Decline to Join the Bottlers in Their Strike." July 3, 1902.

————. "Brewery Men Held." February 29, 1912.

————. "Brewery Strike Disapproved." July 19, 1904.

————. "Brewery Strike Ends." July 29, 1904.

————. "Brewery Wins Test Case." September 23, 1911.

————. "Business Directory: Breweries." February 2, 1881.

————. "Capital Celebrates Beer's Return after 16 Years of Drought." April 7, 1933.

————. "Carry Estate $90,000." April 8, 1925.

————. "Carry's Brewery Sold." August 13, 1889.

————. "D.C. Dry at Midnight." October 31, 1917.

————. "Death of George Juenemann." August 19, 1884.

————. "Death Seals His Lips." April 11, 1889.

————. "Defends Liquor Interests." January 20, 1908.

————. "Drink Capital Dry Ahead of Schedule." November 1, 1917.

————. "Dry Agents Destroy 749 Cases of Beer." November 21, 1923.

————. "Dry Law Costs $500,000 in Taxes to the District." November 1, 1917.

————. "Dunn, Berlin Found Guilty by D.C. Jury." November 29, 1934.

————. "Engineer Severely Burned by Explosion of Brewery Boiler." July 29, 1901.

————. "An Extraordinary Story." November 28, 1878.

————. "A Fatal Bicycle Ride." April 5, 1895.

————. "Fewer Saloons in D.C." November 1, 1916.

————. "Firebugs at Brewery." January 13, 1911.

————. "First Permit for Real Beer Issued to Capital Brewery." November 18, 1921.

————. "Funeral of Washington's First Brewer." January 31, 1881.

————. "Funeral Rites for Heurich Set Tomorrow." March 9, 1945

————. "Garden of Gambrinus." September 6, 1896.

————. "An Immense Brewery." September 27, 1890.

————. "Inquiry into Beer War." August 9, 1904.

————. "In the Hands of Englishmen." May 5, 1889.

————. "Its Formal Opening." July 29, 1891.

————. "Jury Accuses Jett." October 5, 1912.

————. "Knife User Convicted." October 18, 1906.

————. "Kozel Defies the Authorities." May 21, 1897.

————. "Left $1,900,000 Estate." June 21, 1906.

————. "To Lift All the Boycotts." April 1, 1896.

————. "Light Sentence for Plock's Slayer." May 4, 1897.

————. "Local Brewery Is Scene of Prosperous Activity." March 26, 1933.

————. "Looks Like a Swindle." May 6, 1889.

————. "Manassas Is Remembered." June 8, 1906.

————. "A Mark of Enterprise." March 29, 1903.

————. "Men Struck at Noon." July 22, 1904.

————. "The Metropolitan Brewery Accepted." September 12, 1878.

————. "Mrs. Heurich Dies at 89, Widow of Brewery Head." January 25, 1956.

————. "1 Body in Furnace, 1 Dead by Bullet." October 2, 1912.

————. "Opposes Beer Garden License." October 4, 1896.

————. "Order for a Strike." July 20, 1904.

————. "Pledge Loyalty to U.S." March 29, 1917.

————. "The Police Give It Up." April 18, 1889.

————. "The Portner-Carry Consolidation." November 16, 1890.

————. "Prosecutors Also Guilty." July 2, 1896.

————. "Puts Ban on Sale of Beer." June 26, 1910.

————. "Richmond Men Buy Brewery." February 29, 1920.

————. "Robert Portner Dead." May 29, 1906.

————. "Rosslyn Brewery Closed." November 3, 1916.

————. "Running, Brewers Say." April 3, 1915.

————. "Seek a Blanket Injunction." July 22, 1904.

————. "Serious Accident in a Brewery." January 8, 1881.

————. "Services Tomorrow for Albert Carry." February 16, 1925.

————. "Slight Wound Results Fatally." September 4, 1896.

————. "Startling Coup D'Etat." October 8, 1883.

————. "Strike Injunction Denied." July 27, 1904.

————. "A Strike Is Threatened." March 21, 1906.

———. "Three Shots Took Effect." June 11, 1896.

———. "Tri-State Duo to Face Trial in D.C. Today." November 26, 1934.

———. "Union Against Strike." July 26, 1904.

———. "War of Labor Unions." July 23, 1904.

———. "Will Alexandria Go Dry?" June 18, 1906.

Washington Times-Herald. "Honoring Christian Heurich." June 6, 1940.

Wolff, Bob. *It's Not Who Won or Lost the Game—It's How You Sold the Beer.* South Bend, IN: Diamond Communications, 1996.

INDEX

ABOUT THE AUTHOR

G arrett Peck is a literary journalist, local historian and author of five books. *Capital Beer: A Heady History of Brewing in Washington, D.C.*, is his fifth book and sequel to *Prohibition in Washington, D.C.: How Dry We Weren't*. He also leads tours of the Seneca quarry and the Temperance Tour of Prohibition–related sites in Washington. Peck was involved with the DC Craft Bartenders Guild in lobbying the D.C. City Council to have the Rickey declared Washington's native cocktail. A native Californian and graduate of VMI and the George Washington University, he lives in lovely Arlington, Virginia. www.garrettpeck.com.